MEDWAY
TALES

MEDWAY TALES

Life on the Dividing River

WILF LOWER

The History Press

Main front cover image credit: Nigel Pepper Photography.
Reproduced by permission of TRADSAIL.

To long-suffering newspaper editor David Jones for his wise advice,
that most people are interested in what other people do.

First published 2010

The History Press
The Mill, Brimscombe Port
Stroud, Gloucestershire, GL5 2QG
www.thehistorypress.co.uk

© Wilf Lower, 2010

The right of Wilf Lower to be identified as the Author
of this work has been asserted in accordance with the
Copyrights, Designs and Patents Act 1988.

British Library Cataloguing in Publication Data.
A catalogue record for this book is available from the British Library.

ISBN 978 0 7524 5306 4

Typesetting and origination by The History Press
Printed in Great Britain
Manufacturing managed by Jellyfish Print Solutions Ltd

CONTENTS

INTRODUCTION

The River that Divides

Rivers often form a dividing line separating counties or states, or marking the boundary between countries. The River Medway, rising high in the Sussex downs, meanders into Kent where historically there were warring tribes who opposed each other across the river as it made its way to the sea. On one side lived the Men of Kent and on the other were the Kentish Men. Of course, this also refers to the Maids of Kent and Kentish Maids! But which is which?

Well, it is quite straightforward. A Man of Kent comes from the area to the east of the River Medway and a Kentish Man comes from the west of the river. It may seem a little odd at places where the river meanders in an east-west direction – for example, when it passes through the Medway towns between Strood and Rochester – but even then it is not difficult to appreciate which 'side' of the river is which.

It is generally thought that the division may have arisen over 1,500 years ago when the Jutes, a Germanic race from Europe, arrived in Thanet and began to move into the area we now know as Kent, calling one part 'East Centingas' and the other 'West Centingas'. Saxon mercenaries were hired to defend the east from the invaders, and as a reward for their success they were given the Isle of Thanet – then still an actual island.

Mercenaries being, well, mercenary, they then decided to invade the mainland themselves and overthrow their former employers. More Saxons arrived from different homelands and settled in the north-west part of the county. It was at this point that the Men of Kent/Kentish Men division was created, with the River Medway providing a natural boundary. Thus many of the 'Men of Kent' are descended from the Angles, whilst many 'Kentish Men' were formerly Saxons. As time passed the Angles became more dominant, driving the Celts westward and forming what became the English nation.

Whilst most people are aware that William the Conqueror successfully invaded England in 1066, it is less well known that he had tried a year earlier, landing with a small army at Romney in the south-east of Kent, but was roundly beaten off by the locals. However, when William returned with a bigger army, the Men of Kent joined the English King Harold at Hastings to resist William – more stoutly, it seems, than the Kentish Men who weakly surrendered! Even after William's coronation, Kent continued to be a thorn in his side. He took an army to quell insurgency but was 'apprehended' by local leaders at Swanscombe. Not knowing how large the hidden Kentish army was, he decided negotiation was the best option and so Kent was allowed to continue enjoying the rights and liberties that had been conferred on the county by Edward the Confessor.

It is generally believed that the bravery of the Men of Kent who opposed William made them proud, while Kentish Men were believed to be weak-minded, and so a keen rivalry

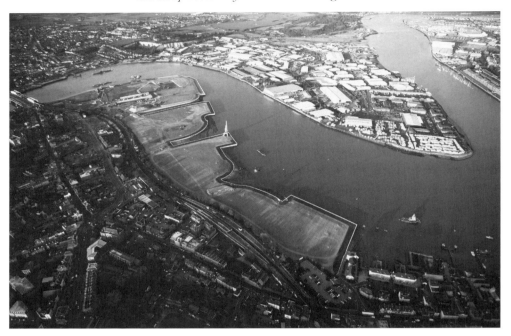

The River Medway passing through the towns to which it gives its name. (Courtesy South-East England Development Agency)

Gillingham Reach seen from the bullnose at Chatham Docks. The Victorians designed the entrance to the dock basins so that a middle course along the reach is in line with the lock.

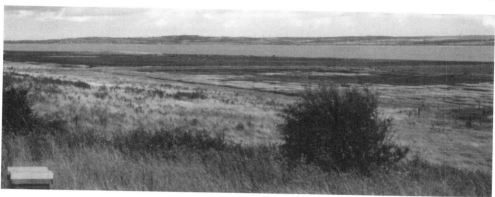

Wide bleak marshland downstream as the River Medway nears the estuary.

developed – though today it is nothing but friendly. However, native-born Kentish Men and Men of Kent guard their birthright with great pride and 'foreigners' immigrating merely to take up residence are not normally or readily admitted to either clan, but it is all very amicable and the most obvious reminders of the division these days are the names of many Kent pubs – to the east of the River Medway many are called the 'Man of Kent', whilst to the west they are most often called the 'Kentish Man'.

Over the centuries the River Medway provided the link between both groups, who together shared the opportunities and prosperity generated by this major thoroughfare. Like their ancestors, many of those who work on and around the river today remain hardy and tenacious but consider themselves 'ordinary people'. As their stories reveal, they may be 'ordinary', but what they achieve is really quite 'extraordinary'.

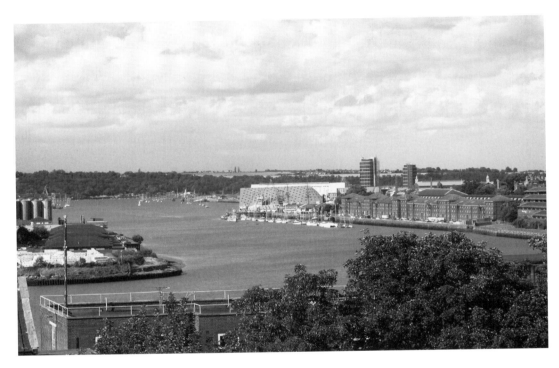

Chatham Reach and the Historic Dockyard.

CHAPTER ONE

CRUISING ON THE MEDWAY

For centuries the Medway was a 'working' river and there was not much time or space for leisure or pleasure activities.

The first organised barge race was held in 1863. A couple of years later the 'smack' races began, although in reality they probably raced each other every day, not for trophies but to get fish to market quickly for the best prices. These races were possibly the closest the crews got to relaxation and occasionally their families might join them. Meanwhile, there were a few yachts owned by the wealthy, usually with a paid crew of local watermen, and some yacht clubs began to appear, although they were actually little more than 'gentleman's' clubs. But what about the workers?

For the better off there were some pleasure boats, often small, commercial sailing ships that would take parties down to the estuary during summer weekends. For other people, tuppence would get them on a steam launch from Chatham to Upnor where, from the 1890s, the council regularly laid sand over the mud to create a beach. Between the wars there were donkey rides, a pierrot show, rowing boat trips and even a small bandstand!

It was not until the 1850s and the arrival of the paddle steamers that 'cruising down the river' became cheap and popular. For the factory workers, the dockyard 'mateys' and, indeed, anyone else, for a shilling or two the paddle steamers would take them from the town's grime and smoke to exotic destinations such as Southend, Herne Bay and even Margate! For a hundred years 'paddlers' were the passport to happiness, albeit only for a few hours!

Paddling Down the River

Today, taking a cruise on a luxury liner is becoming a popular holiday option, perhaps because it provides an opportunity to connect with the traditional British love for the sea. Modern cruise liners, mega-storeys high, can accommodate up to 5,000 passengers and innocent pastimes such as deck quoits have been replaced by fitness gyms, spa pools and shopping malls complete with all the favourite high street shops, which seems to defeat the object of 'getting away from it all'.

Fifty years ago you could cruise from the Medway towns on a paddle steamer, although it was usually only a day trip. But these trips provided just as much enjoyment and pleasure as would a luxury cruise today, though it has to be said that the local weather wouldn't have been quite as

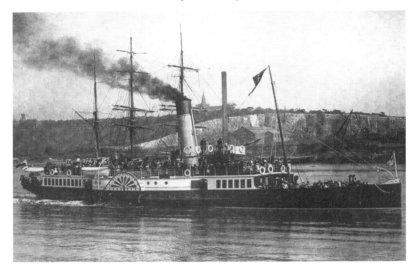

Paddle Steamer
City of Rochester
leaving Strood
in 1904.

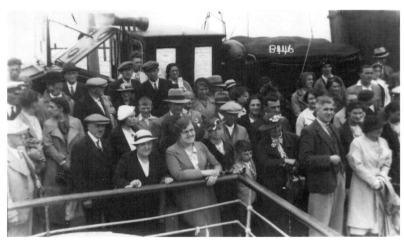

The end of
a day trip by
paddle steamer
in the 1930s.
Passengers
witing to
disembark from
the PS *Medway
Queen* at
Chatham's Sun
Pier.

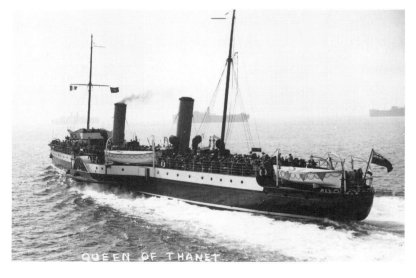

The popular
paddle steamer
Queen of Thanet
on the Medway
in the 1930s.
A former
Royal Navy
minesweeper
that became one
of the Medway's
busiest pleasure
boats.

warm and sunny as the Mediterranean or Caribbean! Maybe the steamers did lack a few features that even the big cruise ships of the day could offer, but they were cheap. In the early 1950s, mum, dad and two children could have a day return from the Medway towns to Southend or Herne Bay, with a cream tea on board during the return trip, and still get change from a pound.

The New Medway Steam Packet Company owned and operated a substantial fleet that included the *Queen of Thanet*, the *Queen of Kent* and the famous *Medway Queen* which they commissioned in 1924. In just a few hours they could deliver you to the heady delights of Herne Bay, Margate or Clacton, invariably via Sheerness – where few people ever seemed to disembark, most preferring the longer voyages to 'exotic destinations' further afield! For many, a trip on one of these paddlers was a great adventure: waiting on Chatham's Sun Pier at about half past eight in the morning for the boat to appear from between the many cargo ships moored in the Pool of Rochester; the scurry of activity as the ship moored; boarding and then ignoring seats in a haste to find a space by the deck handrails from where the departure could be watched. The ships always seemed to have a starboard list following departure, probably from so many people crowding the side to see the Royal Navy ships lining Anchor Wharf, Thunderbolt Pier and the dry docks. As views of dockyard activity disappeared, the list moved to port when the ship passed the Castle and Lower Upnor. By now the ship would be in Gillingham Reach and the river widened with a less interesting shoreline.

Of course, the bars were open and busy, even at that relatively early hour, but many passengers, especially families, brought picnic breakfasts to eat on the deck, although they invariably purchased tea from the ship's café. For those who wished to 'splash out' there were elegant 'saloons' where tea and toast was served on crested china and cutlery … no plastic spoons or polystyrene cups in those days! Before long, many passengers would go to look at the engine and watch the huge pistons driving the paddle wheels. Most of the paddle steamers cruised at about 12 knots which equated to around 40 revolutions of the paddle wheels a minute – fairly slow compared to small engines these days, but the sight of the shiny oiled pistons, as big as tree trunks, thrusting the even larger cams around every one and a half seconds or so was truly awe-inspiring!

Out in the estuary beyond Sheerness it could be choppy and this meant avoiding the foredeck, where the spray could be heavy, green and wet, but soon the destination would be reached. Once there most people would disembark for up to five hours whilst locals or holiday makers boarded for a short sea trip, but by late afternoon people gathered on the piers for the return journey. Of course, it was inevitable that somebody would ask that the departure be delayed because Uncle Fred or Cousin Betty hadn't turned up. The ship might wait a few minutes, then the siren would blast, the gangways would be swung ashore and the vessel would depart – and often the luckless latecomers would be seen waving frantically and running down the pier in vain. Whatever the destination, it could be a long day and it was often eight in the evening or later before the ships arrived back at Chatham. The return trips were distinctly quieter, with most people happy to simply sit and take in the view, either on deck or below in one of the saloons, whilst children happily sucked on sticks of rock. The bars were busy and drunken behaviour was rare, despite those who had chosen to spend all day on board propping up a bar!

People prefer more sophisticated ways to spend their leisure time these days, but the enjoyment – or excitement for children – of a cruise on a paddle steamer such as the *Kingswear Castle* seems undiminished. Maybe it is just nostalgia for a time when the pace of life was slower, when there was time to relax on the deck of a paddle steamer and just watch the world slowly go by.

That was cruising, Medway style!

The New Medway Steam Packet Company

The New Medway Steam Packet Company had been formed from the 'old' company, which could trace its origins back to 1837 when it established the first regular river service between Chatham and Sheerness. This was before the railway arrived, but by the turn of the century, with better roads and a railway line to Sheppey, it was pleasure trips that generated income rather than freight. The older ships were sold off and the company's two new paddle steamers, *Princess of Wales* and *City of Rochester II* were popular and highly successful. But in 1914 they were commandeered by the Royal Navy and converted to paddle minesweepers; nothing much was heard of them again – maybe they didn't sweep well enough and were destroyed!

However, it can be assumed the Steam Packet Company were suitably recompensed as in 1919 they began a rapid programme of growth, purchasing some six paddle steamers, most of which were ex-Navy vessels and modified for passenger use at yards on the Medway. In 1924 a new vessel, the *Medway Queen* was commissioned – incidentally, this was the only new vessel the company ever purchased! By the 1930s, the New Medway Steam Packet Company was the largest pleasure ship business in the south-east, operating trips on the Medway, the Thames, up the east coast and around the Kent coast. They also ran diesel screw-driven trip ships to France and Belgium of which the *Royal Daffodil*, a former Mersey ferry from Liverpool, was one of the first. In addition, the company operated coastal cargo ships working between all the major UK and continental ports. Their biggest rival was General Steam Navigation (GSN), who operated pleasure boats on the Thames and also had a large cargo fleet. In 1936, the New Medway Steam Packet Company merged with GSN but operated under its own name until closed down 1966, by which time there were no more sea-going pleasure boats on the Thames or the Medway.

It was the 1950s that saw the rapid demise of the Thames and Medway pleasure boats, despite a remarkably quick resumption of passenger services in 1946 after the war, but by this time the ships were old. The popular *Queen of Thanet* and *Queen of Kent* were, in fact, converted minesweepers built for the navy in 1916 and purchased by the company as part of their rapid expansion in the 1920s. Within a couple of years it was clear that they were in need of uneconomically expensive refurbishment, so in 1949 they were sold for scrap. The youngest vessel was an ex-Second World War landing craft purchased in 1947 and renamed the *Rochester Queen*. Painted white, she was used on the twice-daily Strood to Sheerness trips, but wasn't a success and so the ship was sold in 1953.

Meanwhile, the *Medway Queen* had returned to 'Civvy Street' after a distinguished wartime record that included the rescue of over 7,000 servicemen from the beaches at Dunkirk in 1940. She was in fairly good condition and, after a total refit in Southampton, she returned to the Medway and the schedule of daily pleasure trips throughout the summer. By the mid-1950s tastes had changed and with more car ownership and holidays abroad, people were no longer satisfied with a gentle trip 'down the river' as a family day out. The numbers of passengers dwindled and in 1963 the *Medway Queen* was withdrawn from service and sold to be used as a restaurant on the Isle of Wight.

Dedicated to Medway's Heritage

It is perhaps hard to believe that nearly twenty-five years have passed since the paddle steamer *Medway Queen* was brought back to the Medway from the Isle of Wight where she had been left to rot following a short and ill-fated attempt to use her as a floating restaurant. A consortium of local businessmen had arranged the return, planning to berth her in the newly created

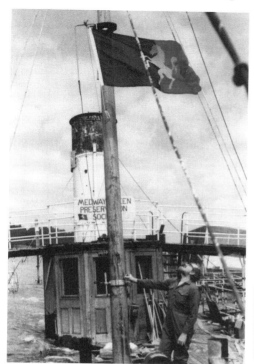

Above, left: Raising the flag of the Medway Queen Preservation Society over the almost derelict vessel to mark the inauguration of the society. (Courtesy Medway Queen Preservation Society)

Above, right: Minesweeper HMS *Medway Queen* in dry dock for repairs after Dunkirk. (Courtesy Medway Queen Preservation Society)

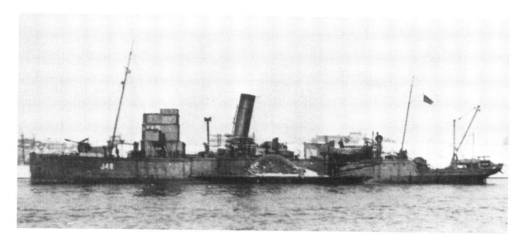

The newly commissioned HMS *Medway Queen* in her wartime colour, grey. (Courtesy Medway Queen Preservation Society)

Medway Queen almost abandoned, 1985. (Courtesy Medway Queen Preservation Society)

Chatham Historic Dockyard, which had recently been vacated by the Royal Navy, and then to restore the grand old lady to her former glory. Carried atop a pontoon towed by a tug, the ship entered the Medway to an enormous welcome, with the mayor and assorted dignitaries on board for the last few miles of her journey upriver. The local press had a field day claiming that part of Medway's heritage had 'come home'.

A year later and this once proud ship lay derelict by the dockyard wall almost completely submerged at high water, buffeted by tides and the wash of passing vessels. After the euphoria of the return, reality had kicked in – nobody had realised the extent of the deterioration or the staggering cost of restoration. One by one, those who had brought the ship to Chatham quietly faded away whilst weeds grew on the steamer's decks and fish swam through her lower saloons.

The sorry plight of the ship attracted steam expert Marshall Vine, who had established an enviable reputation for successfully 'rescuing' examples of Britain's steam heritage. Marshall's energy and enthusiasm was boundless and before long he had assembled a band of like-minded local people and the Medway Queen Preservation Society was founded. It rapidly gathered momentum and before long volunteers from far and wide were busy shovelling mud and scraping off weeds and rust. Publicity was paramount to secure funds, for it was clear the ship needed a secure, permanent berth, and there were countless presentations at every opportunity. These included talks at local schools and it was at one of these that teenage sea cadet John Kempton, already intrigued by a national press report about the ship, decided to join the society. A few days later John was up to his knees in mud, helping to clear the ship, and now, twenty-one years later, he is chairman of the society!

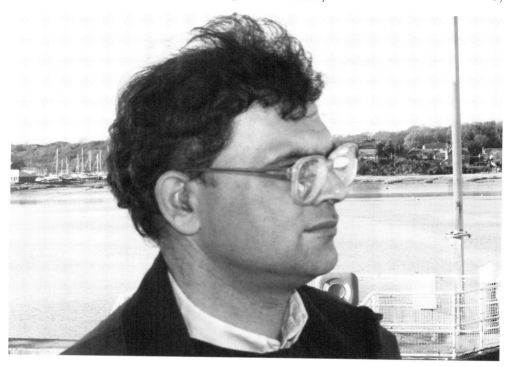

John Kempton, from mud-shoveller to dedicated chairman of the Medway Queen Preservation society.

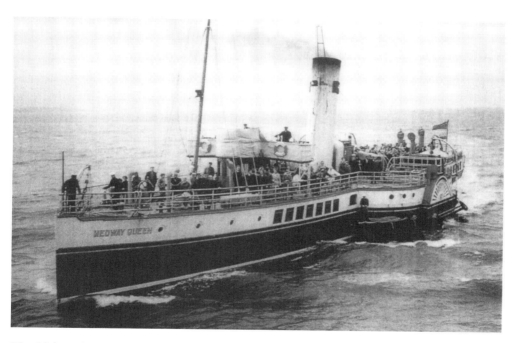

The *Medway Queen* in 1961 during her final season of pleasure trips on the River Medway.

There was little 'marine' background in John's family, although his grandfather had been a naval officer, but the *Medway Queen*'s history and the hands-on approach to her restoration fired John's enthusiasm. As he embarked on a career with a Thames shipping agent, John spent every weekend helping to get the *Medway Queen* afloat. It was clear the ship couldn't stay where she was, so there were endless meetings with local wharfingers and marinas, whilst others explored every creek on the river, then it was back to clearing mud! But their efforts were not in vain: a berth was found at Kingsnorth's Damhead Creek and the ship was finally floated and made secure for the trip downriver to Damhead.

Restoration now began in earnest. The mud had been cleared but now the priority was to repair the rusting steel structure itself. Like other volunteers, John became proficient in cutting, welding and riveting between fund raising and promoting the project. The years on the Isle of Wight had left the ship in a terrible state, so it was an uphill struggle, and the patience and enthusiasm of the volunteers was severely stretched by two serious 'sinkings'. The first was not too bad and prompt repairs plus a lot of pumping got the ship afloat again. But the second, in which floodwater effectively burst some hull plates from inside pressure, showed that despite the skill, determination and unstinting effort by the volunteers, piecemeal repair of the hull was not going to save the ship. A full and professional rebuild was needed and it would cost millions of pounds.

John had become one of the society's most active members, who, in addition to pursuing every avenue to generate funds, were desperately seeking means to secure substantial financial support. A national register of historic ships had been established and the *Medway Queen*, as the only remaining example of a coastal paddle steamer, plus her rescue of over 7,000 service-men from Dunkirk, had been placed on the 'core collection' list. However, this provided no assurance of funding. The only option seemed to be application to the Heritage Lottery Fund (HLF) who were responsible for distributing monies generated by the nation's weekly 'flutter'. The HLF would not simply hand over the much-needed monies; there was a tortuous applications process with no guarantee of success, and even if awarded, it would only be a part of that required – the balance would have to be raised by the society. A small group of the society's members, including John, began to prepare their HLF application.

John admits that the tedium of clearing mud and the depression resulting from the ship's sinking were nothing compared to the torments of the HLF application process! After many months of effort, their application was rejected – and then a second application was unsuc-cessful. It was ten years and three applications later that they finally learned in the autumn of 2008 that they had been awarded £1.8 million, representing 75 per cent of the cost of rebuilding the hull and deck – with the balance of £600,000 raised by the society. Just before Christmas in 2008, John, as chairman of the Medway Queen Preservation Society, formally signed a contract with the Albion Shipyard at Bristol to commence the work, which will be completed in about two years, paving the way for further work to complete the restoration in due course.

John's passion for the restoration of the *Medway Queen* is as strong today as it was when, as a young man, he first became involved, but it is now tempered by the experience of a suc-cessful major funding bid, and he is clear on the route ahead. 'Although nothing can be taken for granted', he says, 'it's clear the HLF think that the Society has by its own efforts thus far, demonstrated that it's capable of generating further funds. Combined with a further successful HLF bid, this means we would be able to restore the engine and engine room – the "heart of the ship", leading to the Medway Queen sailing under her own power again.'

Assuming that the funding is secured, the *Medway Queen* could be sailing again by 2012, although there will be a lot of trials to obtain the regulatory approvals needed before she can visit ports around the UK – and doubtless a return to Dunkirk, as the society hope for the future. There is also the question of where she would be berthed; ideally on the Medway, but where? At present there are no longer any of the piers left on the river where she could pick up passengers.

Nearly ninety years ago, the directors of the New Medway Steam Packet Company were determined and single-minded in their aim to provide a new paddle steamer for the Medway, and the result was the *Medway Queen*. Today, John Kempton and fellow members of the Medway Queen Preservation Society are equally resolute in their aim to see that same paddle steamer sailing on the river again. Part of Medway's heritage will then genuinely have 'come home'.

The *Medway Queen* at Dunkirk

The *Medway Queen* was launched in 1924 at Troon in Scotland and for the next sixteen years she carried thousands of day trippers from Strood to Southend, Herne Bay and Margate. In 1939 she was used to carry evacuated children from Kent to East Anglia before being requisitioned by the Royal Navy who re-named her HMS *Medway Queen*. Painted entirely in grey, she was equipped with an aged 12-pounder gun and an equally old Hotchkiss machine gun, then directed to join the Dover patrol.

In 1940, commanded by a Lieutenant Cook, she went to Dunkirk, probably one of the largest 'little ships' to participate, initially towing a number of small motorboats to ferry troops from the beaches to the ships. The slow and lumbering paddle steamer was an obvious target and frequently came under attack from enemy aircraft, but nevertheless made no less than seven trips across the channel, rescuing at least 7,000 servicemen. It was a miracle she and her crew survived. On one trip a paddle was damaged by enemy action and she spun around out of control for some time before a repair was completed, then, to avoid another ship, she hit a mud bank that put the paddle out of action again! During a later trip, when returning to Dover, she took on board passengers from another pleasure boat, the *Brighton Belle*, which had been hit and was sinking.

As the ship was about to depart on her seventh and final trip, the situation at Dunkirk had deteriorated and Lieutenant Cook suggested that the crew write letters for their families before sailing. Like most of the previous trips, the ancient guns were in constant use with noise and smoke ever present. Dunkirk was in chaos when, for the last time, the *Medway Queen* set course for home, but she was soon forced to take evasive action that resulted in her going further down the English Channel, frequently 'heaving-to' for damage repairs. Meanwhile, back in Dover, Admiral Ramsey and his officers were convinced the gallant paddle steamer had been sunk, which the BBC announced in a news broadcast that was picked up on the ship as she struggled home! As such, there was enormous relief both on the ship and ashore when the *Medway Queen* finally arrived back in Dover.

Lieutenant Cook and many of the crew received awards for bravery, with special mention for the ship's chief cook Tom Russell. Tom had worked tirelessly to ensure that every person rescued got a full hot meal and drink whilst on board – despite the continuous attempts by the Luftwaffe to sink the ship.

The ship returned to Chatham Dockyard where she was repaired and spent the rest of the war as a training vessel. In 1947, following a complete refit at Southampton, the *Medway Queen* returned to providing pleasure trips for the Medway towns. Nearly forty years old and needing

serious refurbishment, the ship was retired after the 1963 season and nearly scrapped, but eventually went to the Isle of Wight to be used (unsuccessfully) as a floating restaurant.

> Fact File – *Medway Queen*
> Overall Length: 180ft (55m)
> Beam: 24ft (7.4m)
> Gross tonnage: 316
> Engine Compound: Diagonal steam
> Speed Maximum: 15 knots, paddles turning at 55rpm

Upholding Medway's Maritime Heritage

It is twenty-five years since the paddle steamer *Kingswear Castle* began providing trips on the River Medway. Now well established as one of Medway's most popular attractions, this delightful vessel is a survivor of the days when a trip on a paddler was the highlight of a holiday or a day out. Built in Dartmouth in 1924 (the same year as the *Medway Queen*) specifically for excursions on local rivers, the *Kingswear Castle* carried thousands of trippers over the years. During the war she was chartered to the US navy as a 'liberty ship', operating between the shore and ocean-going vessels at Dartmouth, and afterwards resumed her career as a trip boat. Sadly, in 1965, with maintenance costs spiralling upwards and with less demand as holidaymakers went abroad, she was retired, destined to be sold as scrap.

She was saved by the Paddle Steamer Preservation Society (PSPS) who purchased her for £600. But funds for repairs were in short supply so the vessel was chartered for use as a floating restaurant on the Isle of Wight – lying alongside the *Medway Queen*, which had been similarly pensioned off. The restaurant business didn't flourish and both paddlers deteriorated, with the PSPS resigned to sell the *Kingswear Castle* for scrap. Thankfully they reconsidered and set up a project team to restore her. She was moved to the Medway where restoration commenced – a project that was to take thirteen years.

John Megoran, champion of paddle steamers and the driving force behind the preservation of PS *Kingswear Castle*.

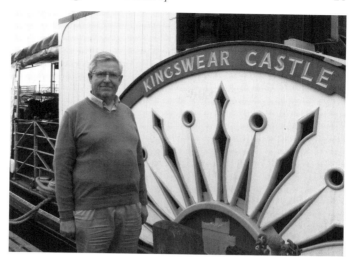

John Megoran by the ornate paddle box of the fully restored PS *Kingswear Castle*.

The PSPS twice saved the *Kingswear Castle* from the breakers, and it is because of their determination that we can today experience the pleasure of a trip on a paddle steamer. Formed in 1959, the society this year celebrates its fiftieth anniversary, as the *Kingswear Castle* celebrates its twenty-fifth year of operation on the Medway led by John Megoran, a quiet and unassuming man who was involved at the commencement of both the society and the paddle steamer.

Born in Weymouth, John's father became a founder member of the PSPS when it was created in 1959, and a year later, although only ten years old, John became an enthusiastic member, helping to raise funds for *Consul*, another paddler that was under threat. As a teenager John worked as a volunteer deckhand on the local paddle steamer *Princess Elizabeth* and later spent his school holidays working on the ferries to the Channel Islands that ran out of Weymouth. He wanted to join the Merchant Navy but bespectacled John was turned down as at that time people with glasses were not accepted. Disappointed, John settled instead for university, gaining a degree at King's College London in chemistry, a subject that he subsequently went on to teach. However, between studying and later teaching, John was at every opportunity back at Weymouth to work on the paddle steamers and other ships. He was only nineteen when he gained his boatman licence, and later an Isle of Wight pilot's licence, and became a relief skipper on the trip boats that moved along the south coast resorts, at times working on the historic trip boat *Balmoral*, which now visits the Medway each year.

A dedicated member of the PSPS, John had closely followed progress on the *Kingswear Castle* and, as restoration neared completion, he became more involved, skippering her first season in 1984 when she operated under a provisional licence that permitted her to carry only twelve passengers. That winter John moved to Medway where he worked tirelessly to prepare the ship for full MCA approval, which was successfully achieved and the vessel was able to commence full passenger-carrying trips on the Medway. A trust was set up to administer the ship, of which John became a trustee and remains so today, whilst he is also employed to manage the day-to-day operation of the vessel.

However, navigating a paddle steamer – even in rough waters – is child's play compared to managing the regulations that apply to a heritage vessel such as the *Kingswear Castle*, not to mention maintaining sponsorship and securing funding. John admits that the early years were a tremendous struggle but things have got easier over time as the vessel has grown in

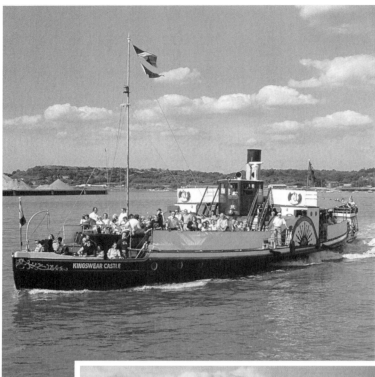

Paddle steamer
*Kingswear
Castle*
packed with
day-trippers
on a summer's
day on the
Medway.

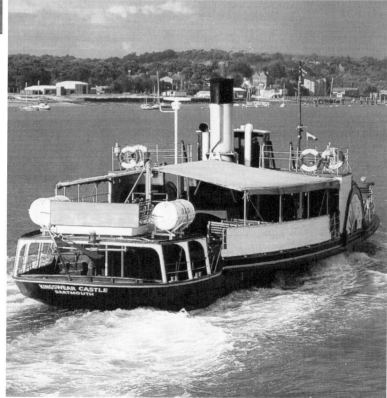

PS *Kingswear
Castle* showing
her low profile
and clean lines.

popularity. There is a full programme of trips that range from half an hour to a whole day, with revenue just about covering the basic running costs, but it is the major capital work that causes the most headaches. The trust has a close relationship with the MCA, who are help-ful, but major work on any historic vessel is expensive and requires John to spend long hours preparing complex applications for sponsorship or for grant injections from bodies such as the Heritage Lottery Fund.

Meanwhile, the *Kingswear Castle* continues to provide the only opportunity for visitors to enjoy a traditional 'trip down the river'. Coach parties are the 'bread and butter' and at the summer peak the ship can operate at her maximum capacity of 235 passengers. At other times she is available for private charter and has also appeared in many films and television productions.

It is a busy life for John who, despite his dedication to paddle steamers, is no 'woollen-capped steam nerd', but a sensible and well-respected authority on these vessels, with a vast practical knowledge of successfully managing their preservation and operation. He has devel-oped extensive links with those involved with paddle steamers in other countries, particularly Switzerland and Germany where many remain in use on lakes and rivers.

We are fortunate to have such great ambassador for Britain's maritime steam heritage and the River Medway.

Fact File – Paddle Steamers

The idea of a paddle wheel to propel ships can be traced back to the ancient Egyptians, and the Spanish are known to have experimented with the idea in the 1600s, but it was not until steam propulsion was developed that it became practicable. The first paddle steamer was the *Charlotte Dundas* which launched in 1802 and within twenty years such craft were operating from nearly every port in Britain.

Paddle steamers require special skills to handle successfully. The paddles only drive forward or reverse and provide no steerage, which requires water flowing over a rudder, and you can't give a quick 'burst' to the propeller as you would on a conventional craft. Therefore, approaching or departing a pier with a paddler requires special co-operation and understanding between the helmsman, the engineer and the deck crew.

Paddles are vulnerable, particularly on sea-going paddlers. In rough seas they roll, which may cause one paddle to be lifted clear of the water whilst the other may 'dig in' to cause unequal stress, and they are easily damaged if they hit anything.

In 1845 the Admiralty set up a tug-of-war between a paddle steamer and a propeller screw-driven boat. The screw-driven ship won, and the future for paddle-driven ships was thereafter limited and confined mainly to pleasure craft or use in shallow waters.

Phillips of Dartmouth built the *Kingswear Castle* in 1924. She is 117ft (35m) long with a beam of 17ft 6in (5.3m) and only draws 3ft (0.9m). A Cox reciprocating steam engine with a coal-fired boiler drives the 10ft-diameter paddles with fixed wooden floats to produce a cruising speed of 8 knots.

WORKHORSES
OF THE RIVER

Nothing better epitomises the River Medway than the sailing barge. For hundreds of years these highly practical vessels carried every conceivable type of cargo and their title as the 'workhorses' of the river is well justified. Coal, bricks, cement, paper pulp, hay and mud were just some of the 'bulk' goods packed into their spacious holds which were invariably loaded (and unloaded) by hand.

The advent of efficient motor barges in the 1930s sounded the end for working sailing barges, and by the 1950s almost all had disappeared, although a few struggled along 'in trade' for a few more years. Today about thirty vessels survive, maintained (at a considerable cost) by dedicated owners who are determined these remarkable craft shall not disappear. Each year most compete in the various barge matches and many offer themselves to companies and organisations wishing to charter a barge to use for staff team-building or simply as a unique venue for a corporate event. Purists sometimes argue that the barges are 'selling out' their traditional heritage, but the financial reality is such that in most instances it is the only means to help fund the enormous cost of maintaining these magnificent vessels.

The Medway Barges

Before railways existed the easiest way to transport goods was by water, and the design of boats evolved with regard for the cargoes they would carry and the nature of local waters. Vessels designed to ply around the coasts had deep keels and high freeboards to cope with rough waters, whilst those to be used on rivers and the inland waterways were usually of lighter construction. Some vessels regularly traded both inland and around local coasts, and their design was an economic compromise balancing cargo capacity with seaworthiness, whilst retaining those aspects relevant to the area, so evolved the 'nobbies' and 'cobles' in the north, the Humber 'keels', the 'flatners' in the Bristol Channel, the Norfolk 'wherries' and probably most successful of all, the Thames and Medway sailing barges.

For some, such as the cobles with their big rectangular lugsail, the design clearly derived from Viking ships, but wherries and barges can clearly trace their origins back to medieval times and the Dutch. The shallow waters and flat exposed landscape of the Low Countries had

Right: Working barges moored overnight below Rochester Bridge in 1938. (Courtesy Kent Messenger Group)

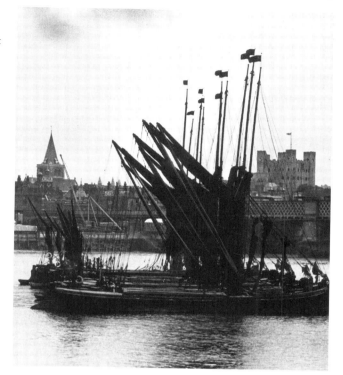

Below: Skipper's mate aloft to give steerage directions on a 'stack' barge making its way upriver fully loaded with hay. A typical river scene a hundred years ago.

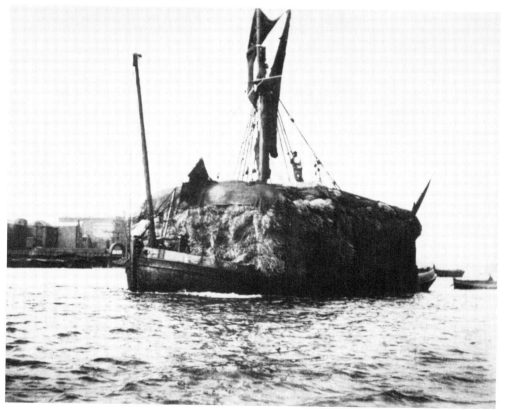

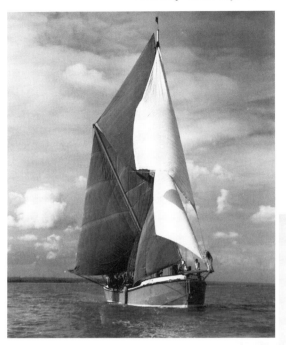

A barge competing in a 1920s match with all canvas set.

Portlight, built 1925 as a sailing barge, converted to a motor barge in the 1950s, then back to a sailing barge again in the 1970s.

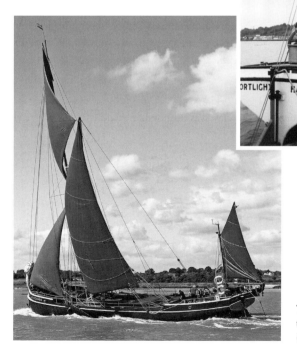

The barge *Wyvenhoe* demonstrating that barges are not necessarily slow! (Courtesy Nigel Pepper Photography)

resulted in ships with a shallow draught but a wide beam for stability and cargo capacity, with masts that could be rapidly lowered and raised to pass under river bridges. The Flemish weavers who came to East Anglia in the seventeenth century undoubtedly influenced local boat builders in the design of the wherries, which could carry substantial cargoes of cloth and other goods, and navigate both inland waterways and along the coast to nearby ports. In fair weather some might make the trip to the Thames, where the design was copied to create the Gravesend wherry, popularly known as a 'goozleboat'. As trade increased and with bigger and more varied cargoes, there was a need for larger boats and gradually the familiar Thames and Medway barge evolved.

Despite the various colourful names such as 'stumpies', 'staysail', 'mulies' and 'spritsail', all the traditional Thames and Medway barges are essentially floating boxes around 80ft long and 20ft wide. They have a flat bottom that enables them to travel far upstream into shallow waters and they can sit on the bottom mud or sand between tides for loading or discharging cargo. Most have a huge single hold accessed by a couple of hatches, invariably comprised of timber battens that support a canvas cover lashed tightly down to keep water out. A small store is normally located up front in the fo'c'sle (forecastle), whilst there is a cramped crew cabin aft that incorporates both living and sleeping accommodation. But the rig was the key to the commercial success of the barges. With a spritsail, foresail, topsail, mizzen and bowsprit jib there could be 5,000 square ft of heavy canvas, yet at most times the barge could be sailed by two people – often just a man and a boy. For a longer sea passage, maybe to a continental port, one or two extra hands might be taken, and for negotiating an upriver bridge a 'huffler' would usually join the barge to assist with lowering and raising the mast in order to 'shoot' the bridge safely. The base of the mast fitted into a hinged tabernacle, by which the mast, sails and all the rigging could be lowered in under a minute without first having to stow the sails. Once through the bridge, a winch is used to raise the mast and set the sails, an operation that an experienced crew could complete in about two minutes. Originally the barges had no engine, so quickly getting the sails set was essential to maintain course and speed after shooting a bridge.

Barges were the 'workhorses' of marine trade in the south-east for over a century, carrying every conceivable type of cargo and often being a key element to several aspects of the manufacturing industry, such as brick-making. The 'saltings', or mudflats, along the lower reaches of the River Medway were rich sources of blue clay, a basic material for bricks that were made in the 'brickfields' or brick manufactories along the riverbanks. A 'muddie' barge would moor in a creek, sitting on its flat bottom at low tide whilst the clay was dug by hand and thrown directly into the hold. As the tide rose, the barge would sail to the brickworks where the clay would be unloaded. Similarly, barges known as 'chalkies' would bring chalk dug from riverside quarries to be added to the brick mix, and the same barges would be loaded with the finished bricks for delivery to London and other ports around the south-east. On return from a delivery trip, the barge would bring household refuse (known as 'rough stuff') from which the cinders of domestic fires became part of the brick mix and the rest of the rubbish was used to filled the holes left by the clay diggings! In just thirty years, from 1880 to 1910, one barge company dug out over 1½ million tons of clay from a creek at Hoo – all of it by hand using a narrow-bladed shovel called a fly. Another company, Eastwoods, operated their own fleet of over seventy barges.

But it was not just mud and sand that the barges transported. Before cars there were horses, which needed food, and specially adapted 'stack' barges carried hay from the country to the town. The name was descriptive as the barges just resembled stacks of hay that rose to over 30ft above the deck. The view ahead was totally obliterated so the mate would sit atop the stack

and shout directions down to the skipper! Coal was another common cargo. Tough sea-going brigantines and schooners brought the coal from Wales, Scotland or northern England, but with a relatively deep draft they couldn't travel far upriver, so coal was transferred to barges to complete the delivery.

The heyday for barges was between 1870 and 1930 and during this time they were probably the most economic method of bulk transport. The advent of the railway had prompted some worries about competition – well justified, as until then the barges had often had a fairly leisurely 'take it or leave it' attitude about meeting delivery schedules. Even those who wanted to offer a faster service couldn't because speed had never been an issue and the sailing rigs could be cumbersome. It was a Sittingbourne barge owner, Henry Dodds, who realised that rigs and sailing techniques had to be improved. In 1865 he achieved this in a novel way by initiating the first ever barge racing match which became an annual event and continues to this day. The result was the rapid development of more efficient rigs and faster vessels that ensured the superiority of barge transport for several decades.

By the 1920s many sailing barges had been fitted with auxiliary engines, but the older barges were increasingly being replaced by purpose-built motor barges that were faster and better able to maintain delivery schedules. Some old barges were converted to become houseboats whilst others were left to quietly rot away in a lonely creek. The last sailing barge to operate commercially was the *Cabby* which was built at Gill's Frindsbury yard in 1928. No longer trading but still sailing, she is one of the few remaining barges that have been rescued, restored and now maintained by private owners. Most of these barges just about manage to survive financially from charter work, corporate events and an occasional film or television requirement, but it is an ongoing struggle. Meanwhile, there is a handful of craft with dedicated owners still hopeful that one day they will have the funds and, most importantly, the barge still around for restoration.

During the latter part of the nineteenth century there were over 2,000 barges plying their trade on and around the River Medway, with nearly 8,000 in operation throughout south-east England. Today just thirty remain.

Across the Generations

Between the mudflats flanking the Medway estuary a very young boy was proudly sailing his small dinghy when he spotted the famous sailing barge *Sirdar* making her way majestically across Half-Acre Creek. The lad was so captivated by the gentle ease with which the barge's skipper and mate were manoeuvring the massive vessel through the narrow channels that it was only at the last moment he realised he was directly in its path. Luckily, the barge skipper slightly altered course and the boy escaped with only a mild soaking from the spray as the bow wave of the barge pushed the dinghy aside. The boy was entranced and vowed that one day he would have his own barge.

The lad was Geoff Gransden and the close shave with *Sirdar* happened nearly fifty years ago, but it led him to a permanent love of barges, bawleys and sailing smacks, and the rivers and swatchways on which they sailed. And today, as he promised himself all those years ago, Geoff has his own barge, the *Edith May*, one of the most famous of all the Thames and Medway barges.

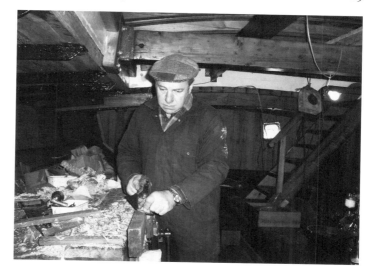

Geoff Gransden, at work on restoration of the sailing barge *Edith May*.

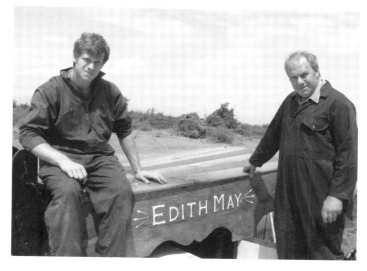

Edward Gransden (left) with his father Geoff, celebrating the restoration of *Edith May*. Edward worked with his father and grandfather, Eric, on the ten-year project, during which time he also acquired a university degree.

SB *Edith May*'s final journey under sail before she was laid up, prior to purchase by Geoff Gransden and her subsequent restoration.

SB *Edith May* on the blocks built
especially at Lower Halstow Creek to
accommodate her for the duration of
restoration.

Geoff Gransden at work on the
restoration of the SB *Edith May*.

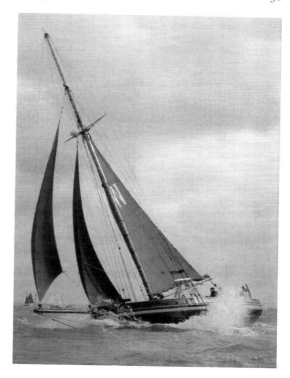

The smack *Thistle* under sail following her rebuild by Geoff Gransden. Designed to bring fish catches home quickly, with an experienced skipper these smacks could outsail most other vessels.

Geoff's father Eric is a master carpenter and founder of a local building company. In the 1950s he built for himself an Eventide sailing sloop, a popular timber craft at that time, on which the family spent every spare moment. Eric still sails today and has one of Britain's best-known and admired motor-sailing craft, a timber-built Miller Fifer. Sailing both with the family and in his own Fireball dinghy, Geoff was soon an expert at navigating the shallow waters of the estuary whilst getting to know the local barges and other traditional sailing craft, many of which were then still working commercially. He avidly read everything he could find about the vessels, learning to appreciate their simple lines and shapes and seeing at first-hand how they were sailed and maintained.

Joining the family business meant less spare time, but Geoff's interest in the river and its traditional craft remained as strong as ever. With an increasing participation in the annual barge and smack races, it was inevitable that his enthusiasm and knowledge would be recognised and Geoff was co-opted into helping organise the sailing matches, a task he continues to enjoy, now as a respected member of the race committee.

It was equally inevitable that Geoff would realise his dream of sailing his own traditional vessel, and in 1990 he found the former Whitstable oyster smack *Thistle*, sadly in a very poor condition, at Pin Mill in Suffolk. Gently nursing the old 1908-built timber smack — over 60ft long including bowsprit — to her new home at Gillingham on the Medway was a delicate but exhilarating voyage. The smack was fast and had been built to deliver oysters from the catching boats offshore as quickly as possible back to harbour for onward carriage by train to London's top oyster bars and restaurants. It was soon obvious that *Thistle* was a thoroughbred, a fast sailing boat, although an engine had been fitted in 1910 to ensure the oysters got ashore even if there was little wind!

Craftsmanship runs in the Gransden family and over the next few years Geoff restored *Thistle* to her original condition, deliberately removing the engine in order to maintain authenticity. With a deep straight keel, a 20ft bowsprit and a 60ft mast carrying hundreds of square ft of sail, *Thistle* is not easy to handle in a 'blow'. But this hasn't stopped Geoff from sailing her along the swatchways and in and out of the east coast harbours – a remarkable achievement for a boat without an engine! *Thistle* has also shown the speed under sail for which she was originally designed by her successes in the annual Bawley and Smack matches and the 'Old Gaffer' races.

Despite his excellent restoration work and the successes of *Thistle*, Geoff's dream of owning a barge had not diminished. In 1999 the owner of a local barge suggested it was time Geoff fulfilled his ambition. One of the most famous barges of the Thames and Medway had been beached at Upnor and was rapidly falling into disrepair. *Edith May* had been built in 1906 at Harwich and was one of the last barges to remain in trade. From the 1960s for nearly twenty years, *Edith May* was legendary for winning almost every barge match. In the 1980s she was converted for charter in the north-west but the enterprise had not succeeded and the barge was slowly moved southwards from yard to yard, ending up at Upnor. Geoff and his many barge friends carefully inspected the vessel and decided she could be restored and, on a cold November day in 1999, Geoff's dream of owning a barge was realised.

86ft of barge has to be berthed somewhere, and the traditional barge blocks that used to exist along many creeks on the river had long gone, including those at Lower Halstow, once busy with barges. Geoff lives at Lower Halstow and he managed to persuade the local parish council to let him install what were probably the first new barge blocks to be built on the Medway for over a century.

First the timber had to be found but luckily Geoff and his father had scoured the Thames and Medway to note where old piers and wharves were being dismantled, and sufficient timbers were soon arriving at Lower Halstow. During one of the coldest and wettest Novembers in memory, Geoff and his father began to construct the new barge blocks. It was no mean task: they had to set timber posts each at least 12in square – and some even larger – into concrete footings on the bottom of the creek, then bolt equally large cross timbers to form supports every few feet for the barge to rest on. All had to be carefully levelled and the work could only be carried out between tides, wading all the while in deep, black, muddy ooze. After many weeks of backbreaking work, the blocks were complete and *Edith May* was brought to her new home.

Geoff originally estimated it would take five years to complete total restoration of the *Edith May* and planned to re-launch for her centenary in 2006. But it was soon realised that the barge was in a very sorry state and restoration would take much longer.

Geoff has had much enthusiastic support and help – in fact, three generations have worked on the vessel. Father Eric had lost none of his professional skills in working with timber and relished the opportunity to use his long and wide experience to restore the craftsmanship that had created *Edith May*. Eric has been working on the barge since she was acquired by Geoff and now, at the age of eighty-eight, has seen the restoration through to completion. Meanwhile, Geoff's son Edward was equally keen to learn the complex skills of shaping timber under the guidance of his father and grandfather. Edward's enthusiasm for the work is almost equal to that of his father: he was fifteen when *Edith May* arrived at Lower Halstow and ten years on is still devoted to completion of the project.

It is the sheer size of the vessel that is astounding. Anyone who has worked with timber knows the problems of positioning long planks into an assembly. The timbers often have a mind of their own. Fitting a replacement plank on *Edith May* usually required the highly skilled technique of scarphing the joint with another plank, which meant it had to be carefully shaped and tapered to fit a similarly shaped plank exactly. It sounds fairly easy but *Edith May*'s hull required planks of

solid deal timber that were 8in wide, 3in thick and 32ft long! Just placing the timber in position needed three people supporting it on their shoulders whilst another checked how the shaping was progressing. Meanwhile, the keelson (the 'backbone' of the hull) is more than 18in square. Most of the hull was sound but some frames were rotten and had to be painstakingly removed and new timbers fitted. It was slow, precise and heavy work. Geoff and his family were grateful for modern power tools, prompting more than a thought to the original builders who only had simple hand tools to shape the huge timbers used to build the barges.

To protect the timbers that were exposed during the restoration, one of the earliest tasks was to construct a full-height weatherproof shed over the entire vessel. The structure, 90ft long, 20ft wide and up to 8ft high, was clad with corrugated sheeting and, with lighting installed, the deck became a gigantic workshop. Once the hull and superstructure had been completed work began on the interior fit-out to provide comfortable accommodation whilst retaining all the necessary authenticity. Pine was used throughout the interior and was finished to a standard far higher than that of any commercial barge. The enormous hold has become a roomy saloon capable of accommodating a reception for up to fifty people, adjoining an open-plan kitchen and servery. Geoff has created comfortable en-suite accommodation for the skipper (and his wife) and the original master and mates' quarters have been extended and improved to provide accommodation for two or three guests. The rustic feel has been maintained throughout with appropriate lighting that creates a relaxing atmosphere.

Finally it was necessary to make a new mast, although most of the spars were salvageable and with these rigged and a set of refurbished sails added, the restoration was complete.

It has been a true labour of love. Geoff, Eric and Edward were totally dedicated to the task and it is entirely thanks to their skills and dedication that *Edith May* is ready to sail for another hundred years. She has been beautifully restored and there will be opportunity for others to enjoy the vessel as Geoff intends to combine his own love of sailing such a graceful vessel with some charter work, taking small groups sailing in the estuaries and swatchways of the south-east. However, one of Geoff's declared priorities as the restored *Edith May* sailed again out of Lower Halstow was to ensure that the barge begins to reclaim her record of success in the barge matches. And at the helm, Geoff will be keeping a close watch for any young lads in dinghies who might be more interested in the barge than in where they are going!

Fact File – *Edith May*

Thames/Medway Sailing Barge

Built: 1906 by J. & H. Carr of Harwich of pitch pine on oak frames

Overall length: 86ft plus bowsprit

Beam: 21ft

Fitted with an auxiliary engine in 1952

Used mostly for carrying grain between Great Yarmouth and London, operated by Sulleys, respected barge owners. Remained in service until 1961 when sold privately and re-equipped with gear from another famous barge, *Veronica*, previously owned by Everards of Greenwich.

From 1962 until the 1980s competed and won virtually every barge match.

In 1985 sold and moved to Liverpool for charter work but unsuccessful and had several owners.

In 1989 taken to Maldon in Essex in anticipation of a full restoration that never happened.

Moved to Upnor in the early 1990s and became almost derelict until purchased by Geoff Gransden.

Moved to Lower Halstow in 2000 and full restoration commenced.

Restoration completed in 2009.

Fact File – *Thistle*
Whitstable Oyster Smack
Built: 1908 of pitch pine on oak frames
Overall length: 44ft plus 20ft bowsprit.
Fitted with an engine in 1910.
Designed to get the oysters from the dredging boats to shore as quickly as possible for market.
Fully restored at Gillingham 1990–94 to original condition (without engine).

The Deceiving Lady of the River

Stroll along the riverbank at Upnor and you might see the elegant sailing vessel *Alice*, a traditional Thames barge. A grand old Medway lady – or is she? Look again and you'll start to get confused. Shiny bright varnish work, clean new ropes and no thick layers of paint spanning eighty or more years. *Alice* is a new sailing barge!

Finding someone who will build you a barge isn't what it used to be. Once upon a time you could drop in to one of a score of yards, order a 'standard eighty-footer', press a dozen crisp white ones into the builder's hand as a deposit and, of course, politely acknowledge his forelock tugging as you departed. Today, it is hard enough to find a traditional yard, let alone one that could build a barge – in fact, the last wooden sailing barge to be built on the Medway was the *Cabby* in 1928, although the last steel sailing barge slid into the water at Strood in 1934. Business hasn't been so good for barge builders during the past seventy years, so to build a barge these days there is only a choice between a restored 'classic' at a staggering price or an interesting winter project to 'suit an enthusiast' who would end up with blisters and a frightening overdraft.

For Owen Emerson, a shipwright trained in Chatham Dockyard where he had constructed frigates and submarines, building a barge wasn't a daunting project. Owen had sailed barges from a young age, his shipbuilding skills are well respected and he's much in demand for restoring these unique old vessels. He built *Blackthorne*, a half-size barge yacht that he and his wife Rita had sailed for some years, and also restored the 1850s barge *Montreal* and another barge *Victor*, now used for charter work. However, Owen and Rita wanted another full-size barge to use for the charter business, but none were available, either well kept or suitable for restoration, so Owen decided he would have to build a new one!

Then, one spring day in 1994, Owen and Rita were sitting on *Blackthorne* at Upnor when a tug arrived towing a dumb lighter loaded with ballast for a nearby construction site. As the lighter was cast alongside for offloading, Owen, with a highly developed feel for the shape of a boat, realised that this uncompromising lighter with two blunt ends would be ideal for conversion to a sailing barge. The lighter's central section was identical to the hold of a barge and the shell could save Owen hundreds of hours of preliminary work. Enquiries were made, a deal was struck and as the last of the ballast cargo was unloaded, Owen and Rita became owners of the dumb lighter *Alice*.

Alice was built in 1954 as a swin-headed budget stern lighter, using very heavy gauge steel. Most of her working life had been spent on the Thames carrying such mundane cargoes as paint, oil and the occasional load of brick and rubble, although Owen learned that she had surreptitiously been used to carry spares for pirate radio stations. However, there were also remains of HM Customs tags on her hatches so she had probably carried bonded goods at some time.

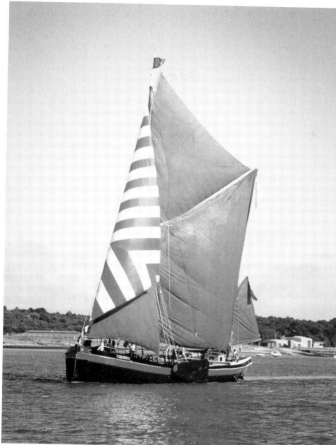

From an ugly dumb lighter to an elegant sailing barge, *Alice* on the River Medway during her maiden trip as a sailing barge.

At the wheel of *Alice*, her creator Owen Emerson. Potentially Britain's only remaining barge builder?

An open and shut case? The swin-heading of dumb barge *Alice* being transformed into the stylish stem of a sailing barge.

Owen and Rita decided to carry out the conversion of *Alice* on the foreshore at Upnor in the traditional Thames and Medway manner. Working on the shore was not always easy as with fore and aft bulkheads intact *Alice* raised and fell with the tide, even when the ends were opened out and re-shaped into a new stem and stern. The crane from an old coaster was skilfully transformed and fitted as a mainmast with what would become the barge 'spreet' – the arm that supports the mainsail, used to form a 'derrick' for lifting equipment during the conversion. However, fitting the large 185hp diesel engine needed more ingenuity, but this was something that Owen has in abundance A large hole was cut into the side of the vessel to expose the engine room and from the shore and above the Medway mud a 15m-long 'ski-run' was created that led through the gap in the hull. News spread and an audience of villagers turned up to watch 700kg of diesel engine slide gracefully down the rails and land perfectly on the engine bearers.

Next came the fitting out above deck. The wooden topmast was formed from a single 13m-long tree trunk delivered from the Forest of Dean and hand shaped by Owen. Meanwhile, deck equipment was assembled from a variety of sources, often donated by friends who had hoarded items for years, including over ninety stout rigging blocks. The steering gear was salvaged from a derelict vessel and winches came from other 'graveyard' barges. All items were completely stripped down and rebuilt with new components manufactured as required. Through their contacts in the barge fraternity, a little-used mainsail was acquired from the former barge *Anglia* which, with some other sails, was fully refurbished to form a complete 'suit'. Then came the equally daunting task of fitting out the interior, but Owen and Rita had found some disused piles from a Thames riverside gasworks, Mexican pine over 14in thick, that consumed endless tools as they were sawn and finished, but the resulting interior was pure luxury. Finally with mast, sails and rigging completed and a hefty diesel engine for back up, *Alice* was transformed from ungainly lighter to graceful sailing barge, and made her maiden voyage, no longer pulled ignominiously behind a tug, but proudly under the power of her own sails.

It took Owen and Rita, with invaluable help from some close friends, over 30,000 hours to complete *Alice*, and her traditional looks hide the latest navigational aids that are so essential in the competitive charter business. With light and airy guest cabins, a massive saloon and a 'galley' kitchen that wouldn't be out of place in a top London restaurant, *Alice* is set to attract many new visitors to barge sailing and her majestic silhouette provides a living reminder of the river's working past.

Of course, purists will argue that the shiny new varnished panels and en-suite bathrooms are not in keeping with the image of sailing barges. But that is probably the most significant advantage for *Alice* over many other barges in the market. Clients' nostalgia doesn't extend to cramped berths and oil lamps – even less to a lever and valve operated toilet! *Alice* has been built exactly as her forbears were, the great barge yachts of a century ago that were fitted out in the style and fashion of the time with panelled staterooms, tiled pantry and a lounge often with a fitted piano. No one today complains these were not proper craft and no doubt in the future people will consider *Alice* a fine example of late 1990s design. Owen and Rita have created a unique vessel of which they may be justly proud.

Update

In 2002 Owen and Rita sold *Alice* to a south-coast charter company and the vessel is now based in Chichester Harbour. With a view to their eventual retirement, Owen and Rita then acquired another dumb lighter and, as they did with *Alice*, converted her into a sailing barge that they have named *Whippet*. Slightly smaller than *Alice*, Owen and Rita have created *Whippet* not for chartering, but just to meet their own requirements, which is principally to leisurely sail and enjoy the Medway, the Thames and the east coast. *Whippet* is based at Upnor.

Chapter Three

In Times of Strife

For over 400 years Chatham and Gillingham were garrison towns that accommodated not just the Royal Navy, but the Army Royal Engineers and the Royal Marines. Unsurprisingly, the dockyard was a target during both world wars and there were many incidents on and around the river. In 1914 the Royal Navy battleship *Bulwark*, moored in Kethole Reach, suddenly and mysteriously exploded with heavy loss of life, and just six months later the former passenger liner *Princess Irene*, which had been requisitioned as a fast minelayer, exploded without warning in Saltpan Reach. The investigations into the causes of these disasters were inconclusive.

The Royal Marines left Medway in the 1950s and the dockyard closed in 1984, but the river still provides home to vessels that once were in the midst of conflict. Today most are owned and maintained by individuals who ensure that the boats – and the service they gave – are not forgotten.

A Brave Old Lady

The harbourmaster had never forgotten the scenes he witnessed in 1940 when some of 'little ships' helping to rescue the British forces from the beaches at Dunkirk arrived in Ramsgate. He certainly couldn't forget *Sylvia*, a 45ft motor cruiser that only a few weeks prior to the evacuation had been a luxury vessel. Formerly the pride and joy of Mr Anstey, a respected garage owner in Maidstone, *Sylvia* had been requisitioned by the Royal Navy, much to her owner's annoyance.

Now *Sylvia* presented a sorry sight as she came alongside the quay, lying low in the water, loaded with soldiers packed on deck and below, many of them wounded. Her ensign was in tatters, there were splinters of timber from where she had been machine gunned by German aircraft and her superstructure was blackened from being set on fire. There was a hole just above the waterline which some soldiers had packed with the remains of their uniforms to keep out the water and others had pumped throughout the journey to keep *Sylvia* afloat. With her precious human cargo ashore, the young naval skipper and his crew began makeshift repairs and informed the harbourmaster that they were going back.

'Sea Red with Human Blood'

The harbourmaster begged him not to, but the skipper looked him straight in the eyes and said 'I've seen the sea red with human blood with severed arms and legs floating past – a sight I shall

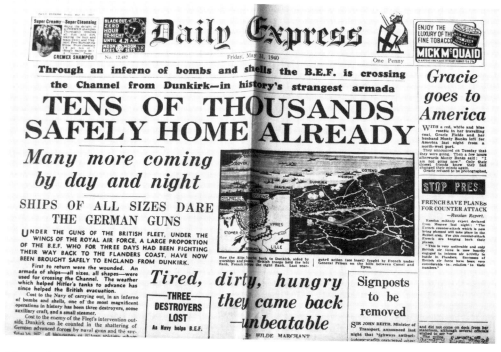

News of the evacuation of Dunkirk, 1940. (Courtesy Association of Dunkirk Little Ships)

never forget. The Lord is with us, the sea is calm and if she goes down, I shall go down with her.' And *Sylvia* departed for Dunkirk.

Late next day, in the turmoil and noise of ships arriving, a ship's siren kept blowing and blowing and there was *Sylvia* lumbering through the harbour entrance, loaded with even more soldiers than before and hooting to attract help. *Sylvia* had suffered more damage and water inside the boat had risen to halfway up the engine. The harbourmaster and his staff ran to help her berth and quickly offloaded the soldiers to stop her sinking. When the last person was safely ashore, the skipper walked out of what remained of the wheelhouse without a word. The harbourmaster never saw him again.

'Five Pence for Services'

Sylvia was patched up and stayed with the Royal Navy, probably as a harbour launch although not a lot is known about her activities until 1945 when she was paid off in London with Mr Anstey receiving 1s (five pence) for her services. The official papers about the transaction have never been released so there is no record of Mr Anstey's response to the deal, but a short while later *Sylvia* was sold. Restored as a private motor cruiser and with her name changed to *Wendy Ken* after the children of one of her post-war owners, she was moored on the River Medway near Maidstone. It was in 1960 during a summer cruise that *Wendy Ken* called at Ramsgate where the old harbourmaster immediately recognised her and rushed to tell the new owner the story of what had occurred twenty years earlier – which was then proudly entered into the ship's log.

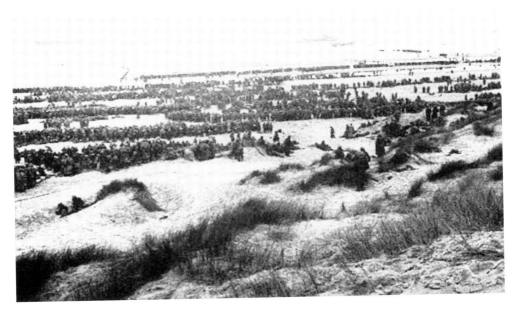

Troops waiting for evacuation from the beaches of Dunkirk in 1940.

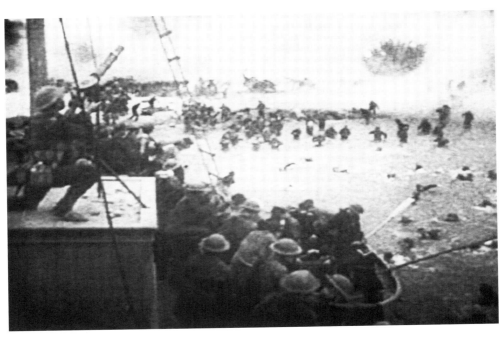

Evacuation of the Dunkirk beaches by the little ships under enemy fire.

New Owners

In 1978 Ian Pearson returned to Britain after many years working in the Middle East and decided to live afloat. Ian, his wife Doreen and their family found they enjoyed the life and looked for a boat with plenty of space. They were delighted to learn that *Wendy Ken*, which they had long admired, was about to be offered for sale. In 1984 they became the proud owners of the Dunkirk little ship *Wendy Ken*, formerly *Sylvia*, and moored her at Cuxton near Rochester where they and the vessel remain to this day.

Wendy Ken/Sylvia had been solidly built in the 1930s by the Southampton Launch & Boat Company. Mr Anstey and successive owners had looked after her well, but even ignoring the rigours of 1940 she was now over fifty years old and needed tender care and consideration, which Ian and Doreen were only too keen to provide. Ian is exceptionally able to maintain the vessel which 'as with all wooden boats is ongoing, but treated methodically is not a chore', he says, adding 'with a boat that was so well built originally, it's pleasure to work on her'. However, Ian does concede that Doreen is a dab hand with the varnish brush!

Happy 'Live-aboard' Life

Ian and Doreen really enjoy their 'live-aboard' life and, unlike owners of static houseboats, can take a holiday without having to pack nor do they have to suffer traffic jams. For example, in 1999 they decided to see in the new millennium on the Thames at Tower Bridge. They had a leisurely river cruise each way in company with some like-minded boat owners, and berthed at St Katherine's Dock in the heart of London – with a grandstand view of the celebrations. Back on the Medway, their permanent mooring at Cuxton provides attractive views across country-side outside of the Medway towns, and as Doreen remarked, 'if you don't like a view, we can always turn the boat around to look the other way!'

Sixtieth Anniversary Return to Dunkirk

The Dunkirk connection is important to Ian and Doreen and, like many owners of those ships that made the perilous trip in 1940, they are eager to ensure that the achievements of the vessels and their heroic crews are not forgotten. As one would expect, the Medway became home to many vessels after Dunkirk (and to some that were simply left to rot) and today there are twelve Dunkirk little ships on the Medway – including the largest and probably most famous of the little ships, the *Medway Queen*. Ian is the Medway representative for the association and ensures that whenever practicable a Dunkirk little ship represents the association at relevant formal events.

Following a frantic initial year getting *Wendy Ken* into tip-top condition and to celebrate her refurbishment, Ian and Doreen sailed her to Dunkirk in 1985 in company with other surviving little ships for the forty-fifth anniversary of the evacuation. Since then, *Wendy Ken* has joined the commemorative return of little ships across the Channel every five years and in 1995 Ian, as the then commodore of the Association of Dunkirk Little Ships, led some seventy of the proud little ships into Dunkirk. In 2000, the sixtieth anniversary return to Dunkirk, Ian was flag officer during what was a very rough crossing – although it seemed not to worry *Wendy Ken* as she celebrated her seventieth birthday. With her varnished timbers gleaming and brightly-polished brass work, *Wendy Ken* doesn't look her age and Ian and Doreen intend to continue taking the vessel across the Channel every five years to commemorate the bravery of those who made the crossing sixty years ago and saved so many lives.

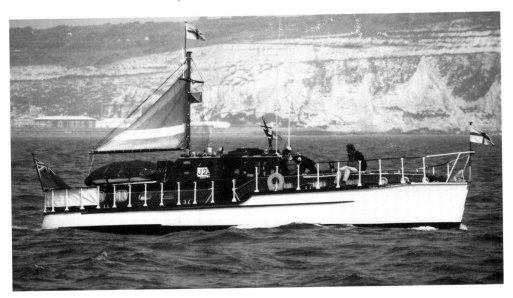

Dunkirk little ship, *Wendy Ken*, formerly *Sylvia*.

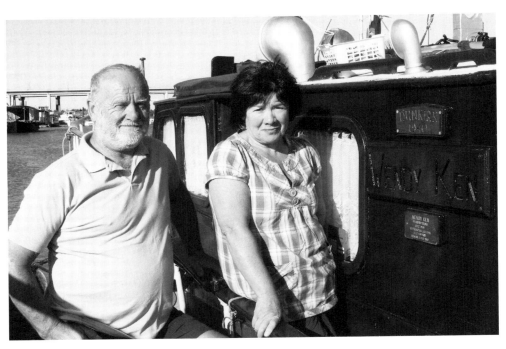

Doreen and Ian Pearson, dedicated to maintaining a ship in memory of her brave crew and those that they rescued years ago.

The Association of Dunkirk Little Ships

A legend was created in the nine days between 26 May and 5 June 1940 when, under constant attack by German dive-bombers, strafed by fighters and torpedoed by E-boats, a bizarre assortment of civilian small boats – pleasure steamers, trip boats, yachts, lifeboats and barges, some without as much as a compass and many that had never been to sea before – were assembled in the Medway Estuary before proceeding to Ramsgate or Dover where they received orders to cross to Dunkirk.

The little ships with their shallow draught were essential to get close to the shore and pluck exhausted soldiers off the beach where they were tending the wounded and vainly trying to shelter from constant air attacks. The little ships made repeated ferry trips to the larger ships moored in deeper water and, where they were not available or had sunk, themselves made the hazardous trip back to England loaded with soldiers.

A hundred of the 700 brave little ships were lost, but over 385,000 servicemen were saved. Today, about 200 little ships survive – some restored and some just decaying in backwaters.

In 1964 Raymond Baxter, the well-known broadcaster and owner of the Dunkirk little ship *L'Orage*, realised that the following year would be the twenty-fifth anniversary of the evacuation. Through a letter published in *The Times*, Raymond found himself in touch with over forty other Dunkirk little ship owners and in 1965, together, they returned to Dunkirk. From that moment the association grew as more little ships were found, many far away in Canada, Turkey and Israel, though the association has 120 members in Europe. The Admiralty has granted them the right, traditionally reserved for Royal Navy Admirals, to fly the cross of St George with the crest of the town of Dunkirk at its centre on the jackstaff (at the bow) of each little ship. This flag also forms the house flag of the association.

Other than the return every five years, many little ships assemble each year for an annual gathering, which usually includes a sail past with a salute as the ships amass. Next day there is a traditional morning service at the quayside following which there is often a low-level fly past salute by the Royal Air Force Battle of Britain Memorial Flight comprising a Lancaster Spitfire and a Hurricane. There is a similar sequence of events at the return to Dunkirk every five years when, additionally, the little ships form a circle into which the aircraft drop a wreath to the memory of the British servicemen who died on the beaches.

Couple's Contribution to Maritime History

People who take up boating usually start with something small and easily handled – maybe a sailing dinghy or one with a little outboard engine. If a little more ambitious, they may opt for a modest motor cruiser, perhaps moored in a quiet backwater. However they choose to get afloat, there is a fair chance they will progress to a larger and more complicated vessel in due course.

Aircraft engineer John Lanahgan and his wife Tracie were no exception to this rule when looking for a comfortable boat – maybe a small canal cruiser that they could use for relaxing at weekends – although they were increasingly becoming enthusiastic about ultimately living afloat on a permanent basis. Like most people thinking of buying a boat, they spent a long time scouring the classified adverts in boating magazines and visiting boatyards each weekend, chatting with boat owners and generally getting to learn the pros and cons of the numerous different types of craft that exist. John and Tracie lived in Slough, so the Thames boatyards from

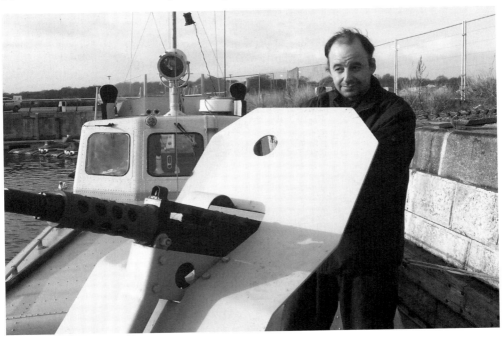

John Lanaghan manning one of the Browning machine guns that provide genuine authenticity to *Velo 2*.

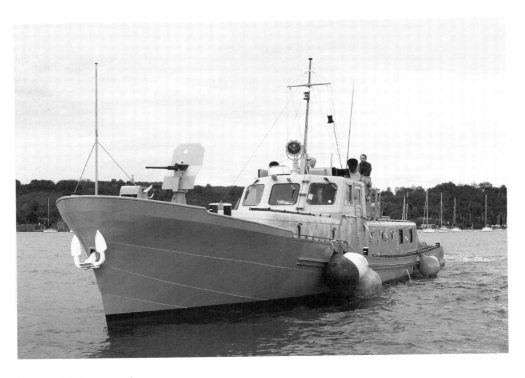

Restored *Velo 2* at anchor.

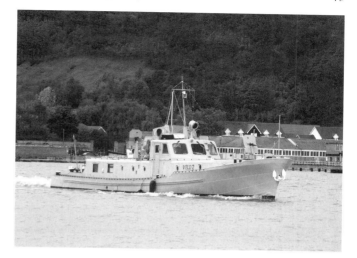

Velo 2 underway again after completion of her restoration, and in her original US Navy livery – but on the Medway instead of the Rhine.

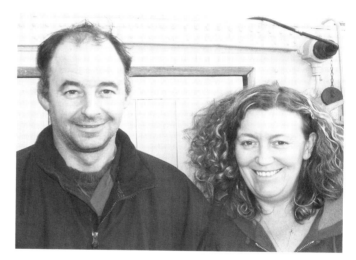

John and Tracie Lanaghan, using high-tech skills, patience and dedication to restore a part of international maritime heritage.

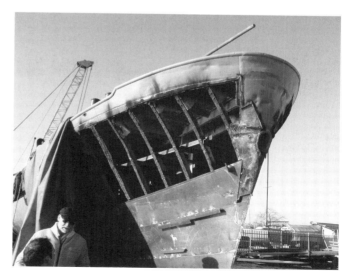

Back to basics: an indication of the deterioration to *Velo 2* that had to be addressed before proper restoration could commence.

Richmond to Oxford were the initial places to search. That is a lot of boatyards and by the time they had finished they had viewed several hundred boats and chatted to dozens of people over numerous cups of tea. Nothing sparked any 'must have' thoughts and so they extended their search to the boatyards and marinas on the Medway. After a few weekends without success they were almost resigned to giving up when, almost by accident, they came across *Velo 2*. Nearly 80ft long and lying almost derelict, they knew immediately it was the boat for them.

Velo 2 was in a very sorry state. The vessel leaked – rain came in from above and the river seeped in from below – and both engines were seized, the superstructure had been vandalised and almost everything of value had been ripped out for scrap. But the vessel's unique shape, with elegant and flowing lines, made her instantly recognisable from many of the war movies that had been made in the 1950s. In addition, there were enormous amounts of interior space that could be converted to provide ample living accommodation.

The ship was a type 21 patrol vessel, built in Germany but designed and used by the US navy to patrol European rivers and coasts during the Cold War. Few survive today and after nearly forty years in service, *Velo 2* had finally been pensioned off in 1989. She languished for months in the yard of a Dutch ship breaker before being sold to a Scottish company for conversion to a diving support vessel. As is often the way with grand ideas, it didn't happen and the ship was moved around the UK by a succession of different owners with aspirations but little practical ability, until she ended up lying forlorn on the mud at Hoo. Despite her condition, which would certainly have warranted the hackneyed advertising statement that she was an 'interesting winter project', John and Tracie recognised the potential and began negotiations for purchase with the yard owner. The ship had accrued substantial debt to the yard but settlement as part of the purchase price confirmed the sale. John and Tracie were the new owners of a piece of recent maritime history!

As an engineer, John realised that the ship's structural integrity had first to be restored, and this meant substantial repair of the hull and superstructure. The vessel was laid up on a slip where John worked through cold winter weekends restoring the hull plates and frames. Once completed, and the vessel again made watertight with doors and hatches refitted to keep out the wind, and in warmer weather, John and Tracie eased their commute from Slough by effectively camping in the forward cabin during their working weekends on the Medway. Meanwhile, John began the repair of two powerful Deutz diesel engines, the generators and all the other mechanical equipment – some of it a far cry from the jet aircraft engines on which he normally worked. As a professional engineer this presented few problems for him and several months later some puffs of smoke followed by deep throaty roars announced that *Velo 2* was back in operation again.

Finally, the interior needed to be rebuilt, a task that meant Tracie could at last start to make a positive contribution. They have taken great pains to ensure that the restoration is, as far as practicable, true to the vessel's original specification. The US navy liked its ships to be comfortable and the upper sections of *Velo 2*'s polished wood cabins were decorated with embossed wallpaper! There was a highly effective central heating system, masses of hot water, showers and the usual facilities, plus a fully fitted galley kitchen that wouldn't be out of place in any modern home. John has expertly restored all the facilities and Tracie has added the final touches to make *Velo 2* into a very comfortable boat. Although designed for an operational crew of five, there are wide luxurious berths for up to eight persons (maybe when in service the crew welcomed overnight guests?) and this means that there is plenty of space on board for John, Tracie and their two young children

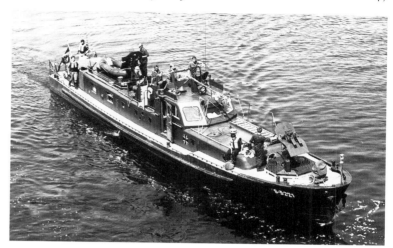

Velo 2 with German Army crew.

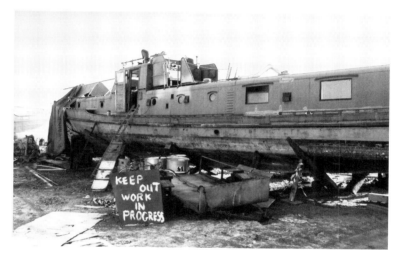

Derelict, unloved and unwanted: *Velo 2* in the 1990s.

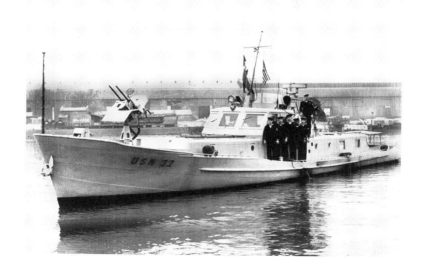

Pride of the US Navy of the Rhine: the newly commissioned *Velo 2* in 1949.

After nearly six years' dedicated work by John and Tracie, the restoration of *Velo 2* is almost complete and they now intend to take the vessel to festivals around the UK and to Europe where there is little doubt that she will attract enormous interest. The ex-patrol vessel has even been equipped with fore and aft mounted Browning 50mm automatic machine guns as were fitted when she was in service – but HM Customs and port authorities can rest assured that these have been de-activated!

The ship is now based at Chatham from where, between visits to festivals, John and Tracie look forward to enjoying some comfortable and well-deserved leisurely cruising. They have spent six years working on *Velo 2* but can be highly satisfied with the result of their efforts. Not only have they created a spacious and comfortable vessel on which they can relax, take extended holidays or, if they wish, even live aboard, but they have also rescued and restored a significant part of recent maritime history.

Fact File – Type 21 Patrol Boat

Between 1949 and 1951 a score of these 77ft-long craft were built at the Hitzler yard in Rettingsburg, Germany. Originally designed and commissioned by the US navy as patrolling gunboats for Europe's rivers, their shallow draught (under 5ft) and excellent handling attracted the interest of the Belgian navy who used them for similar duties in the African Congo. Meanwhile, *Velo 2* was deployed to patrol along the Rhine, but in 1953 she was sent to Holland where her ability to operate in shallow waters made her invaluable in the aftermath of the devastating floods that had left much of the country under water. *Velo 2* and her crew assisted in saving hundreds of lives.

In 1958, and back on the Rhine, the ship changed hands and colour as the US navy handed responsibility for patrols to the German army, and for the next thirty years *Velo 2* and her sister ships were a familiar sight on German waterways. There are two others known to exist today – one maintained ashore by the Belgian navy as a museum exhibit, with another rotting away in a creek somewhere in Europe.

CHAPTER FOUR

CHARACTERS

From medieval times those who worked on and around the river were highly respected, but over the years there was a puzzling change of status. By the seventeenth century they generally had a bad reputation and were associated with smuggling and theft; working on the river had become disreputable.

Working on the river was a world apart and had its own language, a form of back-slang and distinctive names for each of the dozens of trades. Watermen, dredgermen, bargies, lumpers and the toe-rags who worked in the riverside corn mills and wore sacking over their boots. Then there were dockers, stevedores, shouters and the toshers who dredged the river for flotsam (those items floating in the water that can't be attached to any identifiable source) and jetsam (items deliberately thrown or jettisioned into the water to lighten a ship). And many, many more.

With such an eclectic mix it is hardly surprising that colourful characters emerged, and it is not much different on and around the river today, although many of the old trades have disappeared, whilst some have been replaced by new industries. However, most are now highly respectable once again.

A Life on the River

On a bright spring day in 1935 Ben Tandy proudly joined his father 'Buck' Tandy to become one of over a hundred stevedores working on the River Medway. Together they handled millions of tons of cargo each year and were the key to the success of the Pool of Rochester.

Stevedores were the cream of the river, a close-knit community that worked in all weathers, handled all cargoes and were forever competing with deadlines set by ship schedules and the tides. Jobs were handed from father to son through generations, and boys began working unofficially alongside their fathers from a very early age, learning the skills and beat of the river. As they left school, they would be hired on a casual basis until they reached the age of twenty-one when, having demonstrated that they had acquired the skills required, they got their National Stevedores and Dockers Union ticket – the famous 102 – and were eligible to be selected for work with the twelve-strong 'gangs' on the river.

'Young Buck', as Ben was known until his father retired, remained active and sprightly into his nineties and still proudly remembered the day he started work on the river.

Former stevedore Ben Tandy in 2003 looking at the Pool of Rochester, desolate and empty of ships.

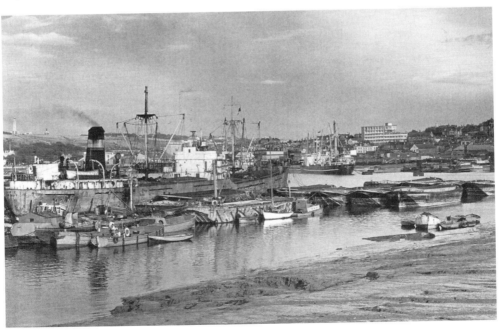

The Pool of Rochester in the 1950s, bustling with activity. Twenty or more cargo ships would be handled every week by dockers at one of a dozen wharves, or by stevedores if anchored in the river. Compare this with the view of the Pool of Rochster today on page 8. (Courtesy Kent Messenger Group)

Ben Tandy in the 1950s with his trademark hat. (Courtesy Mrs Beatrice Tandy)

In those days most people walked to work so from 5 a.m. until 8 a.m. and from about 4.30 p.m. until 6 p.m. Medway's streets were full of people going to and coming home from work. Ben lived with his parents in Chatham at Chalk Pit Hill so it wasn't too great a walk to the 'Stones' where the stevedores waited to be called by the shipping agents. 'Once you were selected it was either straight to work, or wait for a ship expected later with the tide', said Ben, 'if it was a wait then we'd have a "brew" in the nearby café before walking up to Jackson's Fields where you could see the ships coming upriver. Then we'd walk to the nearest pier and go out to the ship as the tugs brought lighters alongside.'

The work was tough and once it commenced there were few breaks. There were no protective or waterproof clothes in those days, no steel-capped boots to protect feet from dropped loads. Stevedores had to provide their own clothing and, of course, the 'hook', a vicious-looking curved steel spike that enabled them to firmly grip a pulp bale or timbers to guide them as they were lifted or dropped by a crane. There was another essential tool: an enamel tea kettle that stevedores always carried. Once on board a ship, one of the gang would sort out a supply of boiling water and, if lucky, some milk, tea or coffee, and arrangements would be agreed with the ship's cook. A quiet spot would be selected for enjoying the breaks in due course and – with these important priorities sorted – work could begin.

And what work it was! Despite all the apocryphal tales, stevedores really earned their pay. This was before the days of containers and travelling hoists; instead there were cranes with slings and nets, a block and tackle, and maybe two to four gangs of stevedores with their hooks. Wood pulp arrived in four-hundredweight (200kg) bales and a good gang would handle up to 400 tonnes a day, with ships turned around in two days. It wasn't just 'lift and drop': the lighters

had to be properly stacked as a badly loaded vessel would not tow correctly and could cause serious delays. The work had to go on, come rain, sun or snow, and could be exhausting; when the day's work was done, the gangs had to get back to shore and then walk a couple of miles or more home.

Safety was another matter. Nobody had lifejackets and if you fell in the river your chances of survival were not good. In winter you could freeze before being rescued and, with the Medway's strong currents, there was always the worry of being forced under a barge, which few people ever survived. Ben saw several drownings during his years on the river and fell in himself a couple of times, but fortunately was quickly dragged out, taken to the nearest pier and left to find his own way home – in soaking wet clothes and boots! The usual treatment after such a wetting was a mustard bath – a tin of mustard powder tossed into a steaming bathtub (often a galvanised tin bath) in front of a blazing kitchen range – and hope you hadn't caught a cold or worse from the river. Then it was back to work.

The community spirit among the stevedores was hardly surprising given the fact that they had almost all grown up together and their families knew each other with uncles, brothers and cousins joining fathers and sons. They were fiercely protective towards each other and everyone had a nickname. Ben remembered all of them: 'Peg Puller', 'Big A', 'Puffed Wheat' and 'Nancy' – an amateur heavyweight boxer who stood over 6ft tall and the complete opposite of what the name implied! Not only did stevedores work together but they also played together, and their football team was famous, or perhaps notorious. They played many teams but the match nobody would miss was the annual 'needle' match against the dockers. Ben described it as the roughest and dirtiest game ever played in Medway, but afterwards bad feelings were immediately forgotten, and what a party that evening!

Ben and his father worked together for some years until 'Buck' retired and then Ben became 'Buck'. But the tricks of the trade were passed on, and Ben remembers one lesson learned when a huge cargo of peanuts destined for the British Oil & Cake Mills in Canal Road at Strood were arriving. 'Get down the hardware store and buy a couple of the largest shovels and buckets you can find', instructed Ben's father. It was only when Ben saw there were 3,500 tonnes of peanuts to be offloaded by hand that he recognised his father's foresight. This wasn't a hook job, it was a bucket and shovel task and men would be kept on it until the ship was empty. The ship had to be offloaded in fourteen days, and that meant extra overtime – called 'rhubarb' – bringing earnings of up to £50 or £60 per man for the fortnight, a fortune in pre-war days.

Ben married his childhood sweetheart Beattie. Their families lived just a few doors apart and they had grown up at school together. Brought up as a regular churchgoer and a Sunday school teacher, Beattie remembers she was fascinated by Ben's mother, the only woman she knew who swore. As a lively teenager, Beattie always wanted to knock off 'that Tandy Boy's' hat – Ben's trademark headgear, but can't remember if she ever succeeded; nonetheless romance blossomed and they married just before Christmas 1938.

In the late 1930s ships arriving at the Pool of Rochester brought terrifying tales of what was happening in Europe. Ben and his mates unloaded paper pulp and timber from Soviet ships under the gaze of 'commissars' – political guardians who watched everything their crews said and did. Few were allowed ashore but this didn't stop them talking to stevedores in a quiet part of the hold, away from prying eyes. However, two incidents made a strong impact on Ben.

During the Spanish Civil War a ship arrived from Bilbao and stevedores were horrified to find they were being watched by soldiers carrying loaded rifles. 'We never knew why', said Ben, 'but we didn't like it a bit and several gangs refused to work the ship. Money was short so

eventually we agreed to work but it was a strange experience – more so because we couldn't believe they thought we were a threat. The ships agents weren't very happy either and told the police or Navy because when the ship sailed, it was boarded and interned at Sheerness.'

Another incident involved a German vessel. 'It was flying the Nazi flag and there were swastikas everywhere', recalls Ben, 'the skipper was a staunch Nazi and to make sure his crew kept in line, there was a handful of fanatical Nazi Youth in uniform, "heil hitlering" everyone and handing out propaganda leaflets. I'd just turned twenty-two and here were spotty-faced fourteen-year olds telling my mates and me that they would rule the world! Our gang boss went to see the captain to complain and got a mouthful for his pains, and as we finished offloading and were leaving, the skipper and his 'youth army' lined the rail and gave the Nazi salute to us. We gave them a very different salute back and shouted "nazi bastards". It was clear they wanted to retaliate, but we were in the dinghies and well away, but we thought they might, like the earlier Spanish, have guns on board.' Ben said that when a few years ago he saw the famous *Dad's Army* episode where a captured U-boat captain asks for names, he felt it was very reminiscent of his own brush with the Nazis, although it wasn't to be his last.

Storm clouds were gathering and by late 1939 few ships from Europe were coming to Rochester. In September there were three ships scheduled to arrive at Rochester but one was sunk in the North Sea, another stopped by a boom at Sheerness and nobody ever knew what happened to the third. The port was closed and all the stevedores went on the dole. They were not in a reserved occupation but were told they would be needed once 'things were sorted'. For over a year they worked only when the occasional cargo ship came into the river, but in 1941 call-up papers arrived and stevedore Ben went off to be a soldier.

Most stevedores liked an occasional flutter on the horses, so Ben was pleasantly surprised to find himself posted to Haydock Park, but there were no horses to be seen, only army recruits undergoing basic training. With the army's reputation for putting square pegs into round holes, Ben expected to be made a postman or cook, but there was need for stevedores and he found himself on the Clyde as an army stevedore. For nearly three years Ben only got away from Scotland when he had leave, and that had to be for at least a week because in wartime Britain it could take days to get from Scotland to Kent by train. Ben worked at most Scottish ports and even out at Orkney, increasingly on the American liberty ships bringing equipment and supplies to keep Britain going, but in 1944 he was drafted south to prepare for the Normandy invasion. The stevedores were told they would cross with the first wave to ensure supplies were offloaded quickly, but in the event they did not embark until late on D-Day itself and it was three days before they actually landed in France.

'We weren't prepared for what we saw', recalls Ben, 'from a mile out the sea seemed to be full of bodies and it was the same on the beaches. On the way in, one of the ships carrying other stevedores hit a mine and disappeared – I lost ten friends. But we didn't have time to think about it as within minutes of landing we were offloading supplies.' In between working, the army stevedores had to look after themselves and they soon found themselves a beached boat in a quiet area, and a brew was soon boiling. But before they could pour the tea, Ben and his mates were under attack from a dozen German soldiers.

'They were mad', said Ben, 'the beach was swarming with allied troops who soon sorted them out. Us stevedores grabbed our rifles – it was lucky we didn't hit each other as about the only thing we could do safely with a rifle was carry it!'

It took a month after the D-Day landings to secure Caen, which was when the army dock teams really came into their own. Getting ports into operation was a prime objective and the

local dock workers remaining were recruited to take over from the army teams who quickly followed the advancing forces eastwards, getting port after port back into service.

After Caen came Dieppe, then Boulogne, to Belgium, Blankenberge and Antwerp and Rotterdam and Breda in Holland. By then the fighting front was in Germany so life was relaxed. 'We didn't get Vera Lynn', said Ben, 'but we did get the footballers of the day – Matthews, Lawton and Swift, who came to Bruges for a match against a former Belgian national team, who won 10-nil!'

Finally, the army dock teams reached Germany and Hamburg where the stevedores unloaded thousands of huts for a population that were homeless from the bombing that had destroyed their city. 'Women and children were starving', remembers Ben, 'and all we could offer was "burgoo" porridge which they gave to the children. There were lots of German soldiers who'd probably lost their units – they were a sorry lot, picking the pig-swill for food. At least they weren't shooting at us like some fanatics called "werewolves" – although we had a different name for them when they started sniping as we offloaded ships.'

In 1946 Ben was demobbed and he immediately returned to work on the Medway, but by the 1950s the writing was on the wall and the port was dying. Stevedoring finally ended in the early 1970s and Ben received £1,800 – not a large sum even in those days. It was a sad time and Ben remembers many still turning up each morning at the Stones before wandering down to look at the river, with perhaps a 'cuppa' at Andy's Snacks and chatting to old mates. Ben was not one to sit around and mope and British Rail wanted station staff at Chatham, so, back in uniform again, armed with a whistle instead of a rifle, Ben became a railwayman.

He hated it, and most days after work Ben strolled down to the river, now almost empty of ships. In 1973 Ben was offered a job in Chatham Dockyard carrying out 'general duties', which meant everything and anything, and he jumped at the opportunity to work alongside, if not on, the river, and there he stayed until retirement in 1979.

Ben and Beattie retired to a neat bungalow tucked away in a quiet close in Rochester, and at the age of ninety-two, amazingly fit – and still wearing his 'trademark' hat – Ben made a nostalgic, if somewhat depressing, trip to Ship Pier. Ben could not conceal the sadness as he looked at a river where only a few years past, even on the calmest day, the waters were never still. Ships, tugs and barges came and went twenty-four hours a day and there was a vast supporting infrastructure that employed hundreds of people. The river was the key to the Medway towns' prosperity, with a commercial trade that kept twenty-four wharves busy, whilst Ben and his fellow stevedores handled the cargoes from ships moored in the river. Now on a calm day the river is still, its mirrored surface reflecting the derelict wharves, a shadow of what was once the flourishing port of Rochester, and Ben Tandy's life.

Sprightly and active to the end, Ben died in 2007 after a short illness. He was ninety-four and, sadly, just a few months from celebrating with Beattie their platinum (seventieth) wedding anniversary.

Ben was the last of the Medway's stevedores. Regarded by some as arrogant and argumentative, they were an amazingly tough and hardworking band of people who made a significant contribution to the prosperity of the Medway towns. We are unlikely to see the likes of such a colourful group of people again.

The Stones

The Stones were known to everyone who worked on the river, although to everyone else they were simply the paving slabs of Furrells Road in Rochester, close to Rochester Station. The

road is still there, the Stones long ago replaced by concrete and tarmac, and today it ends at the arch under the railway line. Originally it led to Blue Boar Pier, similar to Ship Pier (that still exists downstream), the main pier used by stevedores.

For generations, stevedores gathered on the Stones each morning to be called for work. Ben was lucky when he started: the National Dock Labour Board had finally agreed an employment scheme with the unions, and although stevedores and dockers were still hired on a casual basis according to work available, selection was on a strict rota. Before then, men might stand on the Stones for days without being called, simply because they had upset somebody or their 'face didn't fit'. Under the new scheme men still had to report with no guarantee of work, but knew they would be called in turn on a fair basis when ships arrived.

The Pool of Rochester

Between Chatham's Sun Pier and Strood Pier was, and still remains, the Pool of Rochester – the heart of Medway's prosperity – which once hosted scores of cargo ships from many nations. Riverside pubs were alive with the chatter of foreign tongues, and in the surrounding streets were the offices of shipping agents, brokers, tug owners and the many companies who collectively made the Medway the busiest commercial river in the south after the Thames.

In pre-war years over 30 million tons of cargo was handled through the pool each year, but by the 1960s this had dwindled to 12 million tons. Now it is just over 1 million tons a year – mostly through Chatham Docks and Scotline's terminal at Strood.

At its peak, twenty-four wharves lined the watersides where dockers unloaded ships, but most cargo rarely touched the shore. The largest ships of the day anchored in the river, where their bulk cargoes, which were mainly paper pulp from Scandinavia, were transferred by stevedores to lighters ('dumb barges' without engines) that were then lashed together, six or more at a time, and towed upriver to the paper mills at Aylesford.

After the war, the Pool of Rochester was as busy as ever and everyone thought business was back to usual. The regular wood-pulp ships from Scandinavia had resumed, the oil and cake mills were in full production and a good day's work meant £3 18s for a stevedore. But the traditional ways of moving and handling cargoes were disappearing.

In the 1950s came the 'lash' barges – huge dumb lighters floated in and out of transporter ships. Then came the containers, with special cranes at coastal ports to handle 40-tonne units as if they were matchboxes. It was the beginning of the end for the Pool of Rochester and by the 1970s there was hardly a ship for stevedores to offload and the redundancies came quickly. Each man received £100 for every year of service, the dole queues lengthened and the face of the river changed forever.

Today there are only two wharves operating in the Medway towns. Scotline is the biggest operator, with ships bringing in over half a million tonnes of timber a year, whilst Chatham Docks add another a million tonnes of products. It is long way from the 30 million tonnes a year that was handled through the Pool of Rochester at its peak.

A Man of the Sea

The sea and ships always produce 'characters'; some may be a bit eccentric but it is obvious that almost all have a unique personality. Few more so than Ken Stocks, manager of Turks yard in the massive Covered Slip No.7 at Chatham's Historic Dockyard.

Born in Sheffield – 'that great seaport', as he describes it – Ken didn't see the hot and dusty steel mills or the local coal mines as his future, so at the age of fifteen he joined the Royal Navy. Sent to the training establishment HMS *Ganges* in Ipswich, with its famous tall mast that the cadets man for ceremonial events, Ken soon proved himself a natural sailor, showing exceptional prowess handling the *Ganges'* whalers and cutters. This led to him being selected to join HRH Prince Phillip and the crew of *Bloodhound*, the magnificent sailing ketch bought in 1962 by HM The Queen as a present for her husband. Ken sailed many times on *Bloodhound*, whose crew invariably included Uffa Fox, then Britain's best-known yachtsmen and yacht designer. Ken recalls 'Prince Phillip was very competitive, and liked to sail "at the limit" even when the boat wasn't actually racing. There were many "colourful" exchanges between the Duke, Uffa and the crew. But he was a great skipper and I learned an enormous amount from those days that's since proved to be invaluable.'

Prince Charles was taught to sail on *Bloodhound* and a few years ago, as first mate on the sailing ship *Grand Turk*, Ken met the prince and mentioned that he had also learned 'a bit about sailing from the old man'. Ken refuses to reveal the prince's response but it seems there was mutual appreciation of the Duke of Edinburgh's sailing abilities.

Artificer Apprentice Stocks duly qualified as a shipwright and spent the next eleven years with the Royal Navy, seeing service in the Far East, Australia and the Mediterranean, plus the less exotic Plymouth and Devonport. Ken's enthusiasm for sailing grew and on leaving the navy he was quickly recruited by the notorious Australian (but British-born) billionaire Alan Bond to sail the famous (and enormous) schooner *Jessica*, which led to Ken gaining his master's ticket.

The yacht *Bloodhound*, a present from HM The Queen to the Duke of Edinburgh. He wasted no opportunity to race her, crewed by star cadets from the HMS *Ganges* naval training establishment at Ipswich, one of whom was Ken Stocks.

Julia, the topsail schooner skippered by Ken Stocks that starred in many film and television productions. The design of these tough little cargo ships hardly changed over three centuries.

Ken Stocks, bluff and blunt, but with a unique affinity for the sea and sail.

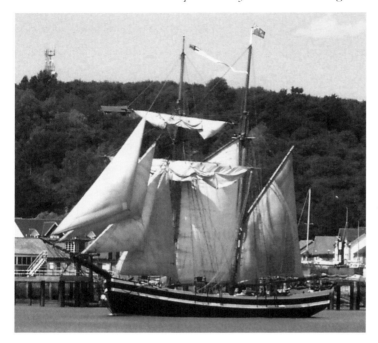

Julia arriving back on the Medway after another filming role. The ship was much used for both period drama and maritime documentaries until live action was replaced with computer-generated images.

Much in demand, Ken subsequently skippered a variety of sailing vessels in the Caribbean, the Balearics, Europe and the UK – where he sailed what he recalls as one of his favourite vessels, the remarkable old herring drifter *Reaper*. As relaxation between trips, Ken widened his experience even further by sailing as crew on the famous Norwegian tall ship *Christian Radich*.

In the early 1990s, and by now one of the best-known 'sail men' in the business, Ken joined Turks Film Services who provide ships, boats and maritime expertise to the film and television industries. Ken has since worked on many blockbuster films including *Troy*, *Golden Age* and the *Harry Potter* films, whilst spending several seasons as first mate and sailing master on *Grand Turk*. Ken took the helm again as skipper of topsail schooner *Julia* – another vessel owned and operated by Turks, which has also featured in many films. *Julia* became Ken's favourite ship and they developed an uncanny affinity for each other. With Ken at the wheel, the ship appeared to handle like a dinghy but with the grace and elegance appropriate for a ninety-year-old 'grand old lady'. Sadly, with film-making technologies changing, the demand for ships like *Julia* has fallen and in 2007 she was sold to a French buyer. Ken delivered her to La Rochelle where, after a full refit, she has found a new career as a charter ship.

Ken's expertise has not been limited to sailing – he is equally adept at handling ships with engines. In 1990 he purchased the Dunkirk little ship *Gay Venture* and set about restoring the 1940 evacuation veteran to her original condition. Built for racing driver Douglas Briault – 'the 'pre-war Lewis Hamilton' – the boat suffered serious fire damage whilst returning with soldiers from the Dunkirk beaches, but her tough construction ensured survival and she served the rest of the war as a naval patrol boat on the Thames and Medway. This historic motor-sailor is now kept on the Thames where Ken's daughter lives on board and lovingly maintains the heroic vessel.

Ken is not just an old salt – even though he actually looks as everyone expects an old sea-dog – but the flowing hair and beard hide a warm and caring personality devoted to the sea, ships and everything maritime. This even extends to sea shanties and Ken can be found at many

of the major shanty festivals joining in with some of Europe's top groups – Johnny Collins, Jim McGill and the ubiquitous shanty group Capstan Full Strength. Although he claims not to have a singing voice – 'I can make "One Fine Day" sound like a dirty weekend' – his rasping tones seem ideal to reflect the feel of shanties which were, after all, simply work songs.

As a no-nonsense Yorkshireman – and they don't come much blunter – Ken probably would not like to be compared with someone from the other side of the Pennines, but in many ways Ken's love for the sea and traditional sailing ships is similar to the late Fred Dibnah's devotion to steam. Ken cares fervently about maritime heritage. In 2007 he and his partner Marie bought the 110-year-old gaff sailing cutter *Romilda*. Built in Guernsey as a carrier for monumental stone, the boat was commandeered during the First World War for carrying munitions to the battlefields of the Somme. Converted to a gentleman's yacht in 1928, *Romilda* is no stranger to the Medway, having been acquired and repaired many years ago by Upnor barge builder Owen Emerson as an insurance write-off following a fire. Sold to a south coast owner, the vessel eventually became derelict and was discovered by Ken and Marie 'under piles of hay and shite' in a Sussex farmyard. Turks have provided space in a corner of their yard, 'for which we'll be forever grateful', and Ken and Marie are busily restoring this historic vessel to her former glory.

It is hoped that *Romilda* will be ready to re-launch in 2010 and there is sure to be enormous interest from everyone involved with Britain's maritime heritage. There is no doubt Ken will have her under sail at every opportunity, and the river will gain another much-needed feature – from the determination of someone who respects and maintains the skills of craftsmen from years past.

Fact File – *Julia*

Julia is a square-rigged topsail schooner, 125ft long, built in 1938, and one of the last surviving genuine Baltic traders. These tough vessels, built of pine on oak, were designed to operate in the unforgiving waters of the Baltic and the north Atlantic. For many years *Julia* worked all year carrying salt to Scandinavian fishing fleets operating around Iceland. In 1997 she was purchased by the Turk Group and after substantial restoration was used in the *Hornblower* television series, filming in the Black Sea off the Crimea and later in the Gulf of Sassimbra near Lisbon. Charitable work for the World Wildlife Fund followed as a platform for whale watching, before the ship arrived in England in 1999 when it was re-rigged by the Tomi Nielsen Yard in Gloucester – who also restored the former HMS *Gannet* at Chatham Historic Dockyard.

Julia continued to be used for various film or television productions, and also became a firm favourite at many major maritime festivals including Brest, Ostend, Liverpool and Douarnenez. The rise of computer-generated images in the film and television industry has led to less demand for real ships, and *Julia* was sold to a French corporate event company. Refitted and renamed, the ship now operates as a charter vessel out of St Malo.

Still Keeping his Head Below the Water

To many people, a diver means somebody in a rubber suit and flippers who silently appears from the water to place a box of (probably soggy) chocolates in a lady's boudoir before disappearing back into the water. Others, perhaps a little older, with memories of films from the 1940s and 1950s will recall lead boots, a brass helmet and a couple of men turning the handles of a pump delivering air to the diver below.

Jim Hutchison lives in Gillingham and knows all about heavy boots and air pumps. A founder member of the Historical Diving Society, he is one of a small group dedicated to preserving the history of traditional diving over two centuries in the most interesting way – by practical demonstrations. At marine and other waterside events up and down the country each year members of the society can be found demonstrating how the cumbersome suits were put on, how the pumps worked and how the divers descended and worked underwater. The demonstrations attract enormous crowds who seem mesmerised as they watch the bubbles rising from below until the diver surfaces again. And more often than not the diver would have been Jim completing yet another dive to add to the thousands he has made before. What few people know is that Jim is in his eighties and has been actively diving for over sixty years!

Born in Bedford – a long way from the sea – Jim was fifteen when, in 1937, he joined the navy. By 1942 he had already been around the world when he found himself on HMS *Resolution* in the Mediterranean, deployed to sink part of the French fleet that had been commandeered by the Nazis. Understandably, the French ships that were being targeted took a dim view of the action and one of them fired a torpedo that put a hole in HMS *Resolution*. Fortunately it wasn't too serious, but young Jim Hutchinson seemed to be the only person available to go underwater and take a look. Jim recalls it as an exhilarating experience, decided that life underwater was for him and that was the start of his long diving career.

Returning to Chatham a few months later, Jim secured a place on a naval diving course that was being held in the dockyard and for the first time experienced the delights of diving in the muddy waters of the River Medway. Jim qualified with flying colours and the final tests were held at Gillingham Pier – where the mud was probably thicker than anywhere else on the river – but it would be a few years before Jim would again be under Medway waters. During the rest of his naval service, Jim dived in many faraway places across the world, including Korea, and was decorated for recovering the bodies of two airmen from a crashed Royal Air Force airplane in Singapore. The aircraft had come down in a swamp and two crewmen had escaped from the wreckage before it sank, but the pilot and navigator had not been so fortunate. The Royal Navy was asked to assist and Jim volunteered to go down in the treacherous black waters of the swamp. Jim admits it was probably one of the worst experiences he ever had during his career as a diver. Visibility was almost nil and the plane just a mass of tangled metal that constantly threatened his air supply, but after many hours and several long dives the task was successfully completed.

In 1953 Jim returned to Chatham with HMS *Belfast* and left the navy to become a freelance diver, working mostly in the dockyard and the River Medway. He subsequently set up the Medway Diving Company that has been called to dive in the Mediterranean, Norway, Ireland and virtually everywhere around the British coast. The company now employs a score of divers, using modern, lightweight, self-contained equipment, and carries out a variety of tasks locally from fouled propellers and surveying underwater structures (such as the supports of bridges) to recovering sunken boats and lost property. Further afield, the company regularly cleans the water intakes of nuclear power stations and recently had to recover a car that had been driven off a quayside into very deep water by someone who had suffered a heart attack. In the past, Jim was frequently called upon to recover bodies but he says that thankfully police divers now usually carry out these fairly gruesome tasks.

Jim's son became a diver and so it became a family business, although in the early 1990s Jim retired to spend more time working with the Historical Diving Association, and ensuring it remained active, particularly in the Medway towns for a very special reason. It was a Colonel Charles Pasley of the Royal Engineers based at Brompton, close to Chatham Dockyard, who,

Leading Seaman Jim Hutchinson in 1943, 'somewhere in the Far East'. As a naval diver, Jim went under the waves of all the world's oceans, not to mention hundreds of rivers and inland waters. (Courtesy Jim Hutchinson)

Jim Hutchinson in his eighties, still demonstrating diving techniques. (Courtesy Jim Hutchinson)

Jim Hutchinson 'suiting up' for another demonstration dive. The canvas suit and brass helmet were devised in the 1830s and remained standard diving equipment for well over a hundred years.

Jim Hutchinson. Diving for over seventy years, especially proud of his work whilst serving in the Royal Navy during the Second World War.

in the 1830s, developed the canvas suit and familiar helmet that became standard diving gear for generations. These suits were first tested in the River Medway, the same muddy waters where over a hundred years later Jim qualified as a diver, by Colonel Pasley's sapper divers working on the wreck of the *Royal George*.

Jim's appearance belies his age. Until 2007 he dived regularly with the association but then, at the age of eighty-five, he finally decided to hang up his helmet and, after a career spanning sixty-five years, finally retired from active diving. Jim's final dive was at the London Aquarium where, in the massive Atlantic tank, he yet again demonstrated the surprising range of tasks that divers in the old cumbersome canvas suits, brass helmets and lead boots, could undertake. Jim fondly recalls chatting to the audience after the dive, and particularly the comments of a young child who thought the divers were robots – doubtless influenced by today's science fiction stories! But Jim certainly isn't a robot, nor has he donned carpet slippers or joined the local pensioners club. With his wide knowledge of many waters, or, to be more accurate, what is underneath, Jim is frequently called upon to advise other divers with regard to working under the waves or the likely location of items lost overboard from craft large and small. And all because a French ship fired a torpedo at a British ship in 1942.

Diving the Old-Fashioned Way

The equipment that Jim learned to dive with, and which he and the Historic Diving Society demonstrate, is known as the 'closed diving suit'.

Colonel Charles Pasley of the Royal Engineers was a veteran of the famous battles of Corunna and Copenhagen, and an innovative engineer who had invented a form of modern cement and a standardisation system for coins, weights and measures. More significantly, in the 1830s he devised the early diving suit, although his designs were improved by Charles Deane of Whitstable who worked with the London-based company Siebe Gorman to produce the first suits on a commercial basis. Apart from slight changes in the type of fittings, the design of the diving suit changed very little during the next 120 years, when the first self-contained diving equipment began to appear.

The suits were made of rubber-backed canvas that was both waterproof and airtight. The helmet, made of brass with a glass window, was fastened with bolts to a thick rubber collar on the suit. To maintain balance and counteract the lifting effect of an air-filled suit, the divers often wore weights around their waist and boot-shaped lead weights strapped to their feet, hence the divers' movements were slow. Divers were normally lowered to the sea or river bed by means of a platform and a safety line was also attached to him so that he could be hauled up in an emergency. This line was often used for communication, the diver or person on the surface tugging the line a number of times for pre-arranged signals.

It is probably the pump that most people identify with 'old-fashioned' diving. This was a rotary air pump that pushed air down to the diver via a hose connected to the helmet. The pump usually had two or three cylinders and was traditionally operated by two people who turned a flywheel to operate a crankshaft, which in turn moved the pump's pistons and pushed air through a valve and into the hose. It was a very simple arrangement but worked well, and the equipment lasted for years, hence the fact that the polished brass and varnished wooden casings of pumps built over a hundred years ago remain to this day and are used by the Historic Divers for their demonstrations.

Everything changed for the diving world when 'scuba' (self-contained-underwater-breathing-equipment) appeared in the 1940s, giving divers the freedom to move underwater without

being hindered by heavy suits, helmets or hoses. Totally enclosed diving suits are still used today for specialised work, but they are very high-tech, with a self-contained breathing system, electronic communications and even built-in tools.

It is a far cry from the many adventure films of the 1930s which many people of a certain age will remember. The hero would invariably at some time in the story don a diving suit and helmet in order to recover some underwater treasure. Then the villains would arrive whilst he was below and take away the pump operator! Fortunately, real life wasn't quite like that, but images of the people slowly turning the pump handles remain, partly explaining people's interest in watching demonstrations of the old-fashioned way of diving.

The Historic Diving Society was founded in 1990 by a number of divers, many ex-servicemen, who recognised the need to preserve the diving heritage. It has grown into an international organisation with members across the world and associated societies in over twenty countries. In addition to maintaining the equipment and techniques of 150 years of diving, the society provides numerous diving demonstrations and displays for the public each year.

Happiness is a Good Felucca

John Button runs a large and successful food- and drink-vending organisation that operates over a wide area of south-east England. It is a busy and sometimes frenetic life, but at weekends John can relax, happy and contented, sailing quietly down the River Medway. However, John's boat is guaranteed to prompt anyone coming out of a riverside pub to think they have had one too many, or been transported to the Middle East, because John will be on his felucca. With a massive lanteen sail suspended from the single mast, the felucca looks like an Arabian *dhow*, but it is understandable that many people don't know what to make of it. After all, as John says, it's probably the only felucca this side of Cairo!

So why a Felucca?
With his friend Eddy Polhill and their respective families, John had holidayed in Egypt many times, exploring the creeks and by-waters along the River Nile on a range of modern passenger and tourist boats. However, it was the small open feluccas, which seemed to glide along silently in the gentle, warm, murmuring breeze that appealed to John – so much so that he took every opportunity to talk to local boatmen, which in turn led to his hiring a felucca at Luxor. John was hooked, and from then on he hired a felucca whenever he could. With its low profile and broad beam, the relatively heavy craft is far removed from any high performance offshore yacht, but it is probably one of the easiest boats in the world to sail, and for John it was the ideal way to relax from the pressures of business. Both John and Eddy were busy people and it was a long way to Egypt for a weekend sail, so they decided to have a felucca built for the Medway. That way, they reasoned, it would provide an opportunity for them to take a sail whenever they could snatch a few hours away from work, even if the sun doesn't shine on the Medway as much as it does on the Nile!

The first problem was getting some plans for a felucca because the 2,000-year-old designs have been passed down from father to son for generations, and rarely has anyone put anything on paper. But John and Eddy were nothing if not determined. They cultivated friendship with an Egyptian boat builder until finally obtaining some sketches 'on the back of some grubby and dog-eared postcards'. It was, says John, an unusual alternative to the popular concept of 'grubby

John Button and Eddy Polhill entertaining visitors on board the only felucca this side of Cairo during a festival on the Medway in the 1990s.

The felucca, built on the Medway to an original Egyptian design, is authentic in every respect, though, being suited to the River Nile, it does not always take kindly to the Medway's sometimes choppy waters!

Feluccas on their placid home waters of the River Nile, Egypt.

postcards' obtained from an Egyptian trader. Armed with the postcards, plus numerous photographs and measurements taken from a variety of feluccas on the River Nile, John returned to the UK and soon construction of the boat was underway at John's premises – then on the Medway City Estate in Rochester. It was launched in 1995.

With a very shallow draught and a huge sail, feluccas always give an impression of being slow, but in fact they are actually quite fast considering their ample beam and weight. In this respect, they are very similar to the wherries, those workhorses which, for hundreds of years, carried cargoes around the Norfolk Broads and other British waterways. Both types of craft carry a huge single sail to harness the lightest winds, and with no heavy seas to tackle the vessels can be wide and low, maximising cargo capacity. As John discovered, whilst many feluccas around the Egyptian tourist 'hotspots' were used to provide trips for visitors, the majority of vessels on the Nile and its tributaries are still used primarily to shift cargoes. The Egyptian potatoes you buy in your local supermarket probably started their long journey to you in a felucca!

Of course, the Medway is not the Nile and it can get a bit windy, so John's felucca has a smaller sail in order to cope more readily with the local conditions, but apart from the addition of a small engine for when the wind doesn't blow, the 30ft steel craft is totally authentic, even to the Egyptian Ankh (key of life cross), which is claimed to protect sailors, emblazoned across the sail.

John and Eddy use the boat simply for relaxation and on sunny weekends they can often be seen quietly sailing on the Medway, accompanied by family and friends. And just for amusement, you can often find them donning in Arab-style robes (complete with a 'Tommy Cooper fez') with a genuine 'hubble-bubble' pipe on a large table in the middle of the boat.

One can only imagine the shock for anyone on a boat arriving in the river – they must ask themselves if they took a wrong turn at Dover!

The Traditional Felucca

A felucca is a sailing boat used in the protected waters of the Middle East and eastern Mediterranean, particularly along the Nile in Egypt. Traditionally built of wood, although steel is a preferred alternative these days, the rig consists of one (and sometimes two) lateen sails. Like the curraghs of Ireland, the wherries in Britain and oriental sampans, they are designed with a huge, easily handled sail, a wide beam and a very shallow draught to carry the maximum load on sheltered waters. Immigrants from the Mediterranean who settled on America's west coast brought the design with them. They were called 'silenas' and by the late nineteenth century provided the principal means of transferring cargo between sea-going ships and the inland places that were accessible by water.

The traditional felucca design has evolved to provide a craft capable of carrying between ten and fifteen passengers or cargo with two or three crew. Despite the commercial advantages of motor ships and ferries, feluccas are still in active use as a means of transport on the Nile, particularly around Aswan and Luxor where passenger versions are highly popular with tourists. For those with a few days to spare, and the desire to sample traditional life on board a felucca, it is possible to take a three- or four-day trip.

It is certainly original. To maintain cultural traditions, passengers are required to remove their shoes and wash their feet in a bucket of water each time they board. The winds and the captain decide the route and timetable whilst passengers are encouraged to pass the time, as do the crew, by watching the world go by, reading or playing cards, although hardened travellers don't recommend joining the crew with the latter, particularly if a small wager is suggested! Sleeping in the open boat under the stars may sound romantic but there are no toilet facilities on board so it is a case of keeping one's legs crossed (or using the communal bucket) when underway or using the public conveniences that are closest to the felucca's overnight mooring.

CHAPTER FIVE

A WORKING RIVER

Sheltered by the North Downs, the river has since Roman times – and probably earlier – provided a safe anchorage for vessels. Evidence shows that the Saxons, the Vikings and the Normans were frequent visitors with their ships to what became the Pool of Rochester. A thriving trading port resulted and, with establishment of the Royal Dockyard at Chatham by Henry VIII, the future of the river seemed to be assured.

By the nineteenth century overseas trade was principally with the Baltic and Scandinavia, although trade with other parts of the UK also flourished: the export of locally produced Fuller's Earth, cement and bricks, with inward cargoes of coal and paper pulp. All this activity generated an infrastructure that included wharves, barges, lighters and tugs and, at the same time, there was still an active fishing industry.

But by the 1950s it was fast disappearing and, a decade later, totally gone. The new larger cargo ships demanded faster mechanised handling for containers at berths that did not entail an hour or more travelling upriver, hence trade switched to modern coastal facilities. Some commercial shipping remains, along with a small number of fishing boats and several vessels that provided support and service when the river was bustling with activity.

Britain's Largest Cargo Fleet

Here is a question for trivia buffs: at the dawn of the new millennium, where was the largest fleet of British-registered cargo vessels based?

Surprisingly, it was on the banks of the River Medway at Hoo. Located at the quaintly named Buttercrock Creek, the Lapthorn Group operated no less than twenty-four cargo ships, although they could never all berth at Hoo at the same time and some of them were just too big to get there anyway.

Tony Lapthorn trained in the 1930s as a naval architect and worked at Southampton for the famous shipbuilders Thorneycroft, but following the early death of his father in 1941 decided to join the Royal Air Force. Against all the military tradition of putting people into the wrong slot, Tony was allocated to the marine section. It is perhaps odd to learn that the Royal Air Force was involved with boats, as most people would consider aircraft to be more appropriate. But the glued timber and ply construction techniques used for early aircraft were borrowed from the boat industry, and there were seaplanes, meaning that boats were needed to carry

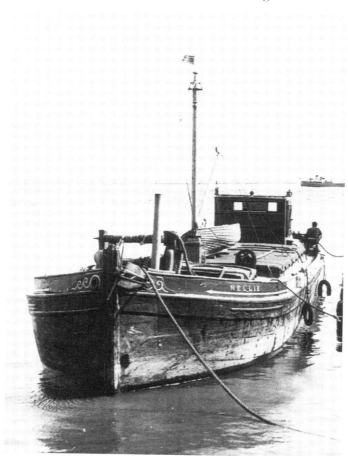

Left: Nellie, an old sailing barge bought for £150 and converted to motor, founding the creation of a major UK shipping fleet.

Below: Hoo Fort, one of the generation of Lapthorn ships that incorporated the word Hoo into their name.

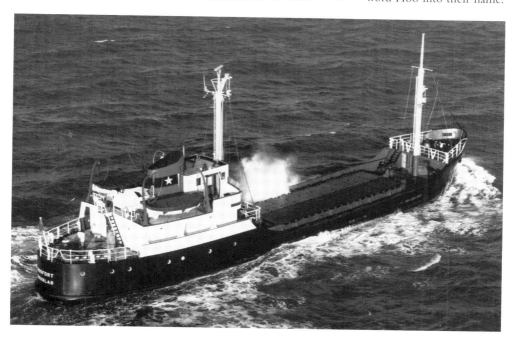

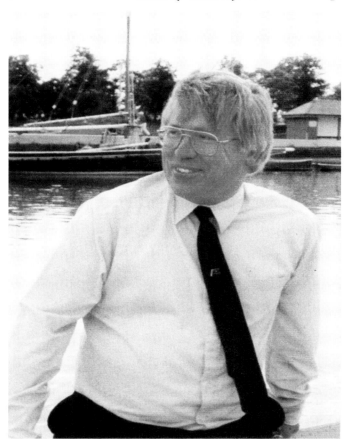

Left: David Lapthorn, from a childhood on the water to running the largest British-registered cargo fleet.

Below: Hoo Dolphin, passing the Houses of Parliament after self-discharging aggregates for the Millenium Bridge in just a few hours, saving over fifty delivery trips by heavy trucks along the capital's roads.

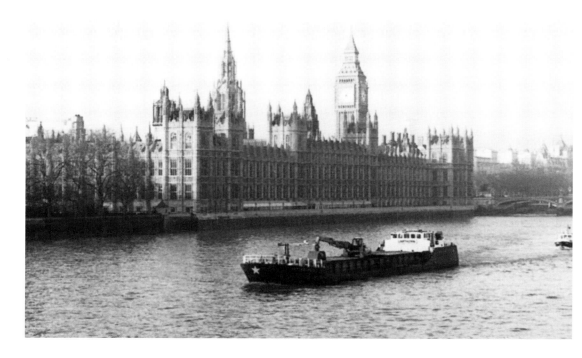

Whitstable Harbour and the first trial of self-discharge by *Hoo Maple*, with a digger mounted temporarily over the main hold. The success of this led to permanent installation on a number of Lapthorn ships. (Courtesy David Lapthorn)

people and goods between these versatile aircraft and the shore. In the early 1930s the air force commissioned a fleet of fast offshore rescue boats, with an enthusiastic T.E. Lawrence – the famous 'Lawrence of Arabia' – much involved in their design, building and testing. By 1942, Leading Aircraftsman Lapthorn was in India, where he designed and arranged production of small boats to assist the Burma campaign. The boats were used mainly in river, lake and marsh-land areas, and Tony's workshop was built from old plywood packing cases, with other cases providing the boat building materials.

Demobbed and back in 'Civvy Street' after the war, Tony returned to the south coast and converted a ship's lifeboat which he profitably operated out of Christchurch, undertaking various marine 'riparian' work (repairing quaysides, constructing mooring places and other marine features) combined with some fishing. In 1947 Tony married Rachel, and their first home was an old Thames sailing barge *Leslie*, which Tony had found on the Medway. Taking space at a Strood creek in return for helping the Whitewall Barge & Yacht Company, the owners of the creek, Tony skilfully converted the barge into a houseboat for himself and Rachel, and returned to Christchurch.

Meanwhile, the owner of the Whitewall Barge & Yacht Company had been very impressed with the high standard of Tony's conversion work and travelled to Christchurch where he offered Tony the post of yard manager of the business in Strood. So no sooner had *Leslie* arrived at Christchurch than the barge was turned around and Tony sailed back to the Medway. During this voyage, Rachel stayed in Bournemouth with their son David, and soon after the family settled their home, the barge *Leslie*, at Hoo. With Tony's energy, the Whitewall Barge & Yacht Company prospered and purchased a former brickfield at Hoo where they planned to expand the business and develop a marina. Sadly, any thoughts about marinas were well in advance of that time and the company had financially over-stretched itself. It collapsed, leaving Tony without a job, few resources, even less money and a young family to support. Not one to feel sorry for himself, Tony recognised that with a power station and other huge building projects about to commence locally, there would be a need for aggregates. Tony leased the former brickfield with the adjoining berth and purchased an old sailing barge, *Nellie*, for £150, converting her

to a motor barge using a surplus Chrysler Crown engine purchased from the Government at a knock-down price. With a contract to carry aggregates from Grays in Essex to the Medway for building the new Isle of Grain power station, the Lapthorn Shipping Company had begun.

Life was tough, both for Tony and for *Nellie*. On one occasion, in bad weather off Grain Spit, heavy seas carried away her wheelhouse and hatches, flooding the engine room. Running under a hastily rigged jury sail, Tony beached the ship at Minster where the Southend lifeboat took Tony and his mate ashore for the night. Next day, armed with shovels and pumps, *Nellie* was refloated and towed to Hoo where she was soon repaired and back in service – and Tony even got paid for salvaging the cargo!

In 1953, Britain's east coast suffered horrendous floods with the sea breaching the sea walls at Grain. Sand and gravel was desperately needed, providing much work for Lapthorns, who were paid £12 a day by the American contractors plus large quantities of canned peaches and ham to supplement the more mundane barge fare. Further business developed and the company acquired more vessels, including the sailing barge *Felix* that, with its tough old skipper Alec Josh, was probably the last spritsail barge to operate commercially before being converted to motor in 1956.

The company was growing fast, and the family moved to a new home and larger premises, the barge *Alice May*, on which they lived for several years before coming ashore to a house at High Halstow, with an office built at Buttercrock Creek. Meanwhile, Tony had added some tugs to his fleet and was carrying various cargoes in addition to ballast and aggregates, which became and remained the core business of the company. Other goods carried included cheese, timber, coal, flints, glass and even explosives – Tony ensured that the company retained a flexible approach to business. In 1962, with the acquisition of more modern ships, Tony decided his ship names should all be prefixed 'Hoo'. The new ship *Herb* was duly renamed *Hoocreek*, starting a pattern that continued, although as time passed the acquisition of other vessels, some initially via a managing agent, resulted in a wide diversity of names throughout the fleet. At one time the towage side of the business acquired numerous unpowered lighters given names that included *HooHa*, *HooDoo*, *Hootch* and even *Dr Hoo* before it was decided things might get out of hand!

Meanwhile, from beginning married life keeping the company's books in a tiny office, first on the *Leslie* and later on *Alice May*, Rachel Lapthorn had ensured that their son David and his younger brother John enjoyed a happy if unusual childhood – David recalls most of his classmates arriving to watch the family 'moving house' when *Alice May* changed her berth at Hoo. There was never any doubt that David would join the family business, and after leaving school he spent some years with various marine companies learning about ship building and repair before joining the renowned firm of Fieldgates in Colchester to study shipbroking and agency work. In 1974, having qualified as a Fellow of the Institute of Chartered Shipbrokers, David was elected to the board of the family company which, as he recalls, meant he did everything and anything that people felt he should do. However, on Tony's sixtieth birthday, in 1981, David arrived in his office to find his father had left a note saying 'I've retired, it's all yours!'

Tony had decided to enjoy more time sailing – he had already skippered many sailing barges to success in the annual barge races held around the south-east and was confident that David would equally lead the company to greater success. Under David's direction, the company developed their expertise in managing vessels for other owners, in many instances leading to the acquisition of the ships and to extension of operations to and from the continent. Lapthorns also developed their marine services and set up a company under the direction of

David's younger brother John, who had qualified as a marine engineer. In 2000 they acquired Denton Slipways at Gravesend where there was capacity to maintain and service ships up of to 1,000 tonnes.

Despite fluctuations in demand over the years, aggregates remained a major part of the company's business, but loading and unloading away from purpose-built sites was always a problem. David felt the only solution was self-discharge and the concept was tried by locating a long-jib excavator over the cargo hold of *Hoo Maple*. The trial at Whitstable in 1995 was highly successful. A few months later *Hoo Marlin* dramatically confirmed the success by offloading 1,300 tonnes of aggregates required for the footings of the Millennium Bridge in less than four hours, under the eyes of the City of London. Arriving, discharging the cargo and departing within a tide was an impressive demonstration and was instrumental in opening the way for increased use of water transport. Just one load carried by a ship would require nearly fifty lorries for road transport and, with two tides a day, amply demonstrated that transporting such loads by just a single ship could replace 100 lorry journeys – an impressive saving of resources, pollution, congestion and wear on Britain's roads. Under the direction of David Lapthorn, the company continued to develop new and innovative ways of handling basic cargoes, successfully competing with alternative transport systems whilst protecting the environment. In the meantime, their ships 'waved the British flag' in seas that were increasingly dominated by foreign-registered vessels.

Approaching sixty years of age, David decided it was time to retire, as had his father Tony. The company was sold to Coastal Bulk Shipping, creating an even larger British–flagged cargo fleet and European leaders in the transport of aggregates by sea. Tony and David can be justly proud of their achievements, not only in maintaining traditional economical methods of transporting cargoes, but also by their development of new and innovative techniques.

In 2008 Coastal Bulk Shipping was badly hit by the massive downturn in international trade prompted by the world-wide recession, combined with a near-total collapse of the UK's building industry. Sadly, the company had no alternative but to cease trading and many of their vessels joined the large numbers of ships laid-up around the world.

A Grand Old Lady

For nearly ninety years Knight's tugs, with their distinctive white rings and 'K' logo on the funnel, were the workhorses of the River Medway. Whether manoeuvring ships in the Pool of Rochester or towing strings of lighters up and down river, these tough little vessels were essential to every activity. But as more efficient cargo handling developed elsewhere, Medway's river trade diminished and, with it, the demand for tugs. Knight's moved with the times as tugs got bigger and more powerful and, although still based in Chatham, the company's operations are now worldwide.

One of Knight's last 'traditional' river tugs was the *Kent*, launched in 1948. Weighing-in at 120 tons and with a huge 880hp engine, she was designed to handle the largest ships of her time, yet had a funnel that could be lowered to pass under bridges which enabled her to be used upriver. Nonetheless her initial trials in 1948 were far from satisfactory. The engine would not run in reverse, the drive shaft kept seizing up and the propeller was the wrong size. In fact, it took four tries before the correct propeller (7ft/2.15m diameter) was found and fitted. Despite the inauspicious start, problems were resolved and *Kent* joined Knight's fleet to handle the massive tankers which were then beginning to arrive at the new Grain refinery.

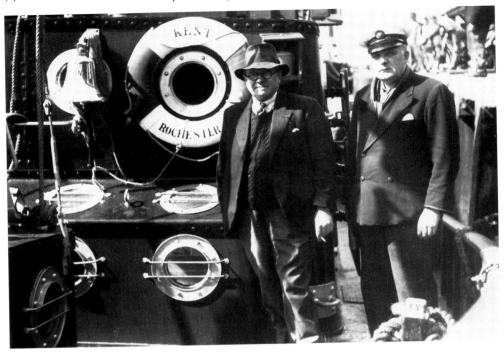

Above: The tug *Kent* during commissioning trials at Lowestoft in 1948. One of the Knight's skippers (a little more formally dressed than usual!) with the yard manager of Richards Shipyard. (Courtesy South-East Tug Society)

Left: Barney Hunt, from greaser boy to heritage conservationist, catching a rare moment of relaxation on board the tug *Kent*.

The power that drives the tug *Kent*. Barney Hunt in the engine room tending the massive Polar Atlas engine.

However, *Kent*'s first job did not require much power. A replica Viking ship had been rowed from Denmark and the *Daily Mail* had arranged a tour of south coast ports. The Danish crew obviously thought this was a bit much after crossing the North Sea and so *Kent* towed the wooden longship between ports, whilst the crew simply boarded to row in and out of the harbours. *Kent*'s master Captain Cornell received an honourable mention for his skilful handling of the tow and doubtless the grateful thanks of the Danish crew!

In the 1950s the highly versatile *Kent* spent several years operating around many British and European coasts before becoming the duty tug at Grain. As the numbers and size of tankers visiting the oil refinery grew, *Kent* was joined by even bigger and more powerful Knight's tugs so that by the 1960s she was considered to have achieved old age and was transferred to Rochester, where she spent the rest of her working life. But conventional tugs such as *Kent* were fast disappearing everywhere as huge new vessels with propulsion systems that could move them instantly in any direction were introduced. Hence the decision by Knight's to pension off the elderly *Kent*, but in recognition of her contribution to the company and local heritage she was carefully mothballed and moored on the river.

Twelve years passed and Knight's decided to sell *Kent*, hopefully to a museum, but found themselves instead talking to some active ex-tugmen who had formed the South-East Tug Society and were looking for a tug to restore. Within a short time *Kent* was sold to the society for £1 and towed to a berth provided by Chatham Maritime, where the society's members set to with vigour to restore *Kent* to her past glory. The members of the society were mostly tugmen and they knew what had to be done to restore the tug to her former

operational condition. For many months the basin echoed with the sound of hammers chipping away at corroded paint and rust. But three years later – and fifteen years after retiring from active service – there was a puff of black smoke from her funnel and a deep thump from her enormous engine. *Kent* was underway again, to the emotional delight of the local tugmen who had devoted their time and energy to achieve this success.

Kent looks exactly how many people think a tug should look: a high bow with graceful sweeping lines down to a low stern, a timber wheelhouse and, of course, a funnel. Since 1999 *Kent* has been a popular visitor to maritime events around the UK and Europe, including many prestigious heritage ship gatherings in Holland and Belgium, and her crew have become informal ambassadors for the county whose name she bears. Modern tugs with their observation tower wheelhouses and enormous swivelling drives may have massive power, but few can arouse the interest generated by *Kent* when she appears at a maritime festival. It is nostalgia, but it is no less genuine and demonstrates that even in an electronic age people still want to see the impressive engineering that once led the world.

From Greaser Boy to Heritage Conservation

One of the proudest people on the day that the restored *Kent* was under her own power again was Barney Hunt, a founder member of the society who for three years had spent every available hour bringing the *Kent*'s huge polar engine and the rest of the vessel's mechanics back to life.

Barney is a typical tugman: unassuming but firm and unflappable with a broad and self-deprecating sense of humour. Despite having a great-great-grandfather who had been the skipper of a Woolwich ferry, as a lad in Woolwich Barney's early ambition was to build motorbikes. However, on leaving school at fifteen he joined the Gaselee Company on one of their Thames tugs as a greaser boy, which was where all aspiring engineers had to start. It was there that Barney first came to know the massive Polar marine engines that provided the power for tugs and many other ships, and any thoughts of building motorbikes evaporated!

It was hard work on tugs in those days, and for the engineers also hot and noisy in the engine room below decks, with little idea of what was actually happening or even if it was raining or snowing. Their contact with the world was the telegraph dial where skipper's requests for 'full', 'half', 'stop' and 'reverse' were displayed. There were no automatic gearboxes; going from forward to reverse meant stopping the engine, changing the gear and then starting the engine again. At times a tug might be required to shunt back and forth several times in a minute or two so the engineers were rarely idle and in addition they had to keep the generators and compressors running. As Barney says, 'I've travelled thousands of miles afloat around the UK and Europe … and seen very little on the way!'

Like most ambitious engineers, Barney worked on other vessels from coasters to tankers gaining more experience and a reputation for knowledge and dependability. The only hiccup was a break for National Service, when to Barney's amazement he was declared not to be 100 per cent fit and was rejected! Instead of marching off to be a soldier for eighteen months, Barney remained in 'Civvy Street', or perhaps 'Civvy River', got married and moved to Cliffe where he and wife Loretta still live.

Working on tankers had provided an introduction to the oil business and Barney left tugs and went ashore to join Conoco at their riverside fuel terminal. There he spent nearly twenty years, becoming superintendent engineer before setting up his own business providing engineering expertise to the oil and marine industries. Barney sold the business and

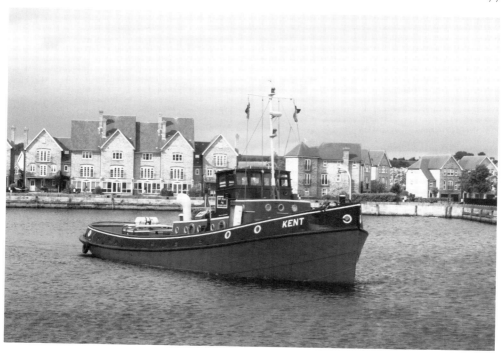

The tug *Kent*.

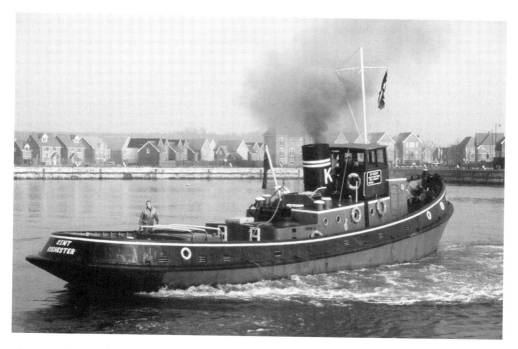

The tug, *Kent*, moving again under her own power after fifteen years 'mothballed'.

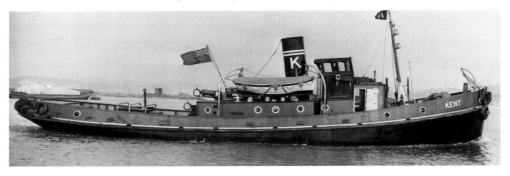

Kent in 1948 off Lowestoft just after commissioning, about to depart for the River Medway.

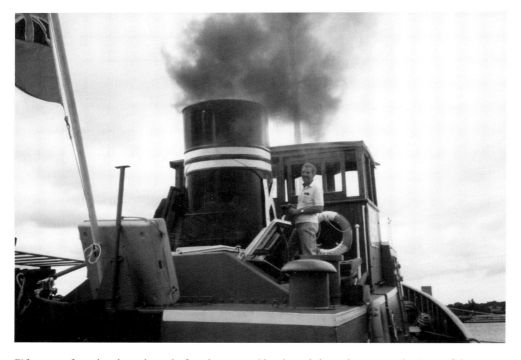

Fifty years from her launch, and after three years' hard work by volunteer enthusiasts of the South-East Tug Society, a puff of black smoke from her funnel announced that *Kent* was alive again! (Courtesy South-East Tug Society)

retired when he was sixty, but was immediately contacted by tug companies to help out when they were short of an engineer – work which Barney still enjoys provided it is not too frequent! But Barney's no 'nerdy old engine freak' and has a life away from tugs. He and Loretta breed champion whippets; Loretta worked in the veterinary business before they married. In addition to their three children, Barney speaks proudly of their seven grandchildren, plus a great-grandchild.

With his knowledge of Polar engines and tug operation it was inevitable that Barney would be part of the group that formed the South-East Tug Society and he has been one of their

most active members. As with nearly every heritage preservation group there is a band of dedicated members who provide the core. Most in the society are retired and they are getting seriously worried as to who will carry on the work of running and maintaining *Kent* in the future. Traditional tugs do not have computers but big (and heavy) chunks of machinery and there is nowhere today for anyone to become a greaser boy to learn how a tug's engine room works.

Kent is a live and working piece of Britain's maritime tradition and she has rightly been identified as a 'designated heritage vessel'. Thanks to the foresight of Knight's in mothballing her when she came out of service, and the dedication of Tug Society members, it is probable that she will not be scrapped. Unless there are people prepared to maintain her she will end up a static exhibit in a dock or, even worse, on land. This would be sad and deny from future generations the sight, sound and even the smell of what was once an essential part of a working river, and which made a significant contribution to our country's prosperity.

But for the present, *Kent* is alive and well, and on the river where she worked for nearly half a century – and open for the public to experience for themselves what life was like on tugs, the 'workhorses' of the river.

Fact File – *Kent*

For the technical, *Kent* is a single-screw, steel-hulled, diesel tug.

Built: 1948 by Richards of Lowestoft

Length overall: 88ft/27m

Beam: 22ft/6.75m

Draught: 11ft 6in/3.5m

Engine: Polar Atlas 5-cylinder type M45M developing 880bhp at 275rpm

Propellor: 7ft/2.15m diameter

Gross tonnage: 125 tons

Bollard Pull: 7 tons

Fuel consumption: 35 gallons (175 litres) an hour at 'modest cruising speed'

Keeping Rochester's River Trade Alive

The River Medway was first used as a major thoroughfare thousands of years ago by the iron and bronze smelters of the Weald as a means of transporting goods to the sea, and by the mid-nineteenth century Rochester had become a very prosperous port with over thirty wharves loading and unloading cargoes. Around a hundred years ago increasing trade led to demand for more wharves and ships were now anchoring in the pool directly offloading wood pulp to barges for transport upriver to the paper mills. The river supported several thousand jobs, with many more indirectly employed in related industries. Sadly, during the past fifty years, as larger deepwater ports have been developed and with the growth of road transport, Rochester's decline as a port was inevitable. One by one the wharves closed and papermaking relocated to the source of paper pulp in Scandinavia. The riverside along the Frindsbury Peninsula facing across the river to Rochester, once packed with wharves, cement factories and warehouses, was transformed into a business park whilst the Pool of Rochester at Limehouse Reach became but an empty shadow of its busy commercial past.

Roy Brooks, dedicated to keeping commerical traffic alive on the River Medway.

In 1994 the company Scotline acquired a large site at Chatham Ness where the Pool of Rochester ends and the river follows a wide curve into Chatham Reach. A shipping company determined to keep alive the tradition of Medway's trade with Scandinavia and the Baltic, Scotline had, since its creation in 1979, become one of the UK's major importers of Scandinavian timber and timber products into the UK. With their own cargo terminals on the Humber and at Inverness, plus regular use of other major ports such as Newcastle, Scotline had grown to be responsible for over 30 per cent of the soft timber used in Britain each year. Within a short while, the new 11-acre Medway site was up and running, with nearly 90,000 square ft of covered storage specially built to handle an additional 100,000 tonnes of wood pulp that Scotline was bringing to the UK each year.

Scotline is not just cargo terminals. There are eight ships in their fleet of modern purpose-built timber carrying vessels, easily recognised by their grey hulls and white superstructure. All are British-registered and are described as single-deck box-hold vessels with reinforced hold covers designed to support deck cargo in addition to that carried below in the cargo holds. Around 85m (275ft) long and about 1,595–2,550 gross tonnage, the ships have a cargo capacity of from 100,000 to 130,000 cubic ft. Each has a single low-emission diesel engine, cruises at 10–13 knots, and is highly manoeuvrable for docking. Scotline have established their own mechanical workshops employing local staff for routine maintenance at the Strood terminal.

In addition to their own terminals, the company have established loading agents at other ports that enable the company to control every aspect of the cargoes, from loading in Sweden or the Baltic States to delivery directly into the buyers' yards in Britain. For the Medway, this has resulted in at least 130 ship visits each year, each turned around in about seven hours, using two massive British-built port crawler cranes. Once ashore, the timber is handled by huge fork trucks fitted with specifically designed lifting gear that loads the timber onto articulated trucks.

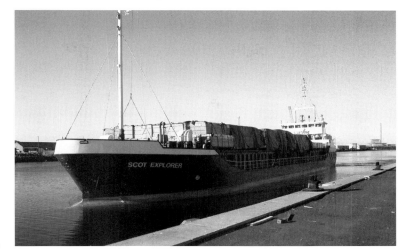

One of Scotline's modern fleet of timber carriers, *Scot Explorer*, preparing to berth.

Unloading softwood from Scandinavia at Scotline's Medway terminal.

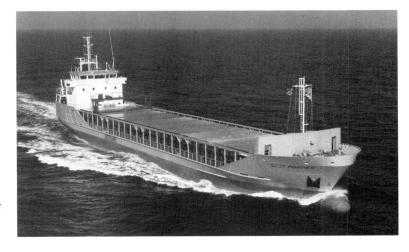

Coastal freight in the twenty-first century. *Scot Mariner* with another load of timber frames, pre-assembled in Scotland for delivery to southern England. Several days by sea, but much cheaper and with negligible environmental impact.

Over sixty of these huge vehicles depart the Strood terminal each day to distribute timber throughout the south of England.

Controlling this massive and non-stop operation is Roy Brooks, a quietly spoken, amiable and (mostly!) unflappable person who knows everything that anyone needs to know about cargo shipping, having been in the business since leaving school. Roy joined Scotline in 1985 having previously been the chartering manager of Crescent Shipping, another Medway-based company and one of the UK's major coastal shipping operators, where he was responsible for the chartering and scheduling of no less than forty-three coastal cargo vessels operating out of UK and European ports. Born in London and with Anglo-Danish parents, Roy has maritime family connections in Denmark with one cousin being the chief hydrographic officer of the Danish navy, and another who was first officer on the Danish royal yacht. Roy speaks fluent Danish which, despite the business links with Scandinavia, he claims he has never needed because, as he says, 'everyone speaks perfect English as a matter of course!'

Roy is a strong advocate for water transport as an environmentally sound means of moving goods, and equally enthusiastic about the need for accessible wharves to serve cargo ships. Much respected in the industry, and a director of the Chamber of Shipping, Roy was appointed in 2006 to lead the Chamber's short-sea committee who consult and advise the government regarding the development of cargo transport on coastal and shorter sea routes. Under his guidance, awareness of the commercial and environmental advantages of water transport continues to grow. Meanwhile, Roy remains a staunch champion of the River Medway and is dedicated to maintaining its commercial viability – he was a founder member of the River Medway Business Users Association. A resident of Medway for over thirty years, Roy lives in Strood with his wife Pauline and their two sons. He is a past chairman of the Medway Rotary Club and, when not espousing use of the River Medway or other matters maritime, can be found promoting deserving local charities with an equal determination and vigour.

It was the ancient Greeks and Persians who first recognised that transporting goods by water was the cheapest option and it remained so for over 5,000 years until challenged by railways. In many countries, such as the UK, rail gave way to road transport which, although efficient for local deliveries, is expensive, even more so with the ever-increasing cost of fuel. Leaving aside local deliveries, moving freight nowadays by water rather than by road reduces congestion and environmental impacts, and can be much cheaper. However, change to water from road has been slow as high port charges have made many potential short-sea shipping routes uncompetitive against road and rail.

The major producers of forest timber board and similar products for the building industry are located in Scotland, and in just a few years distribution costs, particularly to southern England, had risen through the roof. Scotline identified the problem and with its fleet of modern ships and convenient terminals, including one at Inverness, worked to overcome the obstacles to using sea transport. As a result, they introduced a new shipping service to bring timber board from Inverness to their Rochester terminal. It proved to be a great success and financially attractive to other manufacturing companies in Scotland and as such the service expanded to other UK destinations. If fuel costs continue to rise, it is likely that many road hauliers will close and the reduced availability could make waterborne transportation even more attractive.

Transport by sea offers a massive reduction in pollution. Ships use gas oil, a derivative of diesel fuel, and most have only a single high-efficiency, environmentally clean, low-emission engine. Therefore sea transport ticks all the right boxes as far as pollution and the environment

is concerned. The significant drawback is that it is not fast, with the sea journey from Scotland taking a few days instead of ten to twelve hours by truck. It would certainly be no good for the just-in-time practices adopted by manufacturing industries during the past decade, but with transport costs exceeding storage costs, a return to thinking and planning in advance could eliminate the downside of slower transport.

Roy Brooks has no doubts about the future: 'the savings – and hence the potential for reducing cost to consumers is enormous. Our ships each carry at least 3,800 cubic meters of timber product – equivalent to 85 lorry movements that cost four times more than transport by ship – which reduces reduce road congestion and fuel use. It's long been commonplace in Europe – even inland on their wide canals, yet sadly isn't promoted very much in the UK.'

Under Roy's enthusiastic direction, Scotline have invested more than £3 million in their terminal at Strood, which directly and indirectly provides over a hundred jobs. It was created on a site, originally marshland, formerly used to build oil rigs for the North Sea. Despite extensive infill with brick and clay, the land is very slowly sinking with further infill needed from time to time, but this is a lesser problem than what could happen in the near future when Rochester's riverside is developed. Residents in new homes overlooking the river and the Frindsbury Peninsula will not welcome ships arriving with the tide in the middle of the night or the sound of cranes and trucks as cargoes are discharged. Years ago, people who had grown up by the waterside accepted the sound of river activity, but as was quickly realised when houses and flats were built along the River Thames, today's waterside residents are not so content. It will be interesting to see how a compromise might be resolved – or if it ever will be!

Meanwhile, Scotline and Roy Brooks continue to maintain Rochester's marine heritage of trade with our Nordic neighbours and Roy remains optimistic that the traditional industries of the river and new residents will happily live together.

The Fishermen of Medway

A dull, overcast early morning on the river, with a few wisps of mist still hanging low over the water and few people around to notice, a boat quietly slips its mooring at Strood and heads downriver. Just one of the Medway's small fishing fleet off for the day trawling the muddy waters of the river.

There were once well over 200 fishing boats working the river, all making a good living and constantly landing their catches at Strood and Chatham where the fish were quickly sorted, packed in wooden boxes and taken to the railway stations. Later that same day the freshly caught fish would be served at London's top restaurants and hotels. Local high streets from Strood to Gillingham boasted oyster bars and shops selling locally caught fish, shellfish and, that almost forgotten delicacy, the Medway brown shrimp. Now many of the fish have gone and a royal sturgeon hasn't been seen for nigh on 150 years!

Changing trends reduced demand, but pollution and poaching also reduced the fish stocks and the industry declined. The freemen of the river, with their seven-year apprenticeships and appointment by the Rochester Oyster & Floating Fishery first established over 700 years ago, dwindled to a handful. In the recent years, thanks to the efforts of the environmental agencies, the pollution has gone and fish are returning to the breeding grounds of the river. Thankfully, the old fishing families of Medway, the Wadhams, the Hills, the Pococks and others, had kept

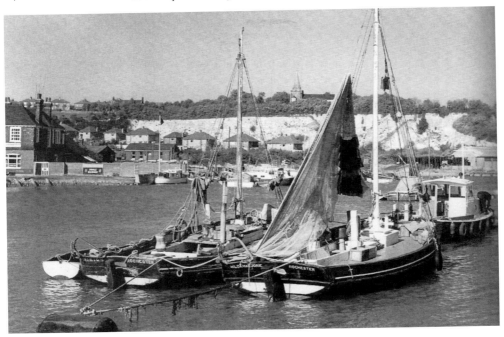

Some of the Medway's fishing boats moored at Strood in the 1950s. The fleet had, by then, dwindled to around thirty-five vessels, including some old traditional bawleys still operating under sail. (Courtesy Kent Messenger Group)

Two of the Rochester Oyster & Floating Fishery's (ROFF) fleet moored at Strood. Now only nine boats remain; all are motor craft. Reduced fish stocks and compliance with international regualtion has resulted in their operation now being mostly on a part-time basis.

the traditions of fishing alive and there are now nine boats working the river, although few are full time.

Brothers Paul and Andrew Starling are typical of today's Medway fishermen. Apprenticed at fourteen to their renowned grandfather, Edwin Thomas Wadhams, they spent seven years learning every aspect of fishing on the Medway – from mending nets to boat handling, in addition to the secrets of where to find the fish. At least three times a week the brothers, often with their father Peter (now retired), take their boat *Melissa E* out to work the river waters with trawls, as have generations of their ancestors.

The fish may have returned to the river but they are not yet in sufficient numbers to make any of the fishermen rich. There is no certainty that there will be any fish in the nets when they are pulled in. They can be sure of a few old tyres and bits of cars but there is always an expect-ant hope, no matter how many thousands of times a fisherman may have done it before, that the net will be bulging with a thrashing silvery reward. The Starlings are philosophical in their approach to what they do. They and other freeman consider themselves simply as 'custodians of the river', nurturing and protecting stocks for generations to come. They are all working to ensure that their children and grandchildren will have an industry that hopefully might be in part restored to the heyday of Medway's fisheries a hundred years ago.

The fishermen at work demonstrate teamwork at a level to which management experts might only dream. Rarely a word is exchanged as a multitude of tasks are undertaken when, on reaching the chosen fishing ground, the trawls are set. *Melissa E* has been converted from a beam trawler (where nets are set either side of the boat) to a stern trawl. The net runs out on cables three times the depth of the water being fished and guided by wooden vanes to keep the trawl running just along the river bed. The boat pulls the trawl with and just slightly faster than the tide so that fish are gently scooped into the net. Against the tide or too fast and many more fish will be caught, but they will suffocate and actually drown in the nets, and many will be young fish or fry. This is what the poachers do: just grab the largest possible catch with no thought for future stocks.

After twenty minutes or so, the boat will stop and powerful winches pull in the nets. The catch varies according to the season. Summer months are good for Dover sole that breed in the river and are popular with the fishermen as they command the top prices, although 'top' for the fishermen is but a small fraction of the amount subsequently charged by shops and restaurants. Other fish include pouting, whiting, gurnard and eels, the latter in great demand by the Dutch who come here to buy, taking the eels live in tanks to Holland where they are smoked. A good number are then sold back to Britain as a fish delicacy! Sadly, the famous Medway shrimps are nowadays in such small numbers that it is barely worth setting the fine nets, even in August and September when the shrimps are traditionally more plentiful. There are also lesser-known but delicious fish such as the blue-finned red tub gurnard (nobody knows why a blue fish is named 'red') and the famous cucumber-scented Medway smelt, once the staple diet of local people.

The net is emptied into a large tank and the catch sorted into individual boxes before it is reset and made ready for the next trawl. Most people would be surprised at the amount of small fish carefully returned to the river to grow and breed for the future. Probably 80 per cent or more of the total catch goes back and it is easy to see why the fishermen will not become millionaires, despite the fact that locally caught fish is in great demand.

A good day's fishing might produce just a few stone in weight, maybe sixty or so large fish. On a bad day it won't even pay for the cost of running the boat. *Melissa E* was built in 1976 in Whitstable by the well-known builder Bob West, and is as tough as one would expect of her

8 tonnes and 30ft of 1½in iroko planked hull. But just a few years ago a new wheelhouse was needed which cost thousands of pounds that will take years to recover.

Fishing on the Medway is not as dramatic as fishing is often portrayed on film and television, it is not the north Atlantic and the waves are not mountainous. The fishing boat might be just a few hundred yards from the riverbank almost in the shadow of Rochester Castle, or between the trots of moored yachts at Upnor. Whilst the waters may be less rough, in rain and freezing sleet during the winter it can be as inhospitable as the ocean. Moreover, they are still required to comply with national and international regulation and quotas, with the masses of paperwork these generate!

But the Starling family, and the other freeman of the Rochester Oyster & Floating Fishery, will continue to fish and care for the fish stocks to ensure that they, like the fishermen, survive for the future.

Poaching

There has always been illegal fishing but these days it is rarely done simply to feed the poacher and his family. With modern technology and powerful boats, it has become a profitable occupation.

The greatest problem is that the poacher fishes indiscriminately with no regard for preserving future stocks. They invariably use ground trawls – basically a large net dragged over the riverbed that disturbs and often destroys the habitat which supports the fish stock. Equally worrying are the fine-mesh trawls used by poachers that trap everything and are often dragged against the current flow with the result that the fish effectively drown. When the net is drawn in, the smaller dead fish and fry are tossed away with the result that the overall stock decreases further which can take years to replace. In recent years poachers have been successfully prosecuted and this has curbed their activities. If poaching was allowed to continue then eventually fish would disappear from the Medway altogether.

It is not only the commercial fishermen that suffer from poaching. When anglers find fish become scarce they are soon off to other places. Medway cannot afford to lose anglers, many of whom come from outside of the area and who contribute an estimated £2 million a year to the local economy.

A Most Unusual Chamberlain

Ask people to describe a fisherman and they will probably talk about a gnarled old salt with weather-beaten brow, unruly beard and wearing a smock. Ask what the Chamberlain of Britain's longest established Oyster and Fishery Guild of Freeman looks like and you will probably find 'octogenarian' added for good measure. Nothing could be further from the truth.

Enter Shane Hales: clean shaven with boyish looks that belie his forty years, with an enormous respect for the River Medway, fish of every type and our heritage and the Chamberlain of Rochester's Oyster & Floating Fishery, which traces its history over eight centuries to 1189.

Born in Rainham into a family that included several free fishermen, Shane was brought up on and around the river, but on leaving school with a string of academic achievements, he was recommended to enter an 'appropriate profession' and so joined one of the major high street banks as a trainee manager. It lasted eighteen months before Shane realised that evenings and weekends spent river fishing with his family were much more fulfilling. Leaving the world of finance, Shane donned a pair of boots and became an apprentice to his uncle Horace Moore,

Shane Hales, Chamberlain of ROFF.

and seven years later he and his cousin Brad Moore completed their apprenticeships together. From his short financial training, Shane realised they could never make a living simply by fishing, so in 1984 the cousins went into partnership and opened a fish shop in Rainham, by coincidence only a few yards from the house in Station Road where Shane was born.

The business has flourished and is now the only traditional fishmonger in Medway that can properly fillet and prepare fish to suit any customer requirement, and is certainly the only shop selling locally caught fish in addition to that from Billingsgate. As a lad one of the free fishermen told Shane never to sell a fish that he wouldn't want on his own plate – something that Shane has never forgotten and which has earned him the respect of his customers over the years.

It is a demanding job with long hours. A typical day for Shane might include arriving at London's Billingsgate fish market at 4 a.m., then back at the shop by 7 a.m. to prepare fish for their many commercial customers before opening to the public. After the shop closes, he may be out on the river at 6 p.m. to clear nets or fish, maybe until midnight.

Today's Fishing Fleet

It is difficult to visualise Medway's waterside a century or two ago, when some 400 fishing boats made a good living on the river.

Today the fleet comprises just nine boats, owned by the twenty-four freemen approved by the Admiral's Court of the Rochester Oyster & Floating Fishery, but all operated only on a part-time

basis. The most frequently available fish are Dover sole, bass, mullet and eel, with the occasional cod and sprat. The Medway was famous for its brown shrimps but today's catches are a poor shadow of the many barrels once landed with every tide. However, the pollution is being beaten and in the last few years salmon has been caught in the river, one at over 9lb, so hope remains.

The waters around Kingsnorth have proven to be excellent breeding grounds for bass and sea trout, where the fish continue coming in large numbers to spawn, and careful conservation has ensured the survival and growth of the young fry. When fully grown, many swim off to the Western Approaches where they are promptly overfished by some fishing fleets, never to return to Medway and spawn the next generation.

Shane's relaxed nature and firm determination to uphold the best traditions of Medway's fishing industry has won admiration from his peers, the twenty-three other free fishermen of the river. This, in turn, resulted in his election as Chamberlain and principal water-bailiff of the Oyster & Floating Fishery, an achievement for which he is justly proud. Shane is passionate about conservation of the river's fish stocks and the oyster nursery beds which hopefully might one day return to the levels of Victorian times when the Medway provided most of the oysters consumed in England. Meantime, the Fishery is frequently consulted regarding new developments along the river and estuary to ensure minimal disturbance to fishing grounds. In addition, commercial poaching still occurs from time to time, and poachers have no regard for the conservation of fish stocks. In such instances local authorities and the Fishery, backed by the 600-year old Charter, have jointly prosecuted the poachers – and successfully secured convictions!

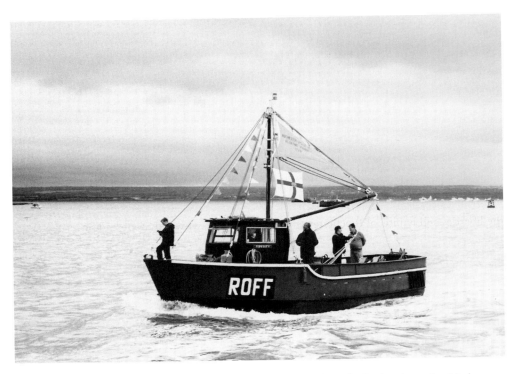

The ROFF Chamberlain's boat, dressed during the annual Admiral's Cruise along the Medway. The 'bounds are beaten' during the trip to affirm the boundaries of the Admiral's jurisdiction and the prescriptive rights of ROFF by Royal Charter.

Shane admits there will be difficult times ahead, but people in Medway are beginning to appreciate their greatest natural asset and the resources it provides, and he is confident that Medway's fishing industry will be revived, even if not to its past levels. As Shane says, 'we've got over the worse, a decade or so ago when people seemed to stop wanting fresh fish, and now demand for local-caught fish is growing rapidly. We just hope that the river's fish stocks will be able to survive.'

The Rochester Oyster & Floating Fishery

The prescriptive rights of the Medway free fishermen stretch back to 1189, but it was not until 1728 that an Act of Parliament was passed for 'regulating, well ordering, governing and improving oyster fishing in the River Medway', under the authority of the mayor and citizens of Rochester. Subsequent Acts in the nineteenth century re-affirmed the establishment of the oyster fishery and gave jurisdiction to the mayor, appointed as admiral of the river.

The fishery was 'free' and 'common' to all oyster fishermen who had served a seven-year apprenticeship and from the earliest times a court of conservancy presided over by the mayor appointed juries, water bailiffs, tried offences and imposed fines. Records show an unbroken series of courts since 1571 to the present time and the court continues to exercise jurisdiction over the floating fishing in addition to the oyster fishery, the free fishermen and everything relating to fish and the river.

Today the Chamberlain, jury and bailiffs meet monthly, and on the first Saturday in July hold an Admiralty court at Rochester's Guildhall, presided over, since 1998, by the Mayor of Medway. Until a few years ago, the court was held in the open hold of a barge or lighter moored at Rochester Pier. Although there is considerable ceremony, substantial issues to be resolved are frequently referred to the Mayor by the Chamberlain of the fishery. Once the court ends, the Mayor and Chamberlain, accompanied by councillors and officers of the fishery proceed to Rochester Pier where a boat takes the party upriver to Hawkwood Stone. There, the mayor 'beats the bounds' of his jurisdiction. Traditionally the party would then make the trip downriver to the estuary where, off Garrison Point at Sheerness, the Mayor would again beat the bounds. However, in recent years the longer downriver trip has taken place the next day in order that more boats can join in what has become the annual 'Admirals cruise'.

The Royal Sturgeon

Since medieval times the sturgeon has been known as the 'royal' fish and any caught 'within the liberties and lymitts of Rochester', that is between Hawkwood Stone and Sheerness, were regarded as belonging to the mayor and Corporation of Rochester, but also had to be presented to the ruling monarch.

Records show that on 5 July 1630 a sturgeon was caught by a Mr Porett who duly brought it to the Mayor as 'his right due'. Oddly, on this occasion, any thoughts of presentation to the King seem to have been forgotten (or perhaps he was away) and it is further recorded that 'it was eaten by the Mayor and his brethren'.

By the nineteenth century, however, the tradition appears to have been revived when, in 1845, a sturgeon caught in the river was the next day dispatched to Windsor as a 'humble offering and small testimony of their loyal and dutiful regard for Her Majesty'. Two days later a letter from the Lord Chamberlain expressed 'Her Majesty's gratification', although it is not clear if the Queen actually ate the fish.

In 1862 another sturgeon was caught and again sent to the Queen, at the time staying in Balmoral, and again her thanks were duly received. With few facilities to keep the fish fresh, by the time it reached Balmoral it probably walked itself to the castle!

There has been no record of a sturgeon caught in the river since that day nearly 150 years ago, but as the river becomes cleaner the Royal Household can look forward to another sturgeon in due course.

CHAPTER SIX

FOR THOSE IN PERIL

Experienced river folk never take the river for granted and safety afloat is treated very seriously. The river may not have the rolling surf and flying spume of a storm at sea, but in a north-easterly blow it can get fairly rough down toward the estuary. Even on calm days the river and mud can be treacherous. The river ebbs at up to 5 knots in places, too fast for even an experienced swimmer. In past times watermen unfortunate enough to fall in were often swept under moored barges by the flow and drowned.

A permanent lifeboat station was established at Sheerness only in 1970, which today operates a modern Trent class fast offshore boat plus a small inshore craft. Most calls are to incidents in the estuary but the station's operational area extends up the tidal Medway to Rochester.

The Royal National Lifeboat Institution set up its national lifeboat museum in the Historic Dockyard, Chatham where over twenty-five lifeboats are displayed, all having served operationally around the UK.

The Medway's Own Lifeboat

It is not widely known that just a few years ago the Medway had its own lifeboat sitting on Thunderbolt Pier at Chatham's Historic Dockyard. Nineteen tonnes of genuine shiny orange and blue RNLI (Royal National Lifeboat Institution) lifeboat: 44ft long, fully equipped and ready to go. Except that this lifeboat was not allowed to go out on a rescue!

The vessel was, and still is, part of the remarkable collection of veteran and vintage lifeboats of the RNLI National Lifeboat Museum located in Chatham's Historic Dockyard. However, it was the only lifeboat in the collection that was afloat and in a fully operational condition. It was also the only lifeboat displayed that didn't have a name, just the number 44-001 where usually would be written the name of the benefactor or sponsor for that vessel.

Lifeboat 44-001 is unique and, surprisingly for a UK lifeboat, not even British. She was built by the US coastguard and purchased by the RNLI in 1964 to evaluate a fast boat concept as part of trials to find a replacement for the slower lifeboats of the time. The trials were a great success: with a top speed of 16 knots, 44-001 was nearly twice as fast as any other British lifeboat. It was also self-righting and proved more than capable of handling the worst seas around Britain, and as a result the design was adopted. Twenty-two of these vessels were built in the UK, many at Lowestoft where the nearby River Waveney provided the class name for the boats. Ironically,

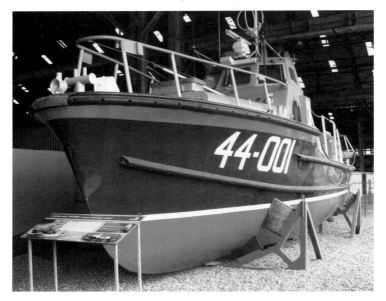

Lifeboat 44-001, now permanently ashore as part of the Royal National Lifeboat Institution's museum at Chatham Historic Dockyard. Based on the US Coastguard's high-speed rescue boats, 44-001 was built in the USA for the RNLI as a prototype to assess the potential for fast craft, a design later embodied in the Waveney class lifeboat.

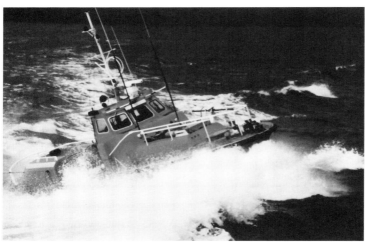

44-001 answering a distress call. Following her use to assess the potential for fast craft, 44-001 was placed in the RNLI's reserve fleet, for use when a lifeboat might be temporarily withdrawn from service for major repair or annual maintenance.

44-001's last crew, all volunteers from the Medway area. Part of the RNLI Museum collection, the craft was maintained and manned in a fully operational condition before financial constraints resulted in her being brought ashore to become a dry exhibit.

44-001 was never deployed to a station, but instead was retained as a relief lifeboat. Nonetheless, when on relief duties she still was responsible for saving many lives. The last Waveney was built in 1982 when the class began to be replaced by more modern craft, although 44-001 remained on relief call until 1996.

At the end of their working life, most RNLI Lifeboats are sold, some to other countries for rescue work – many have recently gone to China and their local crews have been trained by the RNLI. Other boats are acquired by private owners, keen to possess a boat that has undoubted sea-keeping qualities. As the first of the fast boats, 44-001 was retained and, with special funding from the RNLI's public relations department, was transferred to the RNLI museum which was then in the process of being set up in the Historic Dockyard. Not only was 44-001 the only exhibit that was afloat, she was also the only lifeboat in the UK that was in operational condition and permanently open to the public. But 44-001 was not just a static exhibit; she travelled far and wide. For the RNLI's 175th anniversary celebrations she went around to the institution's headquarters at Poole, and each year travelled up the Thames to London for the RNLI awards ceremony. In addition she was a much appreciated and welcome visitor to various maritime events at ports around the south and east coast. It was a credit to her design and the RNLI's thorough maintenance that she was able to demonstrate that she could perform as well as when first launched some forty years earlier.

In service the Waveney boats operated with a crew of five, and although part of the museum's exhibits, 44-001 was similarly manned. The crew were all volunteers and most were from the Medway area. People like printer Dave Cox and electronic engineer Ken Sandicock, both from Gillingham, and Keith Parrot, a recently retired draughtsman. The only non-local crew member was coxswain Steve Reynard, a communications manager from Essex, but all were members of the RNLI's informal Enthusiasts Association, and all had been fully trained and equipped by the RNLI as would a fully operational lifeboat crew. However, despite 44-001's pristine condition, the lifeboat and its crew were not allowed to embark on any rescue missions and a sign sometimes appeared on the wheelhouse entrance stating 'not to be used for rescues'. Of course, everyone knew that if they encountered an incident when on passage, it was highly likely they would render assistance and on one occasion, when underway in the estuary from London to Chatham, they went to the aid of a yacht in distress. The crew were (very mildly) reprimanded by the RNLI for this action, but crewman Dave Cox had memories of his own rescue from his sinking yacht by the Eastbourne lifeboat many years earlier and he knew only too well the anguish that the yacht crew would have been suffering. Like quite a number of RNLI members, it had been his own rescue that led Dave to train and become an active lifeboat crewmember.

Lifeboats are not only popular with sailors in trouble; people who never go to sea are equally interested in looking at lifeboats, and 44-001 provided the public with a rare opportunity to see one of these remarkable vessels at close quarters. The trim craft was one of the most popular exhibits at the museum despite being berthed a short distance away on Thunderbolt Pier. But a serious problem arose and it led to the end of 44-001 as Britain's only lifeboat that was afloat and open to the public.

The RNLI charter requires that all monies received be used only to further the saving of lives at sea by purchasing and maintaining active boats and training the crews. The RNLI's lifeboat museum had been established as a result of funding from the Heritage Lottery Fund and Maritime Heritage and was a one-off payment that did not cover ongoing maintenance. 44-001 was not an active lifeboat and technically could not be funded by the RNLI so its

continuing survival and work in publicising the RNLI was down to the hard work of the local crew and support to maintain the vessel. It was a difficult task, as all operational lifeboats including 44-001 are required to have a regular marine MOT to ensure they remain in a first-class seaworthy condition. Therein lay the big problem for 44-001.

Most motor boats have a drive shaft to the propeller which passes through a special seal that permits the shaft to turn whilst keeping the water out. By 2002, 44-001 needed a very urgent expensive replacement of both shaft and seal, and the cost was way beyond that which might be raised quickly from local sources. Due partly to its charter and financial pressures on other aspects of its operation at the time, the RNLI could not assist. Unable to fund the necessary work, the lifeboat could not remain afloat and despite many attempts to source funding or sponsorship, all were unsuccessful and there was no alternative but for 44-001 to become another static exhibit in the museum.

With much sadness and the realisation that she would probably never again return to the water, 44-001 was given a premier location in the lifeboat museum where she remains to this day. Now similarly retired, most of her final crew are on duty in the museum on most days and are happy to provide a first-hand account of what it is like to be on a shout.

So the Medway towns lost their only floating lifeboat, although 44-001 can still be seen at the RNLI museum in the Historic Dockyard – with the sign 'not to be used for rescue' now a permanent fixture on the wheelhouse!

Dedicated to Saving Lives

Watching any of today's large powerful lifeboats in action, it is hard to realise that from 1824, when the Royal National Lifeboat Institution was established, until the early 1900s, lifeboats were either rowed or sailed. There were some unsuccessful trials with steam engines but it was the invention of the internal combustion engine that finally convinced everyone that the days of sail and oar were numbered. However, first there were to be many trials with experimental boats and engines, interrupted by the First World War, and it was not until 1922 that the RNLI introduced their new and revolutionary Barnett motor lifeboat. That very first prototype Barnett is now privately owned by a former BBC foreign correspondent, Alexander Thomson, who has restored the historic lifeboat to her original appearance, and in 2002 brought her to the Medway where she berthed at Chatham Maritime.

In the 1920s the performance of prototype vessels was rarely evaluated in a detailed fashion during long periods of extended trials as they usually are today, but instead, after some short basic tests, went into service where how they performed was assessed whilst they were operating in real situations. The prototype Barnett lifeboat was no exception. She was named *William & Kate Johnson* after the benefactors who had funded its construction, and made ready for operational service. The vessel was considered to be the RNLI's most prestigious lifeboat, so before going on station, *William & Kate Johnson* was taken on a 2,000-mile trip around the UK. Officially the aim was to show her remarkable features to other lifeboat stations, but perhaps more importantly there was more than an eye on the public and wealthy sponsors whose donations the institute depended on.

William & Kate Johnson incorporated many features that later became standard on many craft, particularly lifeboats, which were likely to be required to operate in arduous conditions. The propellers were placed in tunnels for protection and the engines were housed in separate

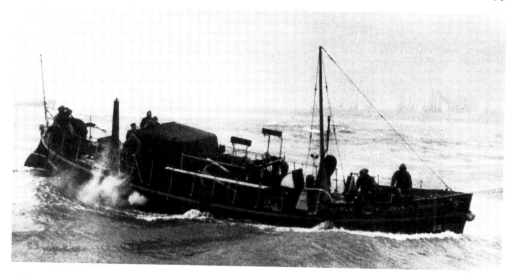

William & Kate Johnson, the original Barnett lifeboat of the RNLI, returning to New Brighton in heavy seas in the 1920s after launching in response to a distress call. (Courtesy Alexander Thompson)

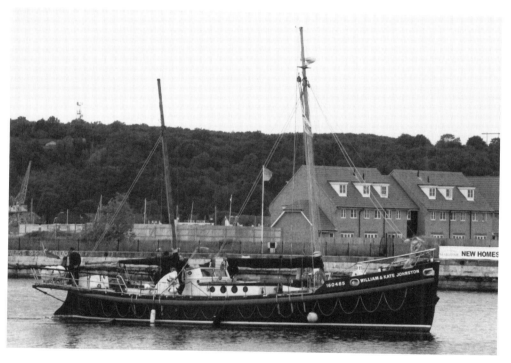

William & Kate Johnson at Chatham in 2002, following completion of an extensive restoration to her external appearance when in service.

Alexander Thompson on board *William & Kate Johnson*. Immense satisfaction from dedication to a part of Britain's maritime heritage.

watertight compartments. There were searchlights, a line-throwing gun and a jump net fitted above the deck to catch those leaping from the deck of a stricken vessel. For the first time in any lifeboat there were cabins for the crew and those who had been rescued, with a galley to provide hot drinks and even a screen to keep at least some of the sea from swamping the helmsman. She could carry up to 120 people in bad weather.

The year following her grand tour in 1922, *William & Kate Johnson* took up permanent station at New Brighton on the Mersey, and she was soon busy saving lives. The approach to the Mersey and Liverpool is hazardous, with shifting sandbanks and strong tides, and it was these conditions that 200 years earlier had prompted the Mersey Docks Board to establish Britain's first organised lifeboat service – fifty years before the RNLI was formed. However, by the 1900s, the RNLI were well established at New Brighton and the most up-to-date lifeboats were always placed there at the entrance to what was then Britain's busiest port. *William & Kate Johnson* replaced one of the few steam lifeboats, and in the next twenty-seven years she was involved in a great number of daring rescues, earning many medals for her crew, including the French Gold Bravery Medal for one particularly courageous rescue.

In the early years of the war the vessel's capacity to accommodate survivors was put to the test. In November 1939, 103 people were rescued from the steamship *Pegu*, and just a few months later the lifeboat brought 107 sailors from HMS *Whirlwind* safely ashore.

By 1950 *William & Kate Johnson* was nearly thirty years old and after ninety-four launches that had saved nearly 400 lives, was still one of the institute's favourite lifeboats – but the time had come for her to be replaced. At a sad ceremony, attended by three of the crew who had first manned her in 1923, *William & Kate Johnson* handed over to her successor – a new, modern Barnett lifeboat. *William & Kate Johnson* was stripped of her engines and specialist equipment and sold to a private buyer who promptly changed her name. Converted to a motor yacht, over the next four decades she had several owners. In the early 1990s the vessel was extensively renovated and moored on Teeside close to the famous hanging transporter bridge that had featured in the *Auf Wiedershen* television series in which the bridge was allegedly sold and rebuilt in America. It was here that Alexander Thomson acquired the lifeboat and decided she should be restored, at least externally, to how she had been in service. So, once again, the vessel became *William & Kate Johnson*.

A cut-away drawing from a magazine in the early 1920s illustrating the many innovative features of a new Barnett lifeboat. (Courtesy Alexander Thompson)

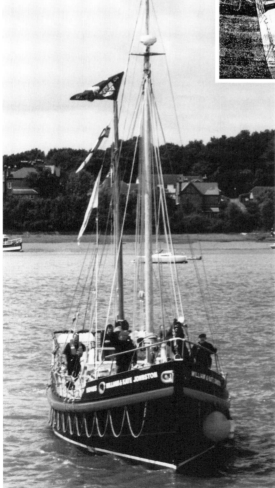

William & Kate Johnson setting sail from Chatham bound for a maritime festival. The veteran lifeboat has become a regular visitor to events in Britain and Europe.

William & Kate Johnson was built at the yard of J. Samuel White at Cowes on the Isle of Wight. White's had a long tradition of building tough and uncompromising vessels for the RNLI and the Royal Navy (they also built the Royal Navy's Second World War Destoyer *Cavalier*, now permanently displayed in Chatham's Historic Dockyard). *William & Kate Johnson* now has a double diagonal skin of teak with transverse and longitudinal steel bulkheads that originally formed no less than fifteen sealed watertight compartments, making her virtually unsinkable. Displacing 44 tonnes, she is 6oft long with a beam of 15ft, and originally had two paraffin motors. More recently she was fitted with two powerful but smooth Ford diesel engines. But why does somebody buy a lifeboat?

Alexander Thomson is a tall man with a huge presence, plus an enormous respect for our heritage. This is probably a natural result of his having spent much of his working life reporting for the BBC from some of the world's most desolate and isolated places in Africa and the Far East. As he admits, 'from afar one can better appreciate and see the need to hold on to those things that have contributed to what we are and the way we live today'. Alexander is now a freelance correspondent but he still spends a considerable time in Singapore, one of the busiest cities in Asia, and with the busiest port in the world, but throughout his career he has always enjoyed the quiet relaxation that boats can offer. He was looking for a boat on which to relax when he was in the UK, but it had to reflect craftsmanship and old-time values which were certainly applied to building vessels like lifeboats, and are qualities that can still be enjoyed today. Hence, when looking for a suitable boat to purchase, *William & Kate Johnson* ticked all the right boxes for Alexander.

Having acquired the vessel and had her renamed, some necessary repairs were urgently carried out. Most importantly a berth had to be found that was not too far from Alexander's London home and which would also offer a degree of security when Alexander was away. Several options on the Thames were considered but the costs were prohibitive. However, after much searching and negotiation it was found that the Medway could offer similar facilities at an affordable price and *William & Kate Johnson* arrived at her new home.

From the outset, Alexander did not want the lifeboat to be a static attraction but instead wanted her to visit events and festivals and take small groups on trips. Normally, few people who find themselves on lifeboats would be there by choice! But without the stress of having just been rescued, people are able to experience and enjoy the secure feel of a lifeboat and the remarkable handling characteristics of this historic and unique vessel.

Within a few weeks of settling in to her new berth in Chatham, *William & Kate Johnson* was off to Liverpool's Mersey River Festival to celebrate the anniversary of Mersey Docks. Then it was a short journey across the Mersey to New Brighton where former lifeboat men, local residents and the local maritime community recalled many happy and sad memories of the lifeboat's years at the town. Back to Chatham for a while then it was Portsmouth for the International Festival of the Sea, then around to Lowestoft and Ramsgate before crossing to Belgium, France and Holland where local lifeboat crews and enthusiasts lost no time in getting on board.

Despite the convenience of her berth in Chatham, it was soon apparent that the specialist skills needed to maintain the vessel and its unique equipment were not always available in the area and, when they were, the costs could sometimes be prohibitive for a private owner. Reluctantly, Alexander was obliged to seek an alternative berth and, following extensive investigation and consideration, opted for a berth in a Belgian port. However, *William & Kate Johnson* remains a frequent visitor to maritime festivals in the UK and Europe, where she is a great ambassador for Britain and its maritime heritage.

Medway's Inland Coastguards

The term 'coastguard' almost certainly will conjure up images of someone in a tower intently peering out to sea through binoculars, perhaps rescuing a hapless holidaymaker who has fallen from a cliff, or maybe directing a helicopter to pluck a yachtsman from a sinking boat. Mention 'Medway coastguard' and you will probably get a blank stare or a look of pity combined with a derisory comment that Medway is 10 miles from the coast!

Whilst Medway cannot, by any stretch of the imagination, be perceived as being on the coast, the waters of the River Medway downstream of the lock at Allington are nonetheless tidal. HM Coastguard Service is responsible for all tidal waters, which means 22 miles of the River Medway from the Medway Buoy just off Sheerness to Allington Lock. Medway even has a coastguard station, although it is located in the middle of the City Industrial Estate on the Frindsbury Peninsula.

Medway coastguard station has eleven coastguards; everyone is a volunteer and all are trained to the same high standards as their full-time colleagues. Each can expect to spend up to ten hours a week on patrol or at the station, but everyone carries a pager and is on a twenty-four-hour call rota. Medway's senior coastguard is Bob Hall who lives in Strood. Bob has many years' experience and, in addition to organising the optimum deployment of his team, is responsible for their training, the routine and on-site risk assessments to ensure the team's safety at all times. It is a tough task requiring fast but vital decisions, often with little information available.

From their inauspicious and unpopular creation in the early nineteenth century, when assisting ships in distress was secondary to helping the Revenue prevent smuggling, the coastguards have developed into one of Britain's most versatile emergency services. The Medway base links through the Whitstable station to Walton-on-the-Naze, which is part of an eastern operations region that stretches from Hull clockwise around the coast to Portland, and the service can call upon some impressive resources. Now integrated as the Marine and Coastguard Agency, the service is also responsible for carrying out safety checks on vessels and ensuring that everyone on board a ship, including the captain and key officers, are properly trained and qualified.

Anyone doubting the need for a coastguard service on the Medway need only look at the record of incidents. Each summer there are at least twenty-five calls for assistance. These range widely from boats that are drifting with engines that have broken down or are aground, missing persons, including wildfowlers lost on the marshes, people trapped by the mud and calls for medical assistance required urgently on a boat in the river. One of the most frequent calls received will concern a jumper – someone who has decided that, for whatever reason, he or she is about to launch himself or herself off Rochester Bridge. The coastguards work with all the other emergency services, such as the Royal National Lifeboat Institution and the Fire & Rescue Services, plus the environmental agencies. It is often only the coastguards who have the ability to rapidly reach someone out of reach of land, and the knowledge of how to tackle the vagaries of dangerous tides and currents.

One of the most hazardous jobs is to rescue someone trapped in Medway's treacherous mud. It is easy to become lost or disorientated on the marshes downriver and a single wrong step can often result in an inability to move – not a happy position to be in if the tide is rising. Even worse, parts of the marshes have deep wartime bomb craters where, decades later, the mud has become a pool of slurry from which it is impossible to crawl or swim. Medway's coastguards are well aware of the problems of mud: they know the local danger spots and use a combination of well-tried standard equipment and some they have made or adapted themselves to suit local

Mud-platens – the mud version of a snow-shoe, developed by Medway coastguards to move relatively quickly and safely across the Medway's often treacherous mud.

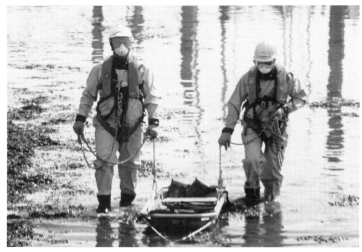

Medway coastguards bringing a mud-sled ashore after an exercise. The sleds are used to move equipment and/or people who have been rescued.

One of the Medway costguard rescue teams, based at HM Coastguard station on an industrial estate at Strood – inland and without a view of the river!

Bob Hall, senior officer at the
Medway Coastguard station,
directing one of his teams during
a rescue on the river.

conditions and requirements. Because mud rescues can be difficult, it is one of the techniques the local team practice frequently.

In most mud rescue situations on the Medway, the coastguards have found it to be safer and more effective to operate in small teams. Picking a route across the ever-changing and danger-ous mudflats requires enormous concentration and those on firm land need to be fully in tune with the movements of the person out on the mud. The only way to gain the confidence and experience needed for such work is by practice out on the mud, so every weekend the teams carry out simulated rescues along the most dangerous areas of the river. These aren't for the faint hearted. On mud the risks are ever present and unpredictable and a wrong movement could be fatal.

A team usually comprises four persons. One of Medway's typical coastguard teams is led by Bob Hall and includes Graham Tassell from Strood, who is also a member of Gravesend's volunteer lifeboat crew, so he has a useful awareness of the co-ordination needed for rescue involving those afloat as well as on land. Robert Armitage-Walker is a security manager who lives in Gillingham and David Fry, a technical manager from Meopham and a relatively new coastguard, completes the team. Like other volunteers to any of the emergency and rescue services, all are committed to saving lives and, when called, will respond without hesitation. On receiving a call, the team quickly assembles at the coastguard station and without delay will be on their way, usually kitting-up in the 4x4 truck en route to the emergency whilst being briefed by radio.

Whether in the heat of midsummer or in the freezing depths of winter, the team will don full kit. With safety of paramount importance, and recognising that mud can also be home to

a lot of unpleasant and sometimes fatal germs, first on is an all-in-one lightweight rubber suit with an elasticated neck, wrist and ankle grips – the world's toughest and biggest condom, as the team refer to it! Then two pairs of gloves, a helmet, mask and a six-point full body harness to which a rescued person can be attached. Finally, a two-way radio is attached, enabling the entire team to talk to each other at any time.

On arrival at the scene, the team leader will make a rapid risk assessment whilst the team prepare the equipment ready to send one or two of them out on the mud with a 'mud sledge'. Similar to a stretcher tray, the sledge can accommodate a casualty or provide a safe rest point for a rescuer. It is equipped with folding shovels and a first aid kit, and it is permanently attached to the harnesses of those out on the mud. There is just one extra piece of equipment: mud pattens. These are simple wooden moccasins with steel heel clamps that are strapped to the boot to provide a remarkably stable platform which, with practice, enables rescuers to walk with comparative ease and safety on the surface of quite soft mud.

From the highest vantage point available (which on the Medway mudflats might well be the roof of the coastguards' 4x4!), the team leader will co-ordinate rescue, directing fully-kitted members of the team as they go on to the mud. Meanwhile, another member of the team, taking the role of winchman, will have initially set out the various safety lines and with his colleagues out on the mud, will be making sure their safety lines do not snag and remain taut. When reached, the victim will usually be installed safely on the sledge and accompanied by one of the rescue team, then be brought back to firm ground and safety. To make recovery as fast as possible, a portable motorised winch can be attached to the line to get the sledge ashore as fast as possible. Meanwhile, the 'mud walkers' will carefully return to firm ground with their rubber suits invariably covered in the Medway's glutinous black mud. The amazingly well-equipped mud rescue trailer that is towed by the truck allows for this with water containers and a pressure washer, so the team's rubber suits (and the team) are soon clean again, and ready to answer the next emergency call.

It is comforting to know that in the event of an emergency on the River Medway, there is a team of trained and well-equipped professionals able to deal with the problems, but Bob Hall and his team would prefer that the situations did not arise in the first place. Educating the public is one of the service's main objectives and, like other coastguards around the country, the Medway team spend much of their leisure time visiting schools and clubs advising people, especially children, on how to enjoy our rivers and coasts in safety. One of the most successful initiatives has been the SeaSmart beach band for children that not only provides immediate identification, but focuses the attention of parents and children to potential dangers and how they can be avoided. Hopefully, education will also help to prevent the hoax calls that, as always, could delay attention to a genuine emergency.

Meanwhile, cars can still be driven into the river, people will get lost on the marshes, irresponsible yachtsmen will still fire flares in celebration and people will still threaten to jump off Rochester Bridge. But be it a real or a false alarm, HM Coastguard at Medway will always be there promptly, for which everyone should be grateful.

The Coastguard Service

Today's Coastguard Service is responsible for marine search and rescue operations around Britain's 4,500-mile coastline and 1,000 miles out into the Atlantic Ocean – and that is not including the hundreds of tidal estuaries and rivers. It has come a long way since the 1820s when the Government established the service to assist the Revenue crack down on smug-

gling, with assistance to ships in distress or saving the lives of crews and passengers being only a secondary role. One of the reasons for this was that in those days it was not uncommon for people to drown just a stone's throw from *terra firma* as there was little anyone on land could do to reach a stricken ship.

That all changed when George Manley, a close friend of Admiral Lord Nelson, perfected a mortar that could fire a lightweight line from the shore to a ship. The light line was then used to transfer heavier ropes and a pulley to the ship, which in turn was set up to carry people to safety. This was what became known as the 'breeches buoy' – so named because those to be rescued sat securely in a large pair of leather trousers with front and back straps suspended from the travelling pulley. The equipment became standard issue to the coastguard, where it remained in service until the late 1940s, and enabled the service to develop the lifesaving part of their work. By the mid-nineteenth century smuggling had become less widespread and the coastguard had been given an additional role as a reserve force for the Royal Navy, and over 3,000 coastguards served with the navy during the Crimean War. But in 1856 responsibility for the coastguard passed to the Admiralty and the Coastguard Service Act was introduced, with 'better defence of the coast of the Realm' taking priority over attention to smuggling. The coastguard was issued with life-saving apparatus and led the way in coastal rescue, despite the fact that they had no statutory obligation to do so. Until after the First World War the service remained with the Admiralty, during which the range of life-saving equipment and techniques developed in leaps and bounds with rockets and line-throwing pistols, cork lifejackets, cliff rescue belts ropes and stretchers. In the fifty years until 1909, the service rescued over 20,000 people. Local volunteers assisted the service at times; these were the forerunners of today's Auxiliary Coastguard, and the first organised volunteer teams were set up at Tynemouth. In 1914 most coastguards were mobilised into the Royal Navy where they suffered heavy losses. After the war administration of the Coastguard Service was passed to the Board of Trade and became a civilian organisation which today is the principal part of the Marine & Coastguard Agency (MCA), with responsibility for every aspect of maritime safety.

The Coastguard Service is now divided into six major regions, each providing a main rescue centre that is equipped with the latest search and communications technology. These co-ordinate and provide help to the scene of an emergency by the fastest possible means, linking RNLI lifeboats and other rescue services with those of the Coastguard Service on the ground, in helicopters or on other coastguard search and rescue aircraft.

It is a service that has been copied around the world, but the extent of their work and responsibilities is still little known to the public at large, probably because it seems only the odd cliff rescue features in a television news report. Meanwhile, the Coastguard Service quietly maintains its watch around our shores, ready to rescue those who, by accident or their own actions, are in danger. Whether on a boat in distress, cut off by a rising tide or maybe stuck in the Medway's mud, we should all be very thankful that they are there.

Chapter Seven

You've Got to Start Somewhere

Getting afloat is easy in Britain! You don't need a licence or have to pass any examinations to handle the average yacht or motor cruiser – unlike some of our continental neighbours. But getting afloat in safety and with confidence is more difficult.

Years ago, most people learned from someone with experience, assuming they knew such a person, or else had to try things for themselves and hope they survived. But today colleges run courses (although mainly about the theory) and many yacht clubs teach the practical side, hands on, to young people – albeit with parents who are club members. In many areas there is still a gap for those who don't belong to a club or have the funds, but happily for those living around the River Medway, not only do some clubs offer training, but there is a sailing centre plus opportunities for ocean sailing as well. Meanwhile, anyone of a naval inclination has the chance to learn the skills necessary for the Royal Navy or Merchant Service.

Medway's Own Tall Ship

Despite the enormous interest created by tall ships visiting Medway in recent years and the publicity arising from Medway's lost opportunity to host the tall ship races in 2005, the fact that Medway has its own tall ship seems to have been overlooked.

Weighing in at a mere 32 tonnes and only 62ft long, *Morning Star of Revelation* may seem a tad small when alongside the really big square-riggers, but under the international classification for sail training vessels, she is technically a tall ship. What's more, since 1981 she has competed in every major tall ship race – with enormous success.

A Concrete Ship
Launched in 1978, the gaff-rigged ketch was built by Tim Millward, then a teacher at Rochester's Kings School, and who subsequently founded the Morning Star Trust to manage and operate the vessel. From her fine lines, it is perhaps difficult to realise that her hull is made of concrete over a steel framework, but that is a very tough form of construction used for many ships that have circumnavigated the globe.

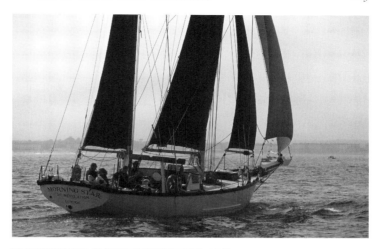

Morning Star departing from her base at Chatham to join another Tall Ships' Race. Since 1981, this concrete-hulled ketch and its young crews (aged fifteen–twenty-five years) have competed evey year in the internation Tall Ships' Races, with great success. (Courtesy Morning Star Trust)

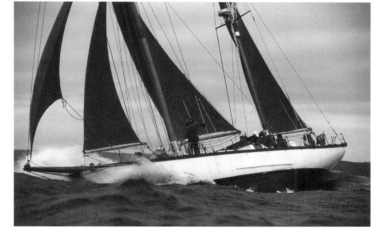

Close hauled and in a lumpy sea, Medway's own tall ship, *Morning Star*, nears the finish of another Tall Ships' Race. (Courtesy Morning Star Trust)

Morning Star returning to her home on the Medway, proudly flying pennants earned from another successful series of Tall Ships' Races.

Above: *Dayspring*, the Morning Star Trust's smaller boat, providing the opportunity for young people to experience short trips afloat on the waters of the Medway.

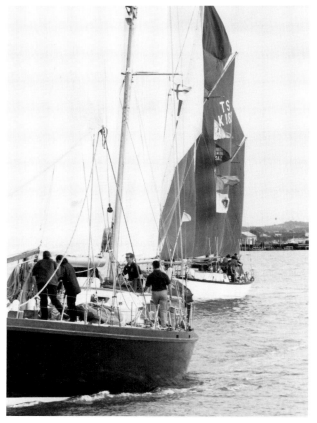

Left: Tall ships *Arethusa* and *Morning Star* returning home to the Medway after the 2001 Tall Ships' Race around 8,000 miles of the Atlantic. In some of the worst weather ever experienced during a Tall Ships' Race, *Morning Star* achieved second place. Sadly, the training ship *Arethusa* was subsequently sold and converted to a private yacht.

The aim of the trust is to provide personal development for young people aged from sixteen to twenty-five. With a professional skipper and permanent crew of two, the vessel can accommodate eleven trainees. *Morning Star* is often described as a breathtaking vessel that captures a small piece of the heart of everyone who has the privilege of sailing with her. Some are won over during a quiet might under the almost unreal bright stars at sea, others by the power of the craft as she confidently heads into rough seas with spray everywhere and the decks awash.

Morning Star can set an amazing 2,300 square ft of canvas and is designed to sail anywhere, in almost any conditions, day and night. With a diesel engine for back up, the vessel carries every modern navigational and safety aid, and skippers and mates are fully qualified to all UK and international requirements. Any young person can apply to sail on *Morning Star*; previous sailing experience isn't necessary and all protective clothes and equipment is provided. Many youngsters are sponsored or subsidised by bursaries and come from all around the UK – some from further afield – but there is also a good sprinkling of young people from Medway. Short trips vary from three to five days, with an option of some exciting longer voyages.

How One Man's Faith Achieved Results

Tim Millward is a quiet and unassuming person to who, in addition to his wife and family, there are two matters of great import. One is his faith as a practising Christian, and the other is sailing. Tim has uniquely arranged that each contributes to the other.

As a science teacher at Dulwich College in the 1970s, Tim spent the Easter holidays afloat on the Norfolk Broads with Christian groups who had found that closeness to the natural elements seemed conducive to helping people become more aware of religious faith. At other times Tim would continue this work, taking small groups sailing on his Wayfarer, a fairly large sailing dinghy, but he realised its limitations in terms of space and range, and decided to build a bigger boat. And bigger it certainly was – a 62ft-long gaff ketch!

Ferro-cement construction was the most economic option – basically a concrete boat which, although seemingly odd, results in a very tough structure that has been used for many craft, from work boats to round-the-world racing yachts. So in 1973, tucked into a corner of London's Royal Albert Dock, Tim began to build the steel frame that would eventually provide a skeleton for the concrete in his spare time.

Five years later, the basic boat was finished and ready to be launched as *Morning Star of Revelation*, which became the first home for newly-wed Tim and his bride Sara. Shortly after Tim took up a new post at Kings School, Rochester, and they moved to Rochester with *Morning Star* still in the process of being fitted out, transferring to a new berth on the Medway at Gillingham. The boat was finally completed in 1981 and that year, with Tim at the helm and a scratch crew from the Combined Cadet Force, *Morning Star* competed for the first time in a leg of the Cutty Sark Tall Ships race to Ostend. They won in their class, having mixed it with the big boys of the tall ship sail training world. A truly remarkable achievement for a newcomer.

By 1983 *Morning Star* and Tim were both busily engaged in sail training such that, with teaching and the arrival of daughter Abigail to the Millward family making increasing demands on Tim's time, something had to go. *Morning Star* had already achieved so much in the development and training of young people that Tim took another step in company with the faith and trust that had helped him through the many problems when building the boat. Tim left the security of teaching to run the boat as a full-time occupation, beginning the process of establishing the vessel as a trust, although it was 1989 before the Morning Star Trust was finally

registered as a charity. Since then over 300 people have sailed with the vessel each year, many subsequently giving their time to help with the many tasks necessary to maintain the boat and dealing with the administrative work at the trust's offices in Chatham's Historic Dockyard.

The objective of the trust is to provide personal development for young people from sixteen to twenty-five. Most activities on board are of a secular nature with a 'thought for the day' (often linked to the day's activities) providing the only spiritual dimension. A typical trip lasts about five days, often beginning and ending at Chatham and usually mixing passage making with pottering and beach barbecues. Longer cruises (often with visits to foreign ports) may be up to two weeks or more for the tall ship races where *Morning Star* is now a respected regular competitor. For young people the trips qualify for the Duke of Edinburgh Award Scheme and many participants often achieve the 'competent crew' qualification of the Royal Yachting Association.

Remarkable Results

Since her first tall ship race in 1981, when Tim and a scratch crew sailed her to Ostend, *Morning Star* has put up some remarkable performances. Bearing in mind that the trainees may have little previous sailing experience, it says much about the teamwork and co-ordination that the skipper and crew are able to infuse and develop in the few days available for preparation before a race. The ship is invariably among the leaders in most races and has acquired a formidable array of trophies.

In 2000 *Morning Star* was away for five months competing in the gruelling 'round-the-Atlantic' Tall Ship Races. Starting from Southampton, there was a short race to Cadiz across the notorious Bay of Biscay, which lived up to its reputation with horrendous storms. Then across the Atlantic to Bermuda and up the US coast, calling at New York, Boston and on to Nova Scotia, before finally back over the Atlantic to finish in Amsterdam. Despite being one of the smallest vessels to compete and up against some of the world's biggest and most powerful tall ships, *Morning Star* achieved second place overall, a truly amazing achievement.

Morning Star has since competed in Scandinavia, across Biscay again to Spain, around Britain and in the North Sea. She began her 2003 season by winning first place in the small ship race to Delfzil in Holland, and was presented with the Aurora Trophy – a piece of silverware so enormous that it had to be brought to Britain by carrier. The trophy was too large to fit on the ship! But the subsequent tall ship races in the Baltic tested ships and crews with everything from dead calms to violent storms. From Gdynia in Poland to the Finnish port of Turku the ships enjoyed light winds, but from the Latvian capital Riga to Lübeck in Germany the appalling weather inflicted serious damage to many vessels. Gale-force winds and boiling seas caused havoc to the fleet with blown sails, broken bowsprits, bent deck-fittings, flooding and severe seasickness. Twenty-five ships out of a fleet of eighty were forced to retire, but thankfully *Morning Star* and her plucky young crew carried on and crossed the finishing line in second place for her class, and eighth overall.

Morning Star's successes in tall ship races have become legendary, and the vessel and the trust are much respected by other tall ship organisations. On one occasion an unnoticed navigational error resulted in the award of a trophy, but Tim discovered their error the next day and promptly returned the trophy to the disappointment of some of the crew. To their surprise, the race organisers subsequently awarded the ship an even bigger trophy to mark their sporting honesty. Hardly surprising that one year there was a tongue-in-cheek complaint from a tall ship they had just beaten that, as a Christian organisation, could it be that *Morning Star* was getting divine help from above?

There can be no clearer example of how one man's faith has achieved what many would regard as impossible. Not only building an ocean-going sailing craft almost single-handedly, but doggedly pursuing the problems of setting up a trust to maintain the aim of providing an opportunity for ordinary folk to taste and benefit from the experience of life on a sailing vessel at a price they can afford. Tim retired in 2005 and now, with Sara, spends time leisurely travelling English canals on a narrowboat. Meanwhile, the trust that he founded continues under the guidance of like-minded and dedicated staff. All are Christians but, as they point out, this does not mean they push their personal beliefs, though if anyone wants to know about it, they are happy to share. No more, no less.

Fact File – *Morning Star of Revelation*
Class III Sail Training Vessel
Launched 1978 at Rochester
Hull: Ferro-cement on steel frames
Gaff-rigged ketch – sail area 2,300 square ft
Length overall: 62ft
Displacement: 32 tonnes
Auxiliary Engine: Perkins 76hp marine diesel
Sleeps 14 in single berths in 5 cabins, fully centrally heated.
Comprehensively equipped with radar and GPS navigational aids.
VHF and MF radio communications.

Winning Young Hearts and Minds

Jason is a fifteen-year-old from Chatham and has been regarded as a 'problem'. An academic underachiever with behavioural difficulties, his school record is pretty bad, and clubs and youth groups claim he is disruptive and reject him. Of course, Jason (not his real name) also rejected everyone, so it seemed inevitable that he would end up drifting into vandalism and petty crime. Then the school decided to send him on a course at the Outdoor Education Centre at the Strand – maybe thinking to pass one of their problems to somebody else for a while, and Jason found himself afloat under sail and part of a team. It wasn't the road to Damascus, but for probably the first time in his life Jason had to depend on others who similarly depended on him for survival – or at least to avoid getting very wet! Jason responded with a confidence and enthusiasm that grew rapidly as the course progressed, but it didn't end there. Within a couple of weeks he turned up at the Outdoor Centre's Saturday morning open sessions having taken odd jobs during the week to pay the fee. Now he is one of the centre's regulars, invariably one of the first to arrive, getting stuck in preparing boats and instilling enthusiasm among other young people.

It may sound unusual but to the staff that run the Outdoor Centre, it is fairly typical of how going afloat can change attitudes. As one of the centre's instructors remarked, 'getting it wrong during a game of football might cost the match and incur the wrath of the rest of the team, but get it wrong when afloat or climbing up a rock face could have a much more serious outcome. That certainly focuses a teenage mind!'

The centre opened in 1985, the result of the vision and dogged determination of a former army physical training instructor. Tom Banks was born and bred in Gillingham and had already

Preparing a boat for saililing at the Outdoor Education Centre based at Gillingham Strand. The centre accepts youngsters from the age of twelve.

The force that is Tom Banks, responsible for creating the establishment that became the Outdoor Education Centre, with his award from the Royal Yachting Association for hard work and commitment to getting youngsters involved in watersports.

commenced an apprenticeship at the dockyard when he decided to join the army and see the world. In 1962, as part of the Army Physical Training Corps (APTC) and responsible for training PT instructors, Tom was based near Kiel, Germany's well-known Olympic sailing centre, where he realised the attractions of sailing as an alternative interest away from conventional PT. Soon Tom was sailing at every opportunity and he lost no time in developing the interest of army personnel in getting afloat.

Leaving the army in 1975 and returning to Gillingham, Tom took up employment at the newly opened Lucas plant but was soon spending every spare moment around the river and estuary. As a former army instructor, Tom was popular with the local sailing fraternity for the advice and help he freely gave to anyone wishing to improve their skills. He would similarly provide opportunity to experience sailing for those young people who might otherwise consider mindless vandalism the only way to pass the time. In 1984, as Tom was helping some children with sailing techniques, he learned from their father, who worked for Gillingham Council, that a piece of land at the Strand owned by the council had just been vacated. Tom realised that it could make an excellent site to set up a sailing centre for local young people and immediately set about lobbying the council, its councillors and just about anyone who might be prepared to support his ideas. Tom's efforts paid off and, in due course, the land was made available. Meanwhile, the dockyard had just closed and there were surplus buildings standing

Young people learning that teamwork is essential when afloat, if only to avoid getting very wet!

A busy day at the Outdoor Education Centre. As some youngsters return to shore, others wait to set out.

empty, including a prefabricated timber building that had been a tailor's workshop. Tom haggled, begged and cajoled, and finally the buildings were given to him, although they had to be dismantled, transported to the Strand and reconstructed. But Tom had kept all his contacts and persuaded the army that dismantling and re-erecting buildings would make a good practical exercise! Before long the centre was finished, with three massive walk-in containers for storage – the result of more haggling by Tom!

Finally, the centre needed some boats. Again, it was the army who assisted after 'persuasion' by Tom to hand over some of their older craft which, with Tom's own boat and some other acquisitions, formed the centre's first fleet. Early in 1985, with support from Gillingham Council, the centre opened and from that day it has been a focal point for sailing activities at the Strand. Hundreds of youngsters have been given opportunities by the centre to learn to sail, handle boats and, of course, all about water safety.

The centre is recognised as one of the south-east's leading sailing centres with accreditation by the Royal Yachting Association and the British Canoe Union. The establishment was transferred to Medway Council when the new unitary authority was created in 1997 and, in addition to the Strand, now operates a still waters site at nearby Cliffe. Canoeing and sailing are still the principal outdoor activities provided by the centre, but there is also archery, cycling and rock climbing – the latter on the rocky outcrops at Tunbridge Wells. Although not strictly

a water-sport, the centre has also taught fishing to children who have suffered serious trauma and are designated to be at risk. That is quite a responsibility for the centre's staff – three full-time, one part-time and a handful of casual session instructors and volunteers. Full-time or part-time, their dedication to ensuring that young people become responsible members of the community and develop outdoor recreational skills is clear to see. They work long hours – many unpaid – yet to the young people who attend the centre, they are constantly cheerful and highly supportive. The centre's success stories include many youths who have progressed to a maritime career in the Royal Navy or the Merchant Service, two have become Olympic helmsmen, others have followed maritime studies at university and one who is now a leading international sailing instructor.

One of the centre's greatest supporters is Kent Constabulary who greatly value the facilities and training provided, which they state encourages personal and social responsibility in young people. As many years ago in Germany Tom had recognised that sailing could provide interest for army 'squaddies', so today the police acknowledge it can provide purpose for otherwise dis-affected young people. One young person who sails regularly at weekends is a sixteen-year-old schoolgirl from Rochester who has already achieved several Royal Yachting Association awards since first attending the centre two years ago. With her interest in sailing encouraged by the centre, she joined the tall ship races to the Baltic last year on board the local tall ship *Morning Star*. Asked what she would be doing if not sailing, the young lady thought for a moment before replying 'I'd probably be in bed doing nothing'. Another sixteen-year-old boy was more forthcoming and admitted that before attending the centre he spent his time 'hanging about doing nothing much' and 'getting into a bit of bother'.

In 2008 Tom was honoured by the Royal Yachting Association for his dedication to intro-ducing youngsters to sailing and water sport. At a special ceremony in London Princess Anne presented Tom with the prestigious UK Community Award for Services to the World of Yachting. The citation read 'for his sheer hard work, commitment and expertise'.

Shortly after his award, and still a driving force behind the Outdoor Education Centre, Tom joined with the staff to battle local council plans to sell off or close down the centre. Sadly, some bureaucrats chose to ignore the proven community benefits and remarkable achievements of the establishment, simply regarding it as an unnecessary expense. The fight for survival continues.

Meanwhile, at seventy-two, Tom has no plans for retirement. He remains as active as ever, working many hours each week – mostly unpaid! But Tom takes it in his stride and is quick to point out that his reward is seeing youngsters who previously had no aims or ambitions turn-ing up in the snow one bleak Saturday in February and asking 'please guv, can we go for a sail?'

Keeping Naval Traditions Alive

Until a few years ago, coming and going from her berth in Chatham Reach every few days was the training ship *Earl of Romney*, a reminder of the days when the *White Ensign* was always to be seen on the river flying proudly from the many Royal Navy ships.

Formerly HMS *Echo*, the *Earl of Romney* was built in 1958 and operated as an inshore survey ship until decommissioned in 1988, when she was acquired, refitted and renamed by the Marine Society. The 189-tonne, 33-metre (106ft) ship was used by the society to provide practi-cal seagoing training at an advanced level for those who intend a sea career or are associated with professional seafaring.

Sent to Sea with Clothes, Bible and Bounty

From the seventeenth century the Royal Navy recognised the value of their officers being properly trained, and cadets at the Royal Navy Colleges were not only taught seamanship, astronomy and navigation, but also mathematics, physics, fortification and gunnery. In those early days most officer cadets came from relatively well-off families and access to the colleges was more difficult for those less fortunate. In 1756 the philanthropist Jonas Hanway founded the Marine Society to encourage men and boys from any part of the social strata to join the Royal Navy. In addition to seamanship and many other subjects taught by the naval colleges, the society also taught English and the Scripture before the trainees were sent to sea with clothes, a Bible and some bounty. During the next 164 years over 70,000 young people were trained by the society for a career in the Royal and Merchant Navies.

In 1976 the society merged with other marine charities which included the Thames-based training establishment HMS *Worcester* and the School of Nautical Cookery which, in its eighty-year life, had trained no less than 104,000 ships cooks.

Concerned at the increasing loss of sea training by recession in the shipping industry, the Marine Society emphasised its commitment to Britain's marine future by developing comprehensive training opportunities and support to those taking up a seafaring career. The Chatham-based *Earl of Romney* not only maintained a naval profile but acted as an indirect ambassador for Medway, introducing many of tomorrows' 'captains of industry' to the Medway towns.

The local connection was strengthened by several permanent crew members living in Medway, such as Chief Engineer Andy Theobald from Rainham who had served twenty-six

Jonas Hanway, a unique philanthropist and founder of The Marine Society that trained boys for the sea and sent them off with clothes, money and a bible. (Courtesy The Marine Society)

The Earl of Romney, first president of The Marine Society, providing contacts and influence to ensure a sound and lasting establishment. (Courtesy The Marine Society)

Andy Theobald on board the *Earl of Romney*, passing on knowledge and experience from a quarter of a century serving with the Royal Navy.

years in the Royal Navy, spending the last three of those years on HMS *Echo*. Andy's retirement from his Royal Navy career coincided with acquisition of the ship by the Marine Society, so his transfer from a service role to civilian role was seamless. Based in Chatham for much of his long career, Andy had served on a number of ships, including HMS *Diamond*, but serving on the *Earl of Romney* enabled him to indulge his two passions – marine engineering and training future seafarers. Andy reckons that he has had a hand in training about half the 14,000 or so persons who had been on the ship since she was first commissioned by the society.

The ship operated with two permanent crews, serving mostly on alternate weeks, with willing help for occasional maintenance from some of the many ex-navy people living in Medway. Weather permitting, the ship visited many ports around the south-east and across the Channel, but in the summer extended her range to include the West Country and Channel Islands. A popular visitor to every port, the *Earl of Romney* always presented a true shipshape appearance thanks to the permanent officers who could, in only a day or so, transform raw trainees into a competent and able crew.

The Marine Society

For over two centuries the Marine Society has provided guidance, life-long learning opportunities and support for over 6 million professional seafarers. In 1786 the society commissioned the first pre-sea training ship in the world and pioneered nautical training for boys, purchasing the merchant ship *Beatty*. Converted to a training vessel and renamed *The Marine Society*, she was moored on the Thames and replaced, in turn, by four ex-Royal Navy warships. In 1862

Andy Theobald preparing the *Earl of Romney* for sea with the same enthusiasm he showed as a lad when he joined the Royal Navy.

the society was loaned HMS *Warspite* following her withdrawal from service and the name was retained, then passed to three other ships. The last was closed in 1939 and broken up for scrap in response to the wartime 'Steel for Victory' appeal.

In the 1980s, with few training opportunities for Merchant Navy cadets, the society decided to commission a small vessel primarily to provide seagoing training, acquiring an ex-Royal Navy survey ship and equipping her as a training vessel, renamed *Jonas Hanway*. The ship was an instant success, leading to the acquisition of a further ex-naval survey ship, HMS *Echo* that, in 1985, became the *Earl of Romney*. Both ships trained thousands of young people, usually in groups of twelve with two adult instructors for courses of up to seven days' duration. Running of the ship was in the capable hands of a master, mate, two engineers and a chef, and her voyages extended from the shelter of the Thames and Medway to the east coast or over the Channel to ports in France and Belgium. In 1996, with the demise of the National Sea Training College, the two ships moved their base to Chatham – an appropriate location as Jonas Hanway's brother, Captain Thomas Hanway, had once been the commissioner of Chatham Dockyard.

Sadly, the heavy financial burden placed on the society's assets by operating two training ships without any outside support took its toll and in 1997 *Jonas Hanway* was returned to the Royal Navy for disposal. But the *Earl of Romney* continued to operate from Chatham and in 2000 had a major refit extending her life expectancy a further eight years. However, by 2004 the society found it could no longer sustain the erosion of funds needed to operate a training ship at a price affordable to the average trainee, and the much-loved forty-six-year-old little ship was sold. During her sixteen years flying the society's flag, the *Earl of Romney* had steamed 165,000 miles and spent 3,400 days at sea. She had been involved in several rescues of yachts and small vessels, attended two 'Festivals of the Sea' and many regattas including Cowes Week – and was welcomed wherever she went.

The *Earl of Romney*, formerly HMS *Echo*, at her berth on the River Medway close by the Historic Dockyard.

Always smart and well presented, the *Earl of Romney* at sea.

In 2004 the Marine Society, whilst still retaining its individual identity, amalgamated with the Sea Cadets to develop and share the unique maritime training facilities of each organisation. In the summer of 2006 a £2.65 million appeal was launched by the society in the presence of the queen to enable commissioning a new vessel to replace the *Earl of Romney* and join the Sea Cadets' training ship *John Jerwood*.

For many of these young people, especially those from more deprived backgrounds, the ships offer a voyage of adventure and personal discovery out of which may come a more confident and self-reliant individual who is more than capable of coping with the pressured and stress of modern life. The vessels also enable them to discover more about the coast and ports of our island nation, seafaring as a whole and, more importantly, instilling a love of the sea whilst fostering good citizenship. These young people often, as a direct result of this experience, feel inclined to pursue a maritime career either on or off shore.

Today's seafarers find that the society's College of the Sea levels the educational playing field by ensuring that they have the advice, support and access to similar learning opportunities as are enjoyed by their counterparts ashore. This is achieved through the provision of educational support programmes which includes distance-taught packages tailored for seafarers and maritime professionals, a library and news service to ships throughout the world; financial support to UK seafarers plus expert impartial advice and guidance on all aspects of life at sea. Jonas Hanway's aims are maintained by the society today, and they are as relevant as they were in 1756.

A Popular Philanthropist

Jonas Hanway was born in Portsmouth in 1712 and while still a child his father died and the family moved to London. Jonas was apprenticed to a merchant in Lisbon, and by the age of 30 he had become a prosperous businessman, setting up trade links with St Petersburg which, in turn, led to travel across Russia to Persia. The return journey was beset with problems that included illness and attack by pirates but he finally returned to London, where writings about his travels made him wealthy and he devoted himself to philanthropy.

He founded the Marine Society to 'keep up the supply of British seamen', and was also instrumental in establishing the Magdalene Hospital for 'penitent prostitutes', and later pioneered an improved system for recording births. In 1762 his former trading skills were revived when he became commissioner for victualling the Royal Navy.

He was the first Londoner to carry an umbrella, but was hated by the hackney carriage drivers for his outspoken and temporarily successful efforts to outlaw tipping, and later became involved in controversy with the renowned Dr Johnson for deriding those who spent their days drinking tea. Jonas hated exploitation and towards the end of his life campaigned against the use of young boys as chimney sweeps. Surprisingly, he also advocated solitary confinement for prisoners and, for reasons that were never known, opposed immigration by Jewish people.

Jonas never married and died in 1786. He is buried in the crypt of St Mary's Church, Hanwell, London.

Medway's Busiest Boat Enthusiast

Medway's river users watching the popular television series *Scrapheap Challenge* would immediately identify the face or at least the shiny bald pate of Paul Mara, one of the busiest people on the Medway. The Channel Four television programme sets two teams the task of creating

Paul Mara – training water police, setting up a film sequence or judging a television contest is all part of a day's work.

One of the powerful RIBs operated by Guardian Marine Agency, the marine training company founded by Paul Mara.

from scrap yard junk the means to complete a challenge, which often requires the construction a boat or raft to race, or maybe even sink the other team's vessel. Paul is advisor to the programme about nautical matters and marine safety, and is frequently also a judge to determine which team is declared the winner.

Whilst this might seem an odd way to spend one's time, it was just another routine 'marine' job for Paul, the person that many film and television companies call when they want to do something afloat. From drama to documentary, if it's on or around the English rivers or coasts, and there is a boat in view, then it is a fair bet that it would have been set up by Paul, and he might even be at the helm, albeit heavily disguised. Much of this work involves coaching the performers, setting up the camera boats and ensuring all the safety aspects have been covered, so when the director shouts 'action', there are no unexpected thrills such as a leading lady falling off a boat as it accelerates away!

Television programmes that have called on Paul's expertise include *Prime Suspect*, *Ultimate Force* and *The Lost Prince* – one of BBC television's most thought provoking dramatised documentaries. One production that did not involve Paul was the James Bond film that included a spectacular speedboat chase down the Thames. This exciting sequence created so much interest that an entire television programme was made recreating the scenes, which were all set up by Paul who also drove some of the boats.

Another programme that Paul was involved with was quite bizarre: he was asked to provide river sequences for a documentary about the attempted diamond heist from the Millennium Dome, when the thieves escaped down the river by boat. In the effort to get 'just the right shots', it was suddenly realised that Paul had made more practice runs than had the crooks before the actual robbery!

But television and films are only a part of the work carried out by Paul, who set up Guardian Marine Training Services, based at the MDL Chatham Maritime Marina. As the name suggests, training in marine activities and safety is a major part of the work and the company even trains the trainers, with several police forces from across the south of England using the company to teach their officers boat handling. The company also works closely with the Maritime Safety Agencies, port authorities and various Thames river operators to ensure that crews on the river buses and trip boats are fully trained in the safety management systems that were introduced following the tragic *Marchioness* disaster on the Thames ten years ago.

Although he had an interest in boats from an early age, Paul followed the family tradition and began his career in the paper industry before setting up a business ran from his garden shed, producing printed and embroidered shirts. Realising that customers don't just turn up, Paul was soon proactively marketing around the country with a purpose-built trailer display unit, and order quantities went from a handful to hundreds of garments as the company prospered. The shed was soon exchanged for business premises, and then a larger factory as the company invested in the latest sophisticated machinery to became a major wholesaler of custom identified garments. By the mid-1990s Paul's company had picked up a selection of prestigious accolades including a Business of the Year award and, in the process, created numerous local jobs in the Medway area.

Despite the pressures of the business, Paul devoted much of his spare time to maritime training, acquiring top qualifications with Royal Yachting Association and others. But the business didn't give him much time to get afloat so in 1999 he sold the company, set up Guardian Marine Services, and put his time and considerable energies into sea training and matters maritime.

Paul frequently helps organisations involved with young people, not only with boating, but in other community projects, which is how he acquired his trademark shiny head that leads to his often being mistaken for the swimmer Duncan Goodhew. Some years ago, helping to clear some wasteland to create an adventure area for young people, Paul was accidentally in the path of a spray of strong weed killer and a few weeks later had lost all his hair, which has never re-grown! Happily, there were no other side effects, although a cap or hat seems to be *de rigueur* during a cold spell. Paul is remarkably sanguine about the matter, claiming that it saves on haircuts and that he never 'looks windswept'.

One of the craft Paul uses for powerboat training is a large and very powerful RIB – a combination of a rigid boat hull with an inflatable side collar, driven by an enormous outboard engine. Highly manoeuvrable and able to outrun most private pleasure boats, Paul uses this boat, which is capable of reaching many of the south-east's ports and a few across the Channel reasonably quickly, if not in the greatest luxury, for what he calls his 'offshore relaxation'. But he does not have many problems finding comfort if it is needed. Paul is in great demand to deliver large luxury motor yachts to a variety of destinations that in recent years have included Corsica, St Tropez, Gibraltar and other Mediterranean ports, in addition to the more mundane (and rain-soaked) harbours in Holland and across the Channel. If that wasn't enough, Paul also manages and skippers the private yacht of a former government minister – whose name is a closely guarded secret! Between all these seemingly glamorous trips, thirty-eight-year-old Paul and his wife Helen (who is not a great boating enthusiast) live quietly in Strood, not too far from the river.

Paul is one of the river's 'characters' and, like others who work on the river and along its banks, does all he can to encourage people to get afloat and those already boating to come to the area. A few years ago, he offered to provide a welcome arrangement for leisure craft visiting the river, combined with a monitoring service, maintaining a watch on the facilities and advising the relevant authorities when attention was needed. Sadly, Paul's suggestions were not taken further. Paul shrugs off any disappointment he may have had, explaining that at least it ensures that he has more time to enjoy his boating!

In 2005 Paul was appointed the Royal Yachting Association's chief powerboat instructor, responsible for the development of training skills throughout the UK. The RYA is probably the world's leading authority on boating, and Paul represents the UK at many international events and conferences. On joining the RYA, Paul sold Guardian Marine Training Services (which continues to provide marine safety training in the south-east) but still lives locally and retains his contacts on and around the Medway. Whenever time permits Paul enjoys 'keeping his hand in' with the 'grassroots' of the marine business by assisting with training and promoting the development of boating opportunities for local youngsters. Paul is open minded as to how people choose to take their leisure afloat – provided they do so with regard for their own safety and that of others. Unmistakable on the river with a bright red sailing suit and his shiny pate, Paul is undoubtedly a true champion for every aspect of boating, from racing in sailboats to leisurely cruising in luxurious gin palaces.

Chapter Eight

Preserving Maritime Heritage

An 'interesting winter project' is the term used by the 'Arthur Daley' salesmen of the marine world to describe a small derelict boat which will in all probability require a lifetime of winters and a small fortune to restore. But that's nothing compared to the problems faced by anyone contemplating the restoration of a ship that is part of our maritime heritage.

Most of such vessels in need of restoration require much more than the enthusiasm of one man and his dog. They need substantial funds to enable the work to be professionally carried out with adept project management, and this costs money – a lot of money. Central Government doesn't really want to know, local government probably haven't got any spare cash and the commercial sector will usually want to see a positive and fairly fast pay-off plus other tangible benefits. Museums are inevitably strapped for cash and true philanthropists are hard to find – and even harder to convince! The remaining possible sources include the Heritage Lottery Fund – taking a chance with tens of thousands of equally worthy causes; or various European Union funding schemes, with a minefield of requirements and complex applications. It is very complicated and time-consuming with no guarantee of success at the end.

Those who do take up the gauntlet are a very special and dedicated breed. Many invest their own time and money, with little encouragement from government or those who should be supportive, yet they persevere with hope and remarkable determination. Some fail but others succeed, providing living history for future generations.

History Rescued by a Colonial

New Zealand business entrepreneur Owen Palmer was on holiday in the UK in 1995 with his English wife Sally and was idly browsing through a boating magazine when he noticed that the Port of London (PLA) was offering its ex-harbourmaster's launch *Havengore* for sale. Like many colonials, Owen knew Britain's recent history perhaps better than many in Britain, and realised this was the vessel that thirty years earlier had been seen on film and television around the world when it had borne the coffin of Sir Winston Churchill along the Thames during the famous man's state funeral.

With only a day before he was due to fly to Australia, Owen promptly telephoned the PLA, and a few hours later he and Sally were on the Thames at Gravesend inspecting *Havengore* – sadly in a poor condition following her retirement from service a couple of years earlier. Shocked that nobody in Britain seemed to care about the nation's maritime heritage, Owen was determined that the vessel should be saved and immediately submitted a tender for purchase before rushing to Heathrow for the long flight to the other side of the world. A month later, on a warm autumn evening in Canberra, the telephone rang. It was the PLA who cheerfully informed Owen that the *Havengore* was now his, adding that it was now uninsured and, also, would he please move it from their mooring!

With heavy business commitments, it was some weeks before Owen could snatch ten days in Britain. However, during that time he had *Havengore* slipped from the water, checked to satisfy insurance requirements and re-launched. There were some rapid negotiations with the Government Development Agency English Partnerships and as a result Owen was offered and gratefully accepted a secure berth in one of the former dockyard basins at Chatham Maritime. Returning to Australia, Owen and Sally thought long and hard about what they would do with such a famous vessel, eventually deciding on the establishment of a trust to handle restoration of the craft and its future. Owen and Sally were particularly keen to pursue a scheme whereby young people might be encouraged to appreciate and better understand history and heritage, and they felt that with its Churchill connection the *Havengore* would be an ideal means to realise their aims. At the same time Owen and Sally decided they would move to England for a few years to administer the project, and early in 1997 they arrived in Chatham and the restoration of *Havengore* began in earnest.

Slowly the magnitude of the project was realised. Although basically sound, *Havengore* was in a sorry state with cracked paint and varnish, broken portholes and missing fittings. Nearly everything was filthy and rusting. A lesser person might have given up there and then, but Owen is a very determined character and he quickly assembled a team of craftsmen who, working twelve hours a day, stopped the rot and the leaks before beginning the serious refurbishment. A small workshop in the adjacent Historic Dockyard was acquired and more staff taken on so by the end of 1998 *Havengore* was beginning to recover some of her former glory. One of the biggest and most urgent of the problems was to stop the deck leaks. This entailed removing, re-caulking and refitting the entire deck, with over 6,000 screws to be taken out and replaced by hand, followed by the replacement of other rotting timbers in the superstructure. The exterior was finished in 1999 but there was much outstanding work to be completed on the interior and the two powerful Gardner engines.

Owen may have been disappointed at the lack of interest in Britain, but soon he was getting calls from various International Churchill societies around the world and many of their members were turning up on the quayside at Chatham Maritime, frequently accompanied by a film or television crew. *Havengore*, Chatham Maritime and the Medway were becoming known internationally. At the same time the Churchill College in Cambridge realised that *Havengore* could provide a practical link whereby some of the enormous range of Churchill archive material might be made available to the public, both in the UK and abroad. The Government South-East England Development Agency (SEEDA), successors to English Partnerships for regenerating Chatham Maritime, with support from Medway Council and the *Havengore* Trust sponsored a 'Churchill Connection' exhibition at St George's, the former naval church in Chatham. The exhibition was a great success and Sir John Boyd, Master of Churchill College, Cambridge wrote congratulating Owen Palmer for his rescue of *Havengore*, stating 'there could

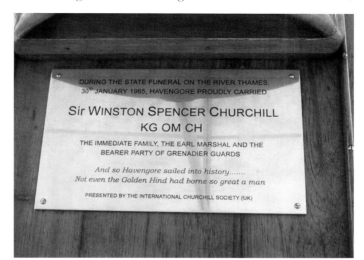

The plaque on *Havengore* marking where the coffin of Sir Winston Churchill rested during the funeral procession along the River Thames.

Owen Palmer welcoming London Mayor Ken Livingstone on board *Havengore* during a visit to the Thames.

The coffin of Sir Winston Churchill on board *Havengore*. (Courtesy The Churchill Archive)

A Remembrance Day ceremony on board *Havengore* in the shadow of Tower Bridge.

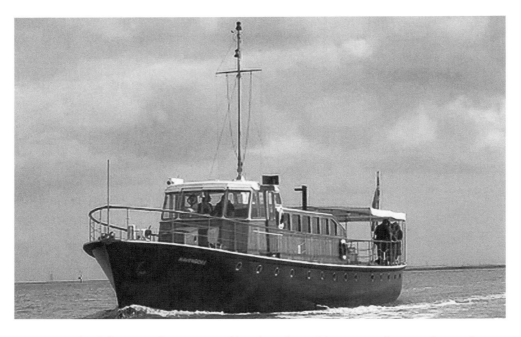

Havengore today, fully restored to create an historic and prestigious venue for receptions and special events. (Courtesy Venues of Distinction Ltd)

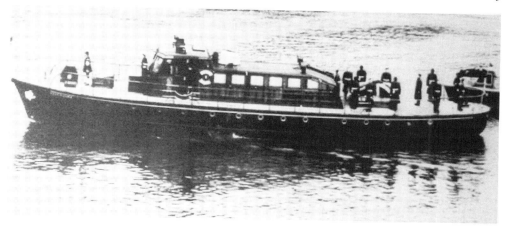

Havengore setting off from Westminster Pier at the start of its momentous journey upriver bearing the coffin of Sir Winston Churchill. (Courtesy The Churchill Archives)

be no more suitable location for *Havengore* than the Historic Dockyard at Chatham, well-known to Sir Winston from his two periods as First Lord of the Admiralty', adding that, 'the ship has an important role to play in educating future generations about the past'. The exhibition had also confirmed the view that *Havengore* and the Churchill Archives could together provide a fascinating insight into part of our heritage and the local perspective of a truly unique person. Churchill had a special affection for Kent, probably fostered by his Gillingham-born nanny, perilous flying lessons at Cliffe during the First World War, his many visit to Chatham as first sea lord and to Dover and Deal as Lord Warden of the Cinque Ports. It was this love for the area that had prompted the great man's purchase of Chartwell, the country house at Westerham that remained his home until the end of his life.

By the end of 1999 and despite an unfinished interior, *Havengore* was underway again, visiting the Thames to celebrate the millennium, appropriately berthing in the shadow of Tower Bridge. In 2000 *Havengore* also made a number of special trips on the Medway, including one for veteran code breakers who had worked at Bletchley Park, where a collection of Churchill memorabilia is now housed. Churchill held the Bletchley code breakers in very high esteem, and one can only guess what his reaction would have been to a contemporary American film where the Enigma code breakers are all depicted as American! Later that year *Havengore* was back on the Thames again as a VIP launch carrying various Lord Mayors and dignitaries at events that included the Great River Challenge and the Oxford & Cambridge Boat Race. The vessel also led a river procession as the world-famous Trinity College of Music, with its patron the Duke of Kent, moved home from Westminster to their new premises at the former naval college at Greenwich. A string quartet played on the aft deck as *Havengore* and her special guests gently cruised downriver.

As restoration approached the final stages, Owen and Sally placed the future of the vessel in the hands of the *Havengore* Trust which launched an educational programme designed to empower students to realise their abilities in an environment reflecting the remarkable Churchill-style leadership qualities. At the same time, and in conjunction with relevant agencies, *Havengore* began to take groups of disadvantaged young people afloat to experience

Deck saloon of *Havengore*, providing a unique setting for dinner. (Courtesy Venues of Distinction Ltd)

inter-dependence skills and team working. These projects worked well and began to show outstanding results but, despite the occasional and often prestigious corporate event, it became clear that such activities would not financially support operation of the vessel.

Owen and Sally had now firmly made Britain their home, and Owen was about to be recognised for his astounding efforts in rescuing *Havengore* from the scrap yard. Owen was declared a Freeman of the City of London for his services to Britain's maritime heritage. At an ancient ceremony in London's historic Guildhall Owen was presented with a traditional sheepskin parchment before being greeted by fellow Freemen as a 'true citizen of London'. Many will think it odd that it has taken a 'colonial', as Owen refers to himself, to rescue and restore part of Britain's maritime heritage. But Owen has no regrets: 'You can't just ignore a ship that carried the coffin of one of the most famous persons in the world', he said, 'it was the centre of the truly moving funeral ceremony when the riverside cranes dipped to salute as the Royal Air Force fly-past roared overhead'.

In 2005 *Havengore* was put up for sale. After months of uncertainty regarding her future, during which it was rumoured that several overseas buyers might be interested, she was eventually purchased by a UK businessman to become a prestigious river transport and hospitality venue based on the Thames. The interior has been refurbished to a much more luxurious finish and a modern central-heating and ventilation system has been installed, but externally she remains as in PLA service when, in 1965, the world watched as she carried the coffin of one of Britain's most famous sons. Despite the earlier worries, *Havengore* remains in Britain and her future seems assured.

Havengore – *The Ship and her Place in History*

Tough's of Teddington, one of the Thames' longest established and respected boat builders, built the *Havengore*, which was named after a small tributary of the Thames. She replaced the wartime ex-Admiralty boat that the PLA had retained as the harbourmaster's launch. Unusually for that time, a model of the boat's hull was built and tank-tested at the National Physicals Laboratory before construction commenced to ensure that *Havengore* would meet the Port of London's exacting requirements. On a cold February day in 1956 the trials took place, but *Havengore* exceeded all expectations and entered service as the PLA's hydrographic survey vessel – with an additional role as the river's principal ceremonial launch.

Havengore is 87ft long with a beam of 18ft and 89 gross tonnage. The hull is Burma teak over oak frames and twin Gardner 150hp engines provide the power. Service speed is 12 knots and her hull shape ensures a smooth passage through the water with minimal wash.

The PLA traditionally ran on naval lines and most of the crew were ex-Royal Navy or ex-Merchant Navy. Surveyors on board were always addressed as 'Mr' and uniforms were worn at all times by the twelve-strong crew; the mate and two chief boatmen wore the uniform of a navy chief petty officer. The vessel was maintained immaculately; regardless of weather, the decks were sanded and scrubbed with fresh water every morning and all the brass fittings polished.

Havengore's pleasing if somewhat spartan interior ensured she was in regular demand for special occasions. These included the annual Thames wreath-laying ceremony on Remembrance Day, carrying the Lord Mayor for festivities or visiting dignitaries from both home and abroad and, of course, PLA officials plus the occasional government minister to inspect a riverside development.

But her most solemn duty was on a cold January day in 1965 when, watched by an estimated worldwide television audience of over 350 million, Sir Winston Churchill's coffin was carried from Tower Pier to Festival Pier. The river journey was especially included in the state funeral arrangements as a fitting tribute to a person who had great affection for all things maritime. An elder brother of Trinity House and Lord Warden of the Cinque Ports, Sir Winston always wore a reefer jacket and Royal Yacht Squadron cap when afloat and considered himself very much a sailor. So it was a sailor's farewell, with a waterborne procession that had not been seen on the Thames since that accorded to Lord Nelson in 1805. As the ship carried the coffin from Tower Pier to Festival Pier, the Royal Air Force, whose wartime pilots had been immortalised by Churchill as 'the gallant few', provided a massive fly-past salute with several aircraft piloted by some of 'the few' themselves. Meanwhile, the cranes along the riverside wharves dipped to signify the respect of those who worked on and along the river, as gun salutes echoed around a city silent in sorrow. This was certainly *Havengore*'s finest hour.

As the echoes of the gun salutes died away, the voice of ex-US President Eisenhower was broadcast as he said a eulogy for the close friend with whom, twenty years earlier, he had planned to secure an end to the war by the invasion of Europe.

Upon the mighty Thames, a great avenue of history moved, at this moment, the mortal remains of Sir Winston Churchill to their final resting place. He was a great maker of history, but his work done, the record closed, we can almost hear him, with the poet, say:

Sunset and Evening Star,
And one clear call for me
And may there be
no moaning of the bar
When I put out to sea …

Twilight and evening bell,
And after that the dark!
And may there be
no sadness of farewell
When I embark …

Heritage Recovered From a Muddy Grave

Richard Grimble is a quiet and determined man with infinite patience, probably the result of a long and distinguished career making and repairing violins. But he is also an enthusiastic amateur sailor with a keen eye for yacht, and recognised that a derelict old wreck almost completely buried on an Essex salt marsh had potential. With the help of his family and a few friends, Richard spent a year digging out a derelict Victorian yacht from the mud of an Essex estuary – often with his bare hands, which prompted much laughter and derision from the locals. But twenty-five years later Richard had the last laugh when he learned that the totally restored classic Victorian yacht could be worth more than £1½ million!

Built in 1878 at Southampton, *Sorceress* was soon recognised as one of the fastest boats at Cowes where her titled owners raced her by day and hosted lavish receptions on her at night. It is claimed she was frequently raced with the Prince of Wales, later King Edward VII, at the helm, and it was well known that the vessel was especially favoured by the future monarch for intimate dinners with his mistress, the actress Lily Langtry. They would spend the evening, or possibly longer, on board to discussing, naturally, the day's racing!

In 1937 the fifteenth of her distinguished owners, the Earl of Macclesfield, decided that after sixty years of outstanding racing, she should be retired and allowed to quietly rot in peace in the mud of an Essex marsh. It was nearly forty years later that Richard Grimble discovered her almost completely buried. After an exploratory dig Richard realised that the salt marsh had preserved the timbers and, after a brief haggle, acquired the abandoned hulk for £1,000. With his family and friends, Richard spent a year digging out the mud, first from inside the boat and then outside from around her hull. During the years that had passed the marsh had built up, so it was also necessary to dig a substantial channel to the sea. On a bright September day in 1975 the water flooded in with the tide and *Sorceress* floated again. Towed to Maldon, she was properly cleaned and Richard began a painstaking restoration that took twenty-five years.

Amazingly, most of the hull and deck comprised the original timbers, but the interior had to be almost totally rebuilt, which Richard has done with faithful adherence to the original Victorian design which is one of the most striking aspects of the boat. Richard's skills as a violin-maker and master craftsman resulted in an attention to fine detail that was truly astonishing. The panelled interior and furniture has intricate inlaid veneer marquetry panelling, and the entire restoration accurately replicates the very highest standards of Victorian tastes – nowhere more impressively than in the saloon or the unique bathroom with its fitted hip bath that perhaps Lily Langtry may have used.

Richard, who lives in Upchurch, chanced upon the yacht through an advertisement in the *Exchange & Mart*. He said, 'I'd been looking for a boat for a long time. This was a bit bigger than I wanted but she had obviously been a beautiful yacht and at £1,000 was a lot cheaper compared to others I'd looked at. Getting her out was the most difficult job as at first we had to wade waist-high in mud to even get close enough to start clearing it away!'

Interior of *Sorceress*, an oasis of calm.

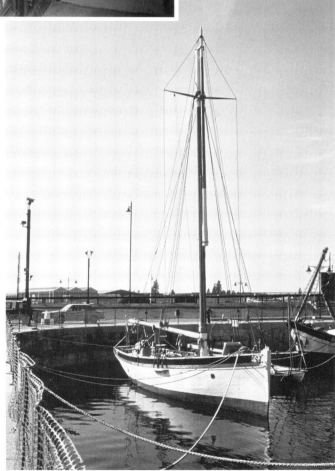

The elegant gentleman's yacht, *Sorceress*, celebrating her 120th birthday at Chatham, restoration nearing completion.

Richard Grimble: twenty-five years spent restoring a Victorian yacht with a remarkable pedigree and an even more remarkable history.

Cleaned out, but with the yacht little more than a bare shell, Richard found a berth on the Thames and began the external rebuilding and restoration work. An early priority was re-decking to make the craft weatherproof and original salvaged timbers were used wherever possible, with the hull caulked in the traditional manner using white lead and oakum. With the ship dry in the true sense, Richard brought it to the Medway and was offered a berth in one of the former dockyard basins at Chatham Maritime. Here he was able to continue restoration of the vessel in a secure location close to his home. Richard began to rebuild the interior but none of the original plans survived so this had to be based on many hours of research into the typical layouts of such yachts combined with extensive discussion with experts in Victorian design. One exception to the original design had to be the installation of an engine. One had been fitted at some time during its racing years, although it had subsequently been removed. Richard opted for a modern diesel engine and disguised its presence by clever positioning of bulkheads – the room dividers of a boat.

By the late 1990s, with mast, spars and deck fittings in place, the yacht was almost complete. The long flush and uncluttered deck with its wheel angled from the vertical (for positive drive to the rudder) demonstrates the Victorian determination for an out-and-out racing machine as today's ocean racers do. Below decks it is a comfortable oasis of calm with chintz furnishings, varnished panels and highly polished brass fittings. In Cowes and the other centres of yachting during the late Victorian times, local watermen and sailors were recruited and paid by the yacht owner to crew the yacht. *Sorceress* would have had a crew of about sixteen in order to handle the heavy sails. At the end of the day's racing the crew would have been paid off, with a bonus if the yacht had won its race. An army of servants would then descend on to the boat to clean and clear ready for dinner at which the owner, maybe with his family, would entertain friends. Dinner would usually be an elaborate affair with food pre-cooked at kitchens on shore and either kept hot en route to the boat or re-heated when on board.

Sorceress quietly celebrated her 120th birthday in a basin at Chatham Maritime, as Richard considered options for the final and most expensive items he needed – the sails. In her original racing condition, *Sorceress* would have set 5,000 square ft of sail, but after consultation with eminent yacht designers, it was decided that 3,000 square ft would be adequate and even that would require at least four or five people to handle the vessel in a stiff breeze.

Finally the restoration was complete and it was then that Richard received the astounding news that insurers and surveyors now valued the vessel at over £1 million. Even more astonishing was that following a report about the ship in a national newspaper, Richard received two calls (one from Japan) offering to buy the yacht for even more. Richard modestly said: 'it's been a labour of love. What it might be worth is irrelevant. Insurers and others tell me it's worth maybe £1.5m to £2m, but that doesn't really matter. I love our heritage, which these days we often seem to be letting slip away far too easily. I suppose all I really wanted to do was restore something of great beauty in the hope I've preserved something of value for future generations.'

As restoration neared completion and news of the boat spread, *Sorceress* began to receive many visitors. Many were themselves craftsmen, history buffs or academics and Richard recognised that opening the yacht to visitors could be a means to financially support its upkeep and maintenance. Sadly, at that time Chatham was not the place to create a tourist attraction. After looking at a number of options, Richard accepted the offer a berth in Wellington Dock at Dover Harbour. After some successful trial sails in the Medway, with Richard at the helm supported by a crew experienced in handling large gaff-rigged sailing yachts, *Sorceress* set off for Dover. It was a bright and sunny, if blustery, day that had the crew working hard. In view

Describing the rescue and restoration of *Sorceress*, Richard Grimble with just two of the many visitors who followed the progress of the work on the historic vessel.

The bathroom on *Sorceress* – varnished panels with inlaid marquetry, decorative Victorian porcelain and an authentic hip bath!

Teak laid deck on *Sorceress*, hand honed by stone in the traditional way and wetted down daily in dry weather.

of the weather, Richard accepted help from a tug to get her finally into harbour and by the end of the day *Sorceress* was secure in her new berth, where for several years she remained a popular attraction.

Richard enjoyed the interest in his achievement but realised that he would rather be out sailing. However, to sail on *Sorceress* he would need an experienced crew each time, and at sixty-five years of age, it would be hard work for him as well. Reluctantly, he felt the time had come for him to sell *Sorceress* and so, with very mixed feelings, the yacht was sold – but the price was never disclosed. The ship was moved to a harbour on the east coast where she is regularly sailed by her present owner, assisted by a small band of tough and experienced yachtsmen.

Richard Grimble acquired the crumbling remains of the Victorian yacht and spent over twenty-five years rebuilding and refitting in every detail to ensure her survival for the benefit of future generations. By working his own magic on the *Sorceress*, Richard has more than achieved this objective, of which he may justifiably be very proud, and a further unique part of Britain's maritime heritage has been secured.

Admiration for a Gentle Lady

Visitors to ports and harbours around Britain's coast will often spot small but fast pilot launches setting out to sea in all weathers. These tough little boats, taking pilots to board incoming vessels, or collecting them from departing ships, are now a familiar sight off our coasts, but fifty years ago there were far fewer and they were much slower. These would wait offshore in the approach channels before taking pilots off an outgoing ship and putting them on the next incoming ship. Quite often this could mean a long and uncomfortable wait as the pilot boat pitched and tossed at the whim of the sea and the wind.

In the late 1950s the elder brethren of Trinity House considered a radical new idea. The concept was to base the pilots on land, taking them out to meet ships or collecting them as and when required. But the proposal would need a powerful, fast boat able to operate in all but the most extreme weathers, and no such craft existed. In those days, with no computer models to experiment with designs, Trinity House simply put all their ideas together and commissioned a boat to meet their criteria. The result was a new type of pilot boat equipped with two powerful Rolls Royce engines that was fast but still capable of operating in all weathers and seas. The prototype was launched in 1960 and named *Landward*.

From the outset, *Landward* proved that keeping pilots ashore with a fast, albeit bumpy, ride to join a ship was more efficient than maintaining boats and pilots, who were at sea for long periods. Within a few years nearly all pilots were shore-based and other countries were quick to see the advantages of the new system and they too changed to shore-based pilotage.

Meanwhile *Landward*, the model for many sister ships, was based first at Cowes on the Isle of Wight, then Dover and finally Cornwall, where she delivered and collected pilots in the dangerous waters of the western approaches. *Landward* remained a special favourite of the pilots, who recognised her contribution to make their arduous work a little easier.

In 1976, whilst returning from a pilot delivery during a terrible storm, *Landward* answered an SOS from a yacht stranded on the infamous Manacles rocks off Falmouth. Local lifeboats were already at sea and involved with other rescues. In mountainous seas and gale force winds, *Landward*'s skipper carefully picked his way between the jagged peaks and hidden ledges of the rocks to rescue the entire crew of the yacht and bring them safely into harbour. *Landward*

Landward following the Royal Navy frigate HMS *Monmouth* into Portsmouth in 2005. The former pilot vessel was chosen to lead the USS *Winston S. Churchill* into the UK port during her maiden voyage.

Landward dressed for a visit to a maritime festival. The vessel had been key to the introduction of modern pilotage development operating from shore stations.

Mick Deller, a talent combining commercial marine work with regard for maritime heritage.

suffered extensive damage to her hull and stern gear as a result, but the damage was repaired and within a few weeks *Landward* was back in service.

By the late 1970s fibreglass boats were replacing the older timber boats and *Landward*, having more than fulfilled her design criteria, was laid up ashore pending sale when she came to the notice of electronics engineer Mick Deller.

Mick Deller

Londoner Mick Deller was looking for a boat to replace his motor cruiser. Mick had been drawn to boats since his schooldays when at every opportunity he would spent hours messing about with boats on the reservoirs and canals of north London. In his teens he had acquired a tiny 10ft runabout dinghy, but by his twenties had progressed to a larger 16ft open launch that he and his young family used extensively along the east coast. During one particularly wet Easter as the rain poured down, the Deller family, water streaming from their soaked clothes, watched from their open boat as an immaculately dressed (and dry) family stepped off their motor cruiser. Mick decided it was time to move up to a boat with a cabin, maybe a small modest little motor cruiser, say 18–20ft long. Mick didn't 'do modesty' and the result of his decision to acquire a small boat was a 48ft seagoing motor yacht that took Mick and his family around most British ports and many in Europe. One of the places they visited during this marathon voyage was the Medway, where they moored for a few weeks at Gillingham. Mick liked what he saw: the river offered pleasant leisurely boating, it was an easy hop up to the east coast or over to the continent, and he had been made very welcome. It was 1967 and Mick decided Gillingham and the Medway was where he wanted to be – so the family promptly moved!

With a growing family, Mick embarked on finding a larger boat and thus came upon *Landward*. As she was laid up, some repair was needed but otherwise the boat was in fairly good condition. Recognising her tough design and the ability to provide safe trips for his family no matter the weather, Mick successfully tendered for the vessel and in due course found himself the proud owner of *Landward*, together with an enormous number of spares. By now well experienced in nearly all aspects of boat repair and maintenance, Mick soon had *Landward* back in operation and brought her to the Medway where, over a period of three years, he gradually

converted the interior to provide comfortable accommodation. The exterior, with the exception of re-positioned guard rails and the removal of a huge illuminated 'pilot' sign, was restored to how it had been in its Trinity House service days – and remains as such today.

A New Career for Mick and Landward

In 1979 Mick decided to quit electronics and work permanently in the marine business. An opportunity had arisen for an honorary piermaster at Gillingham Pier, looking after Medway's largest public slipway and a number of berths for both private and commercial craft. Mick submitted his application and after due process was appointed and became responsible for this council-owned facility, a post he held for over twenty-five years. A well-known and popular figure on the river and easily distinguished by his beard, Mick not only resembled everyone's image of an old salt, but had the skills and experience that inspired confidence in anyone seeking help or advice about boating.

Meanwhile, fully restored to her original service standard, *Landward* and Mick were soon in demand for charter by various authorities both in the UK and abroad. One regular contract was to deliver supplies to Radio Caroline, the pirate radio ship operating in the North Sea. Ironically, a later contract was to take Dutch police out to arrest the same ship and confiscate its equipment. As Mick would often relate, with a wry smile, 'I was paid by one customer to take goods to the ship, and paid by another customer to bring them back again!' During the 1980s, 1990s and into the new millennium, *Landward* was extensively used by environmental agencies and survey companies, not to mention the increasing demand of film and television companies seeking a secure stable platform for cameras, although from time to time *Landward* would herself appear in front of the cameras. On 6 June 1994 film and television companies filming the fiftieth anniversary of the D-Day landings hired *Landward* and she was the only vessel allowed by the French maritime police to cruise through the assembled fleets off the landing beaches. As a result, Mick and his crew had a unique opportunity to see the gathering of multi-national vessels.

At other times *Landward* became a pleasure boat, enjoyed over the years by Mick, his family and friends. A frequent visitor to ports throughout the UK and the continent, *Landward* proved to be a very comfortable and safe cruising boat, as Mick often remarked, 'she's a gentle lady that gives you confidence – and an easy ride in a blow'.

Mick and *Landward* were popular visitors to maritime events, not only in the UK, but also on the European mainland due to the boat's excellent sea-keeping qualities. In 2005 *Landward's* contribution to pilotage was remembered and she was invited to join the opening parade into Portsmouth for the start of a special Festival of the Sea to commemorate the bicentenary of the death of Admiral Lord Nelson. It was an impressive sight as *Landward* joined a Royal Navy frigate leading the huge USS *Winston Churchill*, flanked by military helicopters, on her maiden voyage from the United States. As the fleet passed Southsea it was joined by one of the few remaining spitfire aircraft, providing a stunning air display immediately above *Landward*. Mick recalled the parade and *Landward's* contribution as being one of his proudest moments. However, he later said that 'keeping the boat on course to the constant – and very detailed – navigational instructions from the Royal Navy, whilst being "buzzed" by helicopters and a Spitfire, was a bit different from a gentle Sunday afternoon down the Medway. Still, when the "Winston Churchill" got worried about the low-level passes of the Spitfire, I was able to assure them that it was "one of ours"!'

Back home at Gillingham and despite being a popular figure, Piermaster Mick did have reputation for bluntness, and he certainly didn't suffer fools gladly. It was pure entertainment

to watch Mick's facial expressions as he watched small boats being secured with enough rope to moor a warship, with a wondrous selection of knots that would fall apart at a light tug from Mick. But then he would be the first to assist and, in his deep and measured tones, advise on the best way for 'next time'.

In 2006, and without warning, Mick suffered a fatal heart attack. Many friends and acquaintances from along the river attended the funeral and the procession diverted to Gillingham Pier to pause for a few moments alongside *Landward*. A salute was fired by a local military re-enactment group who had performed at many of the festivals that Mick and *Landward* had attended. The River Medway had lost a stout champion and one of its most popular characters.

Fact File – *Landward*

MV *Landward* was launched 1960 and built by Phillips of Dartmouth.
Designed by Thorneycroft for Trinity House, to a specification that included an ability to fulfil all duties in up to Force 9 gales – with only one engine and one rudder working.
Powered by two Rolls Royce turbocharged straight 8 diesel engines each developing 410hp. Maximum engine speed 2000rpm, driving 3ft diameter propellers through 2:1 reduction gearboxes.
Length: 70ft/21.5m
Beam: 17½ft/5.4m
Draught: 5ft/1.6m
Speed: Cruising 12 knots; Maximum: 16 knots
Fuel consumption: 1¼ gallons/2 litres per mile at cruising speed

Admiral of the River

For one weekend each July, the River Medway bustles with activity as tradition, pageantry and modern-day leisure boating combine to provide a colourful display. This is the weekend of the Mayor's Cruise or, to be more accurate, the Admiral's Cruise.

Prescriptive rights to fish the River Medway were first granted over 800 years ago, but it was in 1446 that a royal charter signed by Henry VI granted the fishermen of the Rochester Oyster & Floating Fishery exclusive rights to fish the river. Just over a century later, in 1571, the monarch gave jurisdiction that the Mayor of Rochester be appointed 'Admiral of the River' to administer such rights, and over the centuries these rights have been re-affirmed and further endorsed by successive Acts of Parliament. It was required that each year the Admiral preside over an Admiral's Court where the fishery's Chamberlain provide account of fishing in the river, and where fishery apprentices who had completed their seven-year training received their indentures from the mayor. In addition, the admiral could direct water bailiffs to deal with any miscreants, such as poachers, who might try to illegally fish in the river. For nearly 500 years the Admiral's Court has continued to meet each year, although this once major industry of the river has all but disappeared and only a handful of fishermen remain. Nonetheless, there is still the occasional poacher using illegal nets and with total disregard for future fish stocks. But the royal charter still prevails and it was invoked only five years ago to deal with repeated poaching by a person from Essex. The matter these days had to be referred through the civil courts, but the charter prevailed and the poaching was stopped. When Rochester became part of the new Unitary Authority in 1997, the responsibilities of the city's Mayor were passed to the new mayoralty for Medway.

Above: The Admiral of the River 'beating the bounds' of his jurisdiction from his 'barge' during the Admiral's Cruise held in July each year.

Left: The Admiral's Court in the 1970s when it was held on board a barge at Rochester Pier. By Royal Charter, the Mayor of Rochester is the Admiral of the River, a title that has transferred to the Mayor of Medway since unification of the Medway towns. (Courtesy Kent Messenger Group)

The annual Admiral's Court of the Rochester Oyster & Floating Fishery was traditionally held afloat, usually on a barge or lighter bedecked with flags and moored at Strood or Rochester Pier. More recently the paddle steamer *Kingswear Castle* has sometimes provided the venue, but to avoid the vagaries of weather the court now often convenes at Rochester's historic guildhall. The ceremony is largely unchanged, combining ceremonial with genuine river business. In traditional robes, the Chamberlain of the fishery escorts the Mayor to join honorary officials and other river fishermen. The prescriptive rights of the free fishermen stretching back to 1189 and the decree of 1571 that gave jurisdiction to the mayor are then re-affirmed. The chamberlain then reports on catches, the state of the river, maintenance of fish stocks and issues regarding the environment. Finally, any new fishermen who have completed their apprenticeships are awarded their indentures; these days, it is usually the sons and daughters of existing fishermen who are dedicated to maintaining family traditions, albeit on a part-time basis as an adjunct to their main employment. However, seven years' active fishing plus a detailed knowledge of the river and fishing is still a mandatory requirement.

Following the Admiral's Court, the mayor as admiral was required to 'beat the bounds' of his jurisdiction, which stretches from the Hawkwood Stone (a plinth on the river bank marking the boundary between Rochester and Maidstone) out to the estuary where the Medway Buoy denotes where the river ends. Once an essential demonstration of where the boundaries were, the practice disappeared during the latter part of the nineteenth century. There were several attempts in the 1950s to revive the ceremony, but these were very informal and half hearted. However, in 1960 the Mayor of Rochester was an enthusiastic leisure boater who owned a small motor cruiser and, with enthusiastic support from other councillors, decided to revive the bounds ceremony. With help from fellow boat owners at the Rochester Cruising Club, this revival was successful and was the start of what has become the annual 'Admiral's Cruise', although, with many people not aware of the original purpose of the event, it is more generally referred to as the 'Mayor's Cruise'.

In the early years following its revival, the cruise would be held immediately following the Admiral's Court. The mayor would transfer to a boat from the Rochester Cruising Club, normally that of the club's flag officer, and proceed upriver escorted by the free fishermen to Hawkwood Stone. After beating the bounds in the traditional manner, the vessels would proceed downriver to Rochester, joined by other boats from the Cruising Club and other yacht clubs, and proceed in 'line astern' out to the estuary where the outer bounds were duly beaten. The vessels then returned upriver to their respective clubs. Some changes evolved – the journey upriver, then down to the estuary and back could stretch the capability of some slower vessels. In addition, some smaller craft weren't really suitable for the rough waters that could build up outside of the river, and were obliged to shelter in one of the creeks whilst the mayor beat the bounds in the estuary. As a result, the ceremony was amended with the trip to Hawkwood Stone taking place immediately after the Admiral's Court on Saturday, and the main trip downriver taken at a more leisurely pace on Sunday. The mayor and a few supporting vessels would still go out to beat the bounds whilst other craft would raft together in sheltered waters.

Today the fleet often comprises over a hundred craft, making an attractive sight as, dressed overall with fluttering flags, they wait as the mayor, with a Sea Cadet guard of honour and Sea Scout escort, boards one of the cruisers that will be his 'Admiral's barge' for the day. The fleet, which usually includes Medway's harbour master on his or her official launch and others from river-related agencies and the armed services, then proceeds downriver with salutes from the yacht clubs and other shore establishments. Nearing Sheerness, close to where in 1916 the

Royal Navy's HMS *Bulwark* exploded with the loss of over 700 lives, the fleet remains still and silent as the Mayor lays a wreath on the water to remember all those lost at sea. Some of the vessels then accompany the Mayor out to the lower limit of his jurisdiction, close to the wreck of the liberty ship *Richard Montgomery* off Garrison Point. Here the vessels form a wide arc for a brief service before the Mayor beats the bounds. The Mayor of neighbouring Swale then formally conducts the Mayor/Admiral and the accompanying vessels a short way up the Swale to Queenborough, where they rejoin the majority of the fleet, who are usually rafted around some lighters, for a reception hosted by the mayors.

By early evening the fleet is safely moored back at Rochester, where a sunset ceremony is performed with pipers and buglers accompanying the traditional flag-lowering ceremony. It is a memorable weekend for everyone who takes part and an opportunity to reflect on the river that previously created so much of the Medway town's prosperity.

CHAPTER NINE

THE FUTURE

The River Medway has had to adapt as the maritime world has changed.

Cargoes are carried across the oceans in huge vessels that few rivers can accommodate whilst roads, not rivers, are the routes inland. Commercial river trade has given way to leisure, with marinas and boatyards attracting new users to the water. The vast sheds and structures constructed to house shipbuilding have found new uses and the skills and experience of those whose forbears built every type of vessel, from barges to battleships, have shown their ability and flexibility to create new and exciting structures that are desired by today's consumers.

There may be less activity on the river compared to years past, but it is far from dead. People will have more time for leisure activity in future years: the River Medway offers space, interest and convenient access to the waters around our own coasts and those of our continental neighbours.

Bringing the River Back to Life

Like many other waterways, the River Medway became desolate as commercial activity gradually disappeared from the river. By the 1960s grass sprouted along quaysides and wharves and at most times it was only the wind that created ripples across deserted expanses of water. There were some private pleasure craft, as there had always been, mostly from local yacht clubs or one of the few boatyards, but their numbers were constrained by the limited berths and moorings. Thankfully, there were some people who had the vision, drive and energy to create marinas, which have been the key to bringing the river back to life.

At some time, anyone who chooses to take up boating as a means to while away their leisure time will have a vision of silently gliding up their local creek after a happy day's sailing, an oil lamp glowing warmly in the gathering dusk as it swings from the yard arm. The home mooring is reached, the sails secured and a happy and contented crew go ashore to be greeted by a warm welcome from their friends in the snug (and oil-lamp lit) bar of the inn.

But it is usually only a dream!

The reality is pushing a foul tide in torrential rain with six attempts to pick up the mooring. Then sitting ankle deep in rainwater in the dinghy and wading the last few yards across the mud because the tide has dropped, finally getting to the pub moments after last orders have been called. And that is one of the reasons why marinas have become so popular!

Chatham Maritime Marina, located in what was originally one of the dockyard basins. Despite initial fears it would reduce demand at other marinas, it has been a catalyst for increased leisure use of the river. (Courtesy MDL Marinas Ltd)

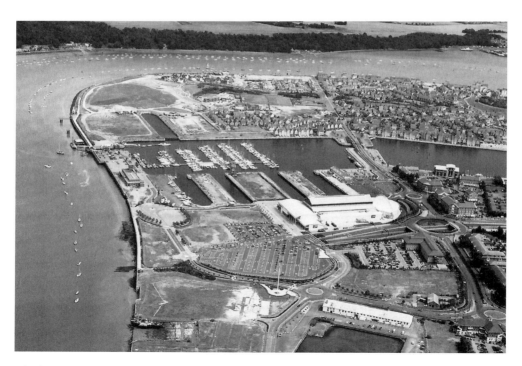

Chatham Maritime Marina, located at the heart of the regeneration of the formal Royal Navy Dockyard. (Courtesy South-East England Development Agency)

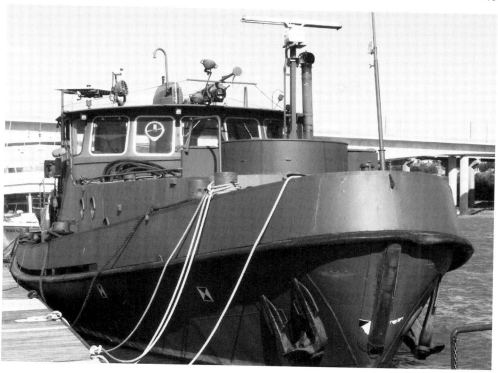

The former East German fast patrol tug, *Bourke*. These vessels combined conventional tug work with military patrol duties and were armed. At Port Medway some tug work continues, but with her well-appointed and spacious crew accommodation she is ideal for leisure cruising.

David Taylor, creating a modern marina that does not ignore the shapes and styles of traditional craft, and the needs of their owners.

The luxurious interior of a modern power cruiser. With Rochester Bridge restricting upriver access to many sailing craft, Medway Bridge Marina specialises in this type of vessel. (Courtesy Birchwood Boats Ltd)

A modern power cruiser underway. Designed for comfortable fast passage between ports, this type of craft is now the most popular with leisure boaters. (Courtesy Birchwood Boats Ltd)

Buying a boat is one thing, finding somewhere to keep is very different. Traditionally, a keen sailor would rent a mooring, often one of a trot of moorings strung along the river or creek. The boat would remain afloat with access, if part of a yacht club, by a trot boat or, for independent moorings, by a dinghy. It is a sad fact that many people have drowned and, sadly, some still do, transferring between shore and boat in an overloaded dinghy or, after an evening in the local pub, with heavily overloaded people.

Facilities built for commercial vessels were rarely suitable for pleasure craft, hence it was not long before harbours, designed and equipped specifically for leisure boats began to appear. The 'marina' had arrived.

Since the 1960s marinas have proliferated around the world and, with the astounding increase in leisure boating, any self-respecting waterside town boasts one. Most allow craft to remain afloat at all times, which in areas with a large tidal range, such as the Medway, means using a

basin (usually accessed via a lock) to retain water when the tide drops or by mooring to float-ing pontoons reached by wide, gently sloping ramps. Each boat has its own electricity socket to keep batteries charged; there is a water supply to top up tanks to reduce environmental pollution and a pump-out facility to empty a boat's waste tanks. There is often a chandlery and general shop, fuel and repair facilities, and sometimes restaurants and bars. Security is paramount and access to floating pontoons is controlled.

Marinas ensure the maximum use of leisure time. No more precariously loading a dinghy with the weekend's food before a hazardous row out to the boat or a trip to the nearest boatyard to fill up with water and fuel. From arrival at the marina, a boat owner can be underway in minutes.

Obviously, these services cost the boat owner more than when a vessel is moored on a trot, but with today's busy lifestyles, people want to get the maximum, in terms of both time and quality, from their leisure. This is what modern marinas are able to provide. Those on the Medway not only pro-vide berths and moorings, with now over 5,000 craft registered on the river, but also offer facilities to suit everyone, be they weekend potterer, racing yachtie, fisherman or skipper of a floating gin palace.

Medway Bridge Marina

Just a few minutes' drive from the centre of Rochester is Borstal village, perhaps best known for giving its name to juvenile detention centres, the first of which was created here a hun-dred years ago. Take the lane down to the river and you will come to one of Medway's major boating marinas in the shadow of the towering bridge across the river valley. Medway Bridge Marina was created from marshland and from modest beginnings has now become one of the busiest centres for motor boating on the Medway.

Boats moored in Chatham Maritime Marina.

Fifty years ago these marshes presented a bleak and unattractive scene. Tufts of grass sprouted from banks of mud criss-crossed by channels that filled with the tide. A few hardy boat owners kept their vessels on this watery wilderness, accessed across rickety planks bridging the channels and over duckboards on the worst mud spots. Frequently a high tide would wash away the makeshift paths, leaving owners stranded to contemplate the decaying wrecks of other boats that had long been abandoned. It was only a couple of miles upriver from Rochester, but it could have been the middle of nowhere.

Then, in 1960, local businessman Ray d'Glanville, a boating enthusiast with vision and an enormous capacity for hard work, purchased the marshland. Ray was also one of the first in Britain to recognise that boating would become a major leisure activity and that owners would want easy access to their craft without first squelching through a quarter-mile of treacherous mud, so he began to create a marina from the wasteland.

Slowly, part of the land was reclaimed, and a floating pontoon pier constructed in order that boats could remain afloat at all states of the tide. Meanwhile, Ray had taken a partner, a retired Battle of Britain veteran ex-Wing Commander Owen Cunliffe, who brought a unique combination of imagination and resourcefulness to the enterprise. 'Wingco' Cunliffe was a lively character, immensely popular with the many boat owners now eagerly wanting to moor their vessels at the new site. In 1969 Ray and the Wingco took a third partner, Peter Howard; the site was named Medway Bridge Marina and expanded to provide more berths for even more vessels.

But for all their innovation, the partners and their families retained a warm and friendly relationship with customers and the boat owners, running the business almost as a hobby. In 1981 Ray d'Glanville retired and sadly, that same year, the Wingco died and his son David, who had joined the company a few years earlier, joined with Peter Howard to run the company. David and Peter introduced a programme of constant development to ensure the marina met all the needs of modern motor yacht owners, whilst not forgetting the owners of smaller perhaps less glamorous vessels who often prefer to carry out their own maintenance. Following Peter's death in 1985, David brought Giles Billingsley into the business. Giles had to learn the business from the bottom up, but with an honours degree in law, he successfully steered a course through the masses of government and EU legislation that relates to leisure craft these days. In 2002 David retired and handed the reins to Giles, who has ensured the continued popularity and success of the marina as a genuine family business.

The low clearance under Rochester Bridge a couple of miles downstream means there are few sailing boats around. With only a short trip downriver to the estuary and beyond, a chandlers store and engineering facilities on site, it is hardly surprising the marina is so popular with motor boat owners, with a motor boat club and a boating school on site.

But it is a real home for some people. It is one of the few places remaining on the Medway that can offer permanent berths for houseboats. Forget the image from years past of 'water gypsies' living on old rotting hulks. Modern houseboats are often purpose built or expertly converted sailing or motor boats: spacious with more mod cons than an average house. Many well-known people chose to live afloat, including, at one time, Richard Branson, who even ran Virgin Records from his houseboat. With a marina general shop nearby, great unobstructed river views and a squawking seagull instead of an alarm clock, you can begin to appreciate the appeal of living on the river.

Because of the high standards of its facilities, the marina has been awarded the UK agency for some of the world's most prestigious motor boats including those of Beneteau, Birchwood and the US Wellcraft sports boats. With a busy brokerage department handling sales of every

David Cunliffe (right) hands over Medway Bridge Marina to new owner, Giles Billingsley. David's father and Ray d'Glanville created the marina in the 1950s on what had been marsh.

Giles Billingsley. Introducing new concepts to Medway Bridge Marina whilst still maintaining traditional values.

type of used boat, Medway Bridge Marina is attracting customers not only from the UK, but from Europe as well – and many are now choosing to keep their boats on the Medway.

One of Giles' most memorable moments occurred a few years ago when a long-standing berth holder asked if he could trade in his somewhat tatty, and almost worthless, old motor launch for a better boat. Out of respect for an old customer, Giles made a generous offer, but stressed much would depend on what the new boat might be. The berth holder slapped down a cheque for £350,000 and ordered a top-of-the-range cruiser. He had just won millions on the National Lottery!

Tugging Along

When choosing a boat, most people think of a family sailing or motor cruiser or if they have just won the lottery maybe a large gin palace. For David Taylor, who owns Port Medway Marina at Cuxton, it was something a little out of the ordinary, an ex-East German army armed patrol tug – although the weaponry had been removed!

But David is himself somewhat out of the ordinary. A chartered engineer, he established and operated a highly successful building company that constructed numerous homes, offices and factory buildings around south-east England. With the advent of recession in 1990, and having been involved with boats and the water since his schooldays in Essex, David decided to change course, and purchased a large riverside site at Cuxton, on the west bank of the Medway near Rochester, which incorporated a fairly run-down boatyard. In fact, it was more akin to a scrap yard, with rotting hulks lying in the mud and on the riverbank, and the remains of sunken vessels exposed at low tide. The pontoons, some weighing over 60 tons, and the catwalks were both unsightly and dangerous – some were held together with pieces of string and electrical wire. The site itself was overgrown, making progress even on foot almost impossible except by the fit and adventurous. It was a challenge from which most people would have turned and ran, but David could see the potential for a marina.

The 30-acre site lies in the shadow of the Medway and Channel Tunnel Rail Link bridges over the river, and was originally open marshland with some mud berths around a shallow creek. In less than twenty years the site has changed almost beyond recognition, and even more remarkable is that it has been achieved by a just small team led by David. Today, over 500 boats are accommodated on 1,200m of fully serviced pontoons and 1,000m of quayside moorings, with two massive boat hoists and three dry docks that can accept craft up to 120ft long. There is a slipway, secure boat parks and a spacious floating office and reception building. The site is now a modern rural marina, which includes a large lagoon that has being landscaped into a country park.

Unlike many modern marinas that prefer to accommodate only white, plastic boats, Port Medway is a user-friendly marina for both those who want to potter and those who want to step onboard, press the starter and go with the minimum of fuss. David especially welcomes do-it-yourself owners who often prefer a leisurely approach to fitting out and will exchange their paintbrush for a mug of tea and a chat at any opportunity. With such a flexible approach, it is hardly surprising that the variety of craft moored at the marina include barges, fishing boats, Dutch Tjalks, a former Thames ferry and even a couple of Dunkirk little ships.

The largest vessel permanently berthed at the marina is the *Rochester Queen*, a former coastal passenger ship built in 1935. With her sailing days ended, the ship has been converted to provide bars and a restaurant (with dance floor) for receptions, parties and conferences, and she's even licensed for civil wedding ceremonies. But what about the tug?

Bouke is far removed from conventional harbour tugs. The former East German authorities were so worried about attack from the west that many tugs were armed and designed to double-up as patrol boats, with two enormous engines that produce speeds that conventional tugs might only dream about. These patrol tugs were deployed along East Germany's Baltic coast, but after *perestroika* and the reunification of Germany their purpose had evaporated. Built to operate in the severest of weather, most have been eagerly acquired by yards in Europe as general workboats. *Bouke* is the only one known to be in the UK.

East German patrol tug crews had a comfortable life on board. Whilst *Bouke*'s engine room stretches from the stern to the mid-ship wheelhouse, the entire forward section of the vessel provides spacious cabins with en-suite facilities, a well-equipped kitchen galley and a saloon with veneered walls and furniture. With such roomy accommodation, the vessel is not only used as a versatile workboat, but also as a cruiser when David wants to take a leisurely break from the pressures of the marina.

David and his team have successfully created a marina that will satisfy most boat owners, and they can rightly be proud of what has been achieved.

Chatham Maritime Marina

MDL are the UK's largest marina operator, with eighteen marinas including the most prestigious in Britain, providing over 6,000 high-standard berths. With many yachting schools and training facilities based in their marinas, it is not surprising that MDL have become involved with the development of sailing as a sport, particularly for young people. For nearly twenty years, and in conjunction with the Ocean Youth Trust, MDL have been running the annual Sail Training Awards. This unique scheme considers the achievements of individual youngsters in circumstances ranging from disability, social deprivation and efforts to fulfil personal ambitions. Six of the most deserving or inspirational young people within each of MDL's regions are selected and have the opportunity to experience a sailing adventure on board the Ocean Youth Trust yacht *John Laing*, which they could also experience through participation in other life skills development initiatives.

Opened in 2004, the MDL Marina at Chatham Maritime marked a new phase in the revival of the River Medway. Designed to eventually accommodate over 600 boats, the first phase of 150 berths were snapped up almost immediately, and it wasn't difficult to understand why. Boat owners can enjoy superb facilities that include fully serviced pontoon berths, twenty-four-hour lock access at all states of the tide, full security at all times plus fuel and all the usual services, including a luxuriously appointed floating facility unit that incorporates toilets, showers and a laundrette. The marina is a partnership between MDL and the South-East England Development Agency (SEEDA) who have been responsible for regenerating this part of the former dockyard. This includes the enormously successful housing development on St Mary's Island, business offices at Chatham Maritime, the Dockside Outlet (shopping) complex, a multi-screen cinema, hotels, restaurants and the Dickens' World attraction.

Some spare capacity in the Medway's existing marinas initially prompted some people to question if another marina was necessary. But that worry quickly disappeared. Whilst a few local craft have moved to Chatham Maritime, the majority of vessels are new to the Medway. More boats on the Medway have generated more use of the river and a greater demand for support services and infrastructure. This, in turn, has prompted more boats to be based on the Medway – which has boosted trade for other marinas.

Many boat owners who live in London originally kept their craft at least one and a half to two hours distant on the south coast, and have been quick to recognise the benefits of a berth on the Medway, which would be less than an hour from home. Once on board, the cruising area for motor boats extends under Rochester Bridge and up to Tonbridge, whilst for larger motor vessels and sailing yachts there is a choice of the entire east coast and beyond. A trip up the Thames to London for a weekend is an easy option or, for the more adventurous, over to Holland, Belgium or France. Holland is only 80 miles from the Medway by sea, under a day's sailing in favourable conditions.

In Conclusion

The scale of leisure boating on the Medway isn't yet anywhere as great as that on, for example, the Hamble at Southampton, or any of the other yachting centres along the south coast. But in recent years the increased availability of marina berths has resulted in the numbers of craft on the River Medway to grow significantly. As with the motor car on land, somewhere to safely park a boat is the most important requirement, and there is little doubt that Medway's marinas and the berths they have created have been a key factors in development of boating on the river, providing greater prosperity for the area.

Building Sparks Links to Maritime Heritage

By any standards, the original shipbuilding slips and sheds in Chatham's Historic Dockyard are unique – and huge! Side by side along the river, they show how such buildings were developed over the years to accommodate the requirements of evolving ship design, and the last, completed in 1855, was to enclose the enormous 400ft-long No.7 slip. The cast- and wrought-iron structure supports early examples of modern steel roof trusses and was designed by Colonel Greene from the nearby Royal Engineers' School of Engineering. It was on this slip, until 1966, that the dockyard built many fine warships and submarines.

Buildings designed to accommodate the construction of large ships have few other uses and there were several unsuccessful attempts to find a use for Covered Slip No.7 slip following closure of the dockyard. One such idea was the creation of an indoor ski slope covered with artificial snow. From the top of a steep slope (on a scaffold structure), the skiers could descend to the gentle slope of the original slip and hopefully stop before hitting the inevitable accumulated pool of water by the gates of the river lock; the project was short-lived. But in 2003 the building was taken over by the well-known boat builders Turks of Kingston, who, although a long established and well-known boat building company on the Thames, originally came from the Medway. After nearly forty years ship and boat building returned to Slip 7 – plus quite a lot more.

Turks operate a large fleet of passenger vessels on the Thames, providing one of the highest standards of service available on the river, and have their own pier at Hampton Court Palace. These vessels and those of other Thames operators now come to Turks' Slip 7 for their annual inspections. Recently some houseboats, or perhaps more appropriately 'floating homes' in view of their £1 million plus price tag, have been built on the slip, then launched and towed to London where they provide riverside pads for wealthy clients. The slip is also used for the restoration of heritage vessels and the construction of ships for film and television companies to whom, for over eighty years, Turks have been the leading supplier of maritime items and services.

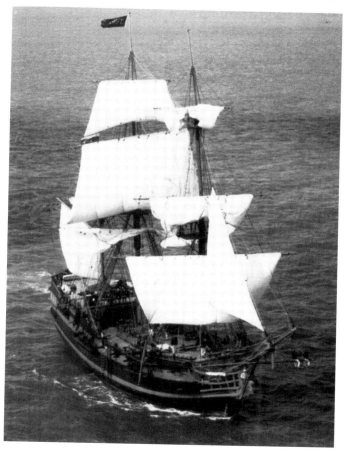

Grand Turk, replica of a Royal Navy frigate of the 1780s, perhaps better known as Captain Hornblower's flagship, seen here in the Medway Estuary during filming of BBC Television's programme *Coast*.

Turks' collection of several hundred old and replica boats used for film and television is now stored in the building, together with hundreds of thousands of maritime props. There is everything you can imagine, from binnacles to baggywrinkles, ship's wheels, masts, spars, oars, ropes – the list is endless. You can even hire a ship's cat – stuffed, of course!

Turks supply the world's television and filmmakers. Their hundreds of credits include the *James Bond*, *Indiana Jones* and *Harry Potter* films, plus many blockbuster films including *Robin Hood* and *Troy*. Turks-built boats feature in many television productions such as *Elizabeth I*, *Longitude* and *The Lost Prince*, and their flagship *Grand Turk* is probably better known as Captain Horatio Hornblower's flagship *Indefatigable*. With Turks now conveniently at the Historic Dockyard, the River Medway and the open waters of estuary have become popular for filming maritime sequences where, over 800 years ago, Turks' ancestors were building and sailing boats.

The Turk from the Medway

The Turk family can trace their ancestry back to the time of Richard the Lionheart. Early records show that in 1195 a shipwright called Turk 'from the 'Medwaeg river', came to London and built two galleys on land near the Tower of London for 'defence of the realm'. And a 'shipwright Turk' is recorded as being Lord Mayor of London in 1230, long before Dick Whittington and his cat made their famous journey.

The magnificent Covered Slip No.7 at Chatham's Historic Dockyard, where submarines were once built, and now Turks' home on the Medway.

Records from medieval times are sketchy but it is known that by the 1600s several Turks were licensed watermen on the Thames and Medway. In those days roads were few and not of a very high standard, hence rivers were the 'motorways' of that time. Many watermen rowed or sailed small skiffs known as 'hoys' – water taxis that would be hailed from the riverbank by the cry 'Ahoy', which is how the term originated. By the end of the seventeenth century one of the watermen was Richard Turk who, in 1710, founded the present company in Kingston. Richard's great-great-great-grandson, Michael, now runs the Turk Group of companies.

Initially the firm concentrated on building fishing boats and wherries, the small barges used to carry important passengers and goods from London to the dockyards at Sheerness and Chatham. But Turk's reputation spread and they were soon building boats for English and foreign royalty. By the nineteenth century Turks were exporting pleasure craft, skiffs and canoes (such as that which inspired J.K. Jerome's *Three Men in a Boat*) all over the world and winning prizes at international exhibitions. Turks even built small boats for the amusement of Queen Victoria on the lakes and ponds at Windsor Great Park.

Today, Turks are one of the major operators of passenger boats. In addition to some of the most modern riverboats on the Thames, their fleet includes a fully restored traditional 'side-wheeler' or paddle steamer built in 1892, and a replica New Orleans twin-funnelled stern-wheeler that was built by the company.

Realising a Childhood Dream

Michael Turk is a remarkable man, dedicated to sailing and the sea. Like many of his predecessors he is a swan master and barge master to the Worshipful Company of Vintners, master to the Company of Watermen & Lightermen and one of the Queen's Watermen. Whilst these functions embrace long-established traditions, they nevertheless also play an important role in ensuring our rivers and waterways are properly maintained and developed for commercial and leisure use, and that the environment is safely preserved for everyone.

Forty years ago Michael Turk was a young man and, as you might expect of someone with generations of maritime ancestors, very interested in old sailing ships. So whilst others might save to buy a car, Michael saved enough to have a full-size ship's figurehead made in the form

of a Turkish warrior. Young Michael vowed that one day he would have a ship built on which the figurehead could be fitted, and that the ship would be called the *Grand Turk*.

The years passed and Michael took over the company from his father as involvement with the film industry prospered. In the early 1990s Turks were approached by Hollywood and no less a director than Steven Spielberg, who was planning a blockbuster movie about Anne Bonney, the infamous female pirate of the eighteenth century. It is well known that Anne at one time sailed an ex-British Navy frigate that she had 'acquired' and such an impressive ship was demanded by the film company. Michael's chance to build a ship to match his figurehead had arrived, and plans were prepared based on some of the frigates built at Chatham Dockyard in the late 1700s. Sadly, the facilities to build such ships no longer existed or were available in Britain and to meet the film's timescale there was no alternative but to have the ship built under the direction of Turks' own shipwrights in, of all places, Turkey. Within a few weeks the keel was set, when news came that the film was on hold and the ship would not be needed for several years. Michael's figurehead had nowhere to go!

A silver lining appeared through the black cloud and a television series based on the famous *Hornblower* novels was given the go-ahead. The series needed a ship to take the role of Captain Horatio Hornblower's flagship, the frigate *Indefatigable*, and Turks were able to proceed with the building of *Grand Turk*. Back in the eighteenth century it would have taken the shipwrights at Chatham, or indeed any of the royal dockyards, from eighteen to twenty-four months to build. But Turks' skilled craftsmen, supported by local boat builders in Marmaris and with modern tools, completed the vessel in just eight months. Michael's figurehead, now nearly forty years old, was fitted on the bow, and *Grand Turk* was launched.

Grand Turk – *Living History*

In 2000, to celebrate the millennium and Britain's maritime heritage, the National Trust created 'Operation Neptune', an exhibition that was taken to a large number of ports around Britain. The centrepiece of the event at each port was *Grand Turk*, and during the 3,000-mile circumnavigation tour of Britain more than 75,000 visitors came on board to experience what it was like to live and work on one of Nelson's fighting ships.

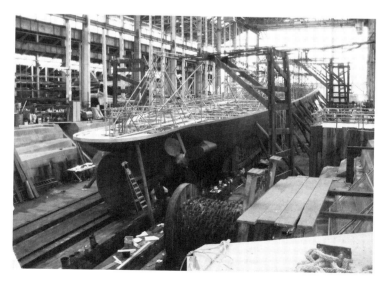

Shipbuilding returns to Covered Slip No.7, but only for a few weeks in early 2009. Turks created a Victorian shipyard, complete with ocean liner in Slip No.7 for Guy Ritchie's Sherlock Holmes film starring Jude Law and Robert Downey Jr.

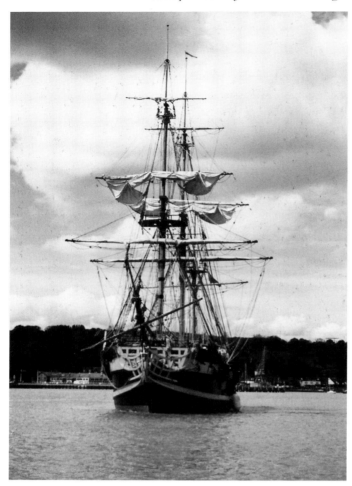

Grand Turk arriving at Chatham for one of her many visits. Thousands of people have taken the opportunity for a day-sail on this unique ship.

Grand Turk is an impressive ship. Over 150ft long with a massive 34ft beam, and carrying 8,500 square ft of sail, the ship reflects the skills and craftsmanship that over two centuries ago ensured Britain was the world's superior sea power. Frigates such as these were built in Chatham and at other naval dockyards from whence they sailed to all parts of the globe, maintaining security and defending British interests. It was a tough life for everyone on board.

Despite its size, there were a lot of people to accommodate, plus animals to provide fresh food, and there were few places below decks where it was possible to stand upright. Crew slung their hammocks where they could, often between cannon on the gun decks. However, there were three square meals a day, a jar of grog and as many weevils as you could eat. Discipline was strict, with flogging and leg-irons for anyone caught 'on the fiddle', and in battle, after trying to disable an enemy ship with cannon fire, it often resorted to hand-to-hand combat with pistols and swords. Medical aid on board could be as damaging to health as war itself and burial at sea was commonplace.

Life for the crew on *Grand Turk* is a little easier. Externally, she is an accurate replica of a 1780s vessel, but the interior would astound an eighteenth-century sailor. Several decks have been omitted which means full standing headroom in most places. Hammocks are still used simply because there is no more comfortable way to sleep on a moving ship, but there are tables

and seating that can accommodate up to 140 people for a banquet, and a galley kitchen that would not be out of place in a top London restaurant. Two 450hp diesel engines mean lack of wind is not a problem and because it is used for filming and television there are four huge generators capable of vast quantities of electricity all tucked away below.

Grand Turk carries twenty-six crew who wear period clothes and provide demonstrations of the skills necessary to survive at sea 250 years ago, such as sail making, rope work and navigation, all of which visitors are encouraged to try for themselves. There is an exhibition showing life at sea in those times with many examples of the equipment and tools that were used, and visitors can also find out what 'swinging the lead' or 'letting the cat out of the bag' really means. Those with a more macabre mind can discover how they buried the dead at sea.

Within weeks of her launch in 1997, the ship was in the Black Sea filming *Hornblower* and has since sailed extensively in the Mediterranean, the Atlantic and in northern European waters working on feature films and television productions. In 1999 she starred in *Longitude*, the fascinating story of Harrison's quest to design and build a marine chronometer. Appearances at major maritime events soon followed and the ship is now a frequent visitor to international maritime festivals where she has proved to be a major attraction.

Nelson Bicentenary 2005

In 2005 Britain commemorated the bicentenary of the death of Admiral Lord Nelson at the Battle of Trafalgar in 1805. At the end of June 160 ships from over fifty countries assembled at Spithead, off Portsmouth, where HM The Queen reviewed the fleet from HMS *Endurance* which was followed by *Grand Turk* representing the Royal Navy of Nelson's day.

Later that day, *Grand Turk* led a small fleet of tall ships into the Solent to meet a similar fleet led by a French replica vessel and for nearly two hours these ships recreated key aspects of the Battle of Trafalgar, accompanied by the deafening roar of massive cannon fire. Over 500 million people watched this amazing event on television across the world. Of course, in these days of political correctness, the fleets were not referred to as the French or British, but instead as the red fleet (France) and blue fleet (Britain). Happily, the blue fleet emerged the winner, so history didn't have to be re-written!

Floating Homes Costing Millions

Television programmes about property development have featured a number of what once were referred to as 'houseboats', and many have been built at various yards on the River Medway. Not all have been successful; in fact, one constructed mostly from scrap materials went disastrously wrong. But early in 2008 a new floating home, not a houseboat, was launched from Turks Yard in the Historic Dockyard at Chatham. Shortly after launch, it departed under tow for the River Thames and a permanent mooring at the prestigious River Quarter of floating homes established just across the river from Hurlingham. Built professionally on what was originally a huge dumb lighter, it bears little resemblance to the popular concept of living on the water, but instead provides a lifestyle more akin to that enjoyed by footballers' wives or successful City executives.

Essentially, it is a two-bedroom home extending over nearly 2,000 square ft on two floors, larger than many modern four-bedroom homes, with a genuine 'wow' factor interior that offers unrivalled luxury. At deck level there is an entrance hall with side cloakrooms, leading to an enormous lounge (complete with a real fire in a stone fireplace) and an equally huge

Afloat and almost ready to go. The first of a new generation of floating homes about to be towed to its prestigious permanent location on the River Thames.

Nearing completion, part of the huge open-plan kitchen and dining area on the floating home.

En route to her riverside berth on the Thames, the floating home approaches Tower Bridge, although low tide meant it was not necessary for the bridge to open. (Courtesy Graham Fletcher)

kitchen/diner finished with granite tops and the latest domestic technology. Large windows project beyond the main walls to provide scenic views and there is a sundeck at either end, with steps to an enormous rooftop terrace garden that extends over the entire structure. Glass spiral staircases lead below deck to a study, a guest bedroom with en-suite and a laundry room. The main bedroom boasts a separate dressing room and a bathroom with 'his and her' facilities either side of a bath with a picture window set just inches above the outside water level, so you can sit in the bath and imagine you are in water that extends to the horizon!

Whether a houseboat or a floating home, living afloat has changed beyond recognition in the past fifty years. Long gone are most of the former MTB's and similar military boats that were converted to provide homes during housing shortages in the post-war years. Similarly, the Dutch barges with their converted cargo holds are slowly disappearing, although there are some remarkable exceptions. However, the desire by many people to live afloat is as strong as ever, but they want comfort with all the mod cons. Forget decks that need to be scrubbed or chemical toilets, think jacuzzis and air conditioning!

Television and media consultant Christopher Turner and international record industry executive Graham Fletcher conceived this unique floating home. They had identified that riverside developments, especially in Central London, rarely offered much space in the desire to provide river views, and believed that living on the water could resolve this, given that modern technology has overcome the problems that beset old-fashioned houseboats. At its mooring on the Thames, this centrally heated home is connected to all services, including the internet, as is any modern property, but also has its own exclusive private mooring, plus a fitness centre and secure car parking on shore. The views are stunning, and more luxurious (and larger) homes are scheduled for this and other riverside locations.

The trip up the Thames continued past some influential near-neighbours! (Courtesy Graham Fletcher)

The home was designed by architect Chris Palmer, and is based on the Parkgate concept of the renowned yacht designer Charles Nicholson, which successfully combines the often conflicting disciplines of ship construction and house building. Christopher and Graham spent long hours considering where they could find the necessary expertise and craft skills to fulfil their ideas before finally deciding that these could be found in the Medway area. In addition, building inside Turks' Covered Slip No.7 provided the added advantage of being able to maintain factory standard control without worrying about the weather. Christopher and Graham have nothing but praise for the Medway craftsmen who built and fitted out the home. 'Facilities in Medway are ideal', said Graham, who has directly managed much of the day-to-day construction, 'it was possible to properly launch and ballast the completed unit before it went on to the river. The local workforce was ideal, and we plan to build all our future units here in Chatham.'

A few days later construction of another luxury floating home, even larger than the first at 2,800 square ft, commenced on the same slip. Built on its own floating base, not an existing barge, and with a roof garden, sun terrace and several guest suites, construction took just eight

A real fireplace on the floating home, built from stone.

weeks before the fully completed home was launched and towed to its permanent berth on the Thames by the docklands, close to the City. No sooner had the home been launched than building commenced on yet another floating home.

Clearly there is a market for such upmarket properties, which seem to remain highly desirable and in demand irrespective of changes to the financial climate. Meanwhile, construction of these luxury floating homes at Chatham has demonstrated that the skills which created Britain's warships, from Nelson's *Victory* to nuclear submarines, and commercial ships from bawleys to barges, still exist along the river Medway. The craftsmen easily adapt to meet changing styles and techniques whilst maintaining the high standards and a regard for tradition.

It is hardly surprising that everyone seems very reluctant to reveal what it costs to buy one of these floating homes, but most are going to prestigious Thames moorings, which helps to indicate a price. It is believed the first home, with its fifty-six-year mooring lease, cost the buyer nearly £1.5 million. The larger and more luxurious home cost £2.5 million. But both homes come complete with views to die for and a river bus to whisk the occupant to Central London and the City in a matter of minutes.

Of course, living on water is not new, but with global warming and dire warnings about rising water levels, one of the safest places to be in the event of flood is a home that floats! One of Britain's most respected authorities on future living has said: 'there will be at some stage a massive catastrophic event that will finally goad us into doing something – in the meantime my advice is that everybody should get a boat!' In Holland, where living with the water has been a way of life for centuries, there are already 'villages' of floating homes similar to that just launched in Chatham. With state-of-the-art architecture and design, such homes could well be a 'must-have' for the future.

Without doubt, Christopher, Graham and others have identified a niche market that seems able to weather financial ups and downs – and even a recession! There is certainly no shortage of people prepared to pay a lot of money for a very exclusive home in a unique setting. With more floating homes to be built in Chatham, who knows, maybe some, in due course, will be moored on the Medway!

Other titles published by The History Press

Medway Shipping: From Frigates to Freighters

GEOFF LUNN

The River Medway is Kent's main waterway and has been regarded as a safe haven for shipping for centuries. In this book, author Geoff Lunn covers topics including paddlers, cargo and passenger ships, as well as the ports and harbours of the Medway Towns. Illustrated throughout with black and white photographs and a selection of miscellaneous illustrations, *Medway Shipping: From Frigates to Freighters* details the history of shipping on the River Medway.

978 0 7524 3565 7

Chatham: Naval Dockyard & Barracks

DAVID T. HUGHES

The history of Chatham Dockyard has been an eventful one. It owes its inception to King Henry VIII who, in 1547, selected the River Medway at Gillingham to be his main fleet anchorage. As more ships were added to the royal fleet the work of the dockyard was increased, until it was deemed necessary to build a small castle to protect the yard and anchorage from attack. David T. Hughes has compiled a thoughtful and insightful volume of photographs and ephemera on the Chatham Naval Dockyard and Barracks, looking at it from its early days of existence until its role in more recent years, from the First and Second World Wars to the Faulklands.

978 0 7524 3248 9

Medway Towns

ALUN PEDLER

Using over 200 images from around the turn of the twentieth century, this book presents the social history of the Medway Towns of Strood, Rochester, Chatham, and Gillingham alongside the smaller settlements of Snodland, Halling and Cuxton, Cobham and Higham, the Hoo peninsula and Rainham and Upchurch. From images of the castle at Rochester, the oldest of the towns, to the founding of Chatham Dockyard in the Elizabethan period and on to the buildings that were to inspire Charles Dickens in his writing, the reader is taken on a journey through Medway Towns.

978 0 7524 3303 5

Visit our website and discover thousands of other History Press books.

www.thehistorypress.co.uk